Alice Neel

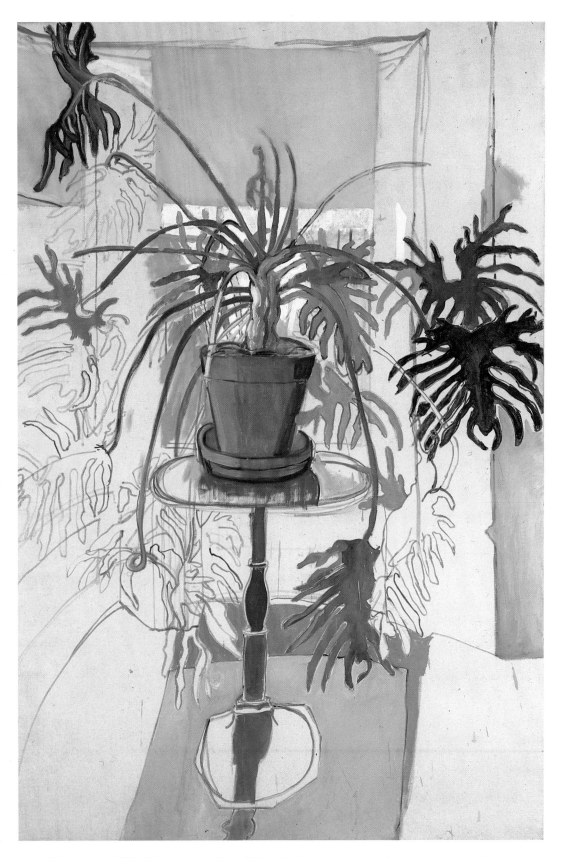

Philodendron. 1970. Oil on canvas, 80 × 52″. Collection the artist and/or family, courtesy Robert Miller Gallery, New York City

Patricia Hills

Alice Neel

Harry N. Abrams, Inc.
Publishers, New York

Editor: Nora Beeson

Designer: Dirk Luykx

Design Consultant: John Cheim

Rights and Reproductions: Barbara Lyons

Library of Congress Cataloging in Publication Data
Hills, Patricia.
 Alice Neel.
 Bibliography: p. 203
 Includes index.
 1. Neel, Alice, 1900– I. Title.
ND1329.N36H54 1983 759.13 82-25534
ISBN 0-8109-1358-5

The publisher wishes to acknowledge the contribution of the
Robert Miller Gallery to the production of this book and the
making of the photographs

Published in 1983 by Harry N. Abrams, Incorporated, New York

Printed and bound in Italy by Amilcare Pizzi, Milan

Contents

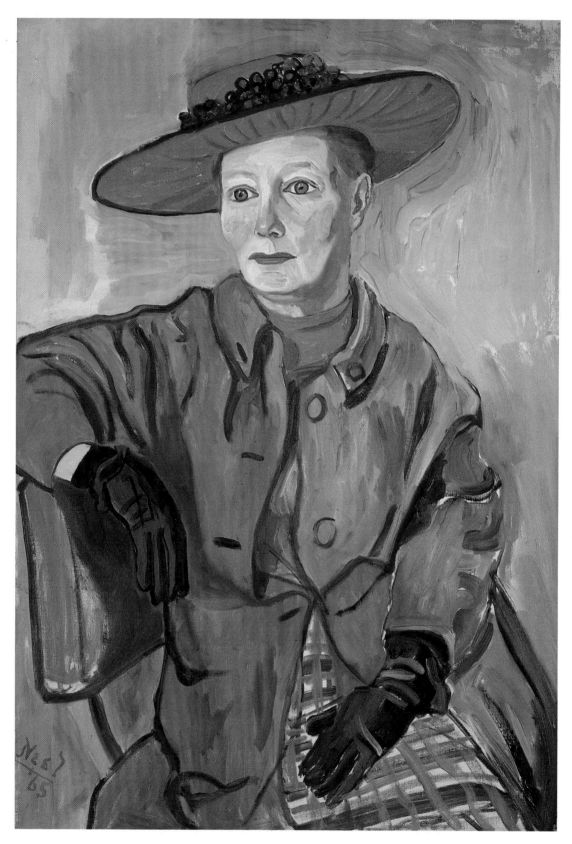

Mary Shoemaker. 1965. Oil on canvas, 39 × 26″. Collection the artist and/or family

Foreword

In the mid-sixties, when I first saw an exhibition of Alice Neel's paintings, the images burned their impressions into my memory. Little did I know that I was at that moment caught in her net and within a decade would be added to her collection of spirits. Our personal acquaintance began in 1974 with a series of long telephone interviews in preparation for an exhibition catalog. I was charmed by her gentle manner and looked forward to our daily telephone conversations as I pried into her life. But I was terrified when the time came for us to meet. Suppose, after sharing so many personal thoughts, we hated each other. Instead, we became friends—a friendship I treasure.

Alice Neel has not had an easy life. The youthful Alice's exceptional sensitivity to ordinary circumstances made it difficult for her to fit into the routine expected of a child growing up in Colwyn, Pennsylvania. Yet, from her early experiences, Alice formed ideas that would separate her from the usual events of a lifetime, placing her in the innovative realm of the most remarkable artists of our time.

After surviving many difficult events in her formative years, Alice became a person of great individualistic strength and will. Her keenly developed insights into twentieth-century life are so exceedingly sharp and perceptive that we, as viewers of her paintings, are, on the one hand, frightened and, on the other, charmed by her wit, humor, and sensitivity. The personal images in Alice Neel's work not only reflect her life, they also provide metaphors related to politics, economics, and philosophies of contemporary American life.

Like Chichikov in Gogol's novel *Dead Souls*, Alice became a "collector of souls." The shelves in her studio are full of spirits seeking release from the bondage of her paintings and of being human. There is no peace and tranquility in the paintings, only agitated recognition of inevitable struggles on this earth.

Since that first encounter with Alice Neel's paintings, I've felt that I've been in communication with her collection of souls and spirits, each one agonizing with its own fate as it plays out its part in her special world. Her subjects are helplessly locked into their niches and are eternally contained within the four edges of her canvases. The faces in her portraits call for answers, but none are given. There is loneliness in these final judgments by Alice Neel, and in these captured moments we sense a presence of ourselves. Yet in spite of a never-ending terror of confronting one's fate, there is a compassionate humanism in her paintings. Alice Neel's portraits, landscapes, still lifes, and interiors are tense with both emotion and contradiction; they are aggressive and uncompromising. Even though the paintings convey deep perceptions and are often dark and oppressive, they nevertheless reflect the painter's vigor, love of humanity, and determination.

Alice Neel's highly personal art reveals her private emotions and the realities of her world. But more importantly, she shares with us her remarkable ability to penetrate the psyches, minds, and emotions of her subjects. More often than not, the candor of Alice's vision has left her sitters ruthlessly exposed, stripped of veneer, for all the world to see.

The "Alice Neel experience" never leaves us neutral; it demands a response. At a 1975 exhibition of her paintings, I recall one academic old fogy who objected to young people seeing these images. His reservations were absurd; the young people he thought he was "protecting" fell in love with Alice, her paintings, and her clear view of the world.

Alice Neel's concentration on the human predicament is unique in this century. Even though a number of prominent artists have emphasized the figure in their paintings, none in our time has done it with the directness that characterizes this artist's work. I have been amazed by the freshness of her paintings and intrigued by her loving, although usually bald, descriptions of subjects in these pictures. She describes her sitters with a colorful vocabulary, and the iconography of her images not only encompasses human attributes but also includes a wide range of bestial equivalents: he's a fox; she looks like a turkey; he has the face of a fish; his hands are like worms. (When she painted my portrait in 1975, I asked about myself and was disappointed not to have been told my zoological counterpart, although she must have one for me.)

There is a singleminded perverseness to her expressionist interpretations. Alice told me once that in her youth she wanted to die; but now in the later years of her life, when it's time to die, she only wants to live. And live she does. In recent conversations I have sensed an assurance that I didn't perceive nearly a decade ago. Yet this is counterbalanced by occasional irreverent reaffirmations of the convictions and doubts of a lifetime. In September, 1982, I showed some of my own collages and drawings to a New York museum curator. After politely but cautiously handling them, he muttered, "They're nasty!" Later, I described this visit to Alice, who said, "But life is nasty!" Alice, at eighty-three, with the wisdom that comes from long life and the security that accompanies acceptance of her work, does not deviate from themes central to her art.

Even though Alice has had a rough life, she has produced a legacy of work that will bring pleasure to the lives of many others.

William D. Paul, Jr.
Athens, Georgia
January, 1983

Preface and Acknowledgments

In November, 1979, after discussing the project of an Alice Neel book with Margaret L. Kaplan at Harry N. Abrams, I began taping my conversations with Neel. In the summer of 1980, I taped about eight more hours in preparation for an exhibition held at the Boston University Art Gallery in October, 1980. On the basis of these tapes I assembled a narrative that I read to Neel in July and August, 1982. I then recorded her comments on these readings, incorporated her written pages on the paintings, and wove everything into the manuscript. I have also included parts of statements and addresses that Neel gave to me for inclusion. Published here for the first time are her poems "My house is beside a river of lead" and "the great renunciation"; her short story, "The Dark Picture of the Kallikaks"; and her reminiscence of the suicidal ward, written in 1931 or early 1932.

Neel is well known for her public lectures, and the quality of her language is preserved. Her narrative reveals a woman who struggled and achieved recognition in the art world. It is both a personal testament to her strengths and a document for our own era.

Nancy Neel should come first in any list of acknowledgments, for her patient help to Alice Neel and myself has been invaluable. She arranged for and participated in the interview sessions, she provided photographs and slides, she pulled paintings from storage for my study, and she carefully and sensitively reviewed all the pages of the manuscript for possible errors of fact and for inadvertent misinterpretations.

I am grateful to Nora Beeson, Senior Editor at Abrams, who skillfully handled editing problems and the preparation of the final copy for publication. John Cheim, the design consultant, spent many days with Neel and myself in the summer of 1982 reviewing paintings for inclusion as reproductions.

I want to thank Shirley Boulay, Mary Whitfield, Christina Hills, and Peggy Burlet, who assisted me in transcribing the tapes and typing. I am grateful to Terry Davis of the Graham Gallery, New York, for providing information regarding Neel's exhibitions.

I also want to record here my own deepest thanks to my husband, Kevin Whitfield, who advised and talked over with me the many issues suggested by Neel's life and work.

Finally, I thank Alice Neel herself, with whom I have talked, debated, and argued over the years, but especially intensely in July and August, 1982. Her stamina in holding fast to her beliefs, and her energy and fighting spirit when confronting the future, will long be an inspiration.

In the text, my comments and questions are in square brackets; Alice Neel's own words are in italics.

Patricia Hills

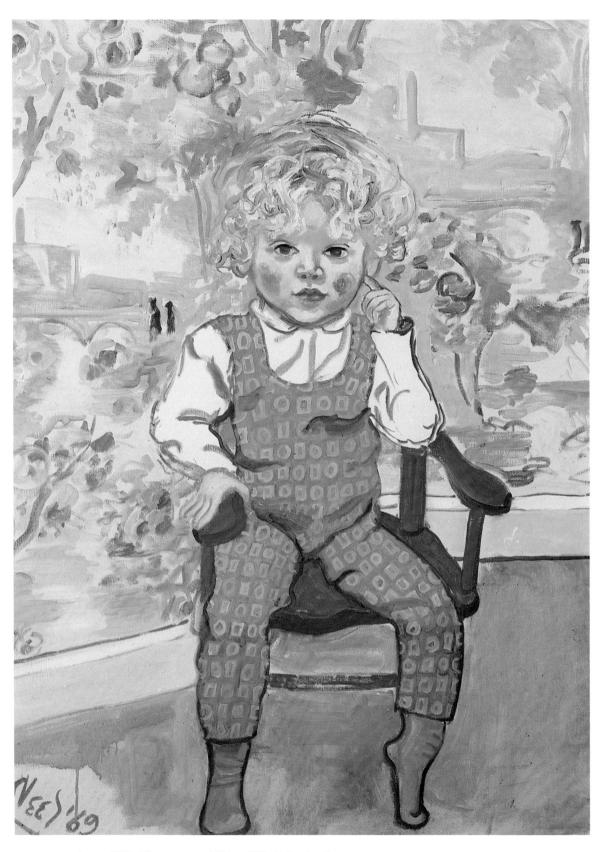

Jenny. 1969. Oil on canvas, 35½ × 26″. Collection Jonathan and Monika Brand, Philadelphia

Alice by Alice

The minute I sat in front of a canvas, I was happy.
Because it was a world, and I could do as I liked in it.

Alice Neel, 1980

[Alice Neel was born on January 28, 1900, in Merion Square, on Philadelphia's Main Line, Pennsylvania. Her mother was Alice Concross Hartley and her father was George Washington Neel. Her brother, Albert Edward, had been born in 1888; her sister, Lillian, in 1890. Her younger brother, George Washington, Jr., followed in 1905. The family moved to Colwyn when Neel was about three months old.]

I lived in the little town of Colwyn, Pennsylvania, where everything happened, but there was no artist and no writer. We lived on a street that had been a pear orchard. And it was utterly beautiful in the spring, but there was no artist to paint it. And once a man exposed himself at a window, but there was no writer to write it. The grocer's wife committed suicide after the grocer died, but there was no writer to write that. There was no culture there. I hated that little town. I just despised it. And in the summer I used to sit on the porch and try to keep my blood from circulating. That's why my own kids had a much better life than I had. Because boredom was what killed me.

There was nothing to stimulate my mind except my mother. Her ancestor, Richard Stockton from New Jersey, had signed the Declaration of Independence. She was very intelligent, well read, but art wasn't her field.

My mother took me to see Faust *when I was about fourteen. She took me there so I wouldn't get pregnant. Still, she took me to other things. I saw Pavlova dance and heard Paderewski, the Polish pianist and composer. I also saw Sarah Bernhardt. She had a wooden leg. You know whose acting I did like? Eleonora Duse. She used no make-up and was marvelous. She was heroic.*

My father's family were opera singers, and they died when he was twelve. They died broke; they didn't leave him anything. He never got much of an education. He just worked in the Pennsylvania Railroad all his life. He was the head clerk in the per diem department of the Pennsylvania Railroad. He was very refined, a wonderful, kind man, whom my mother lorded it over. I really grew up in a matriarchy.

I always wanted to be an artist. I don't know where it came from. When I was eight years old the most important thing for me was the painting book and the watercolors. I'm not like Picasso. He loved the Katzenjammer Kids. Even though I was given a book of the Katzenjammer Kids when I was ten years old, I hated them. I liked romantic couples, and pears and flowers, and that kind of stuff. And I'd get watercolors for Christmas. I didn't take art in high school, but I used to draw heads on the edges of my paper. I was so unsure of myself that the back of the head always went off the paper.

I felt such an obligation to my family, because they didn't have

much money, that after the two years of regular high school I took the business course. I became an expert typist and stenographer. At the end of school, I took the Civil Service examination. Since I was so good at mathematics, I immediately got a very good job with the Army Air Corps in Philadelphia, just at the end of World War I. I made what for those days was considered very good money, $22 a week. I took care of the filing and the letters. I worked for a man named Lt. Theodore Sizer. Later he became an art historian in New England.[1] He used to take me on his shopping trips for his family.

I never told anybody about my art. But even then, at night after work, I went to art school, to the School of Industrial Art, and then to another one in downtown Philadelphia. The teacher there was an old German, very dogmatic. In one picture I was putting the hair on the head like it grows, and he said: "You don't have to do that. You can just put a tone in." So he showed me how to fill in the side of a head with up and down strokes. I said: "Well, that isn't the way the hair goes. I don't want to put in a tone." So he looked at me in fury and said: "Before you can conquer art, you'll have to conquer yourself. Even if you paint for forty years you may not get anywhere." And I said: "That's not for you to say because you are only my beginning teacher." He didn't bother me, though. I just kept going.

In the three years after high school I worked in various Civil Service jobs besides the Air Corps job. At the end I was making about $35 a week, which was a lot of money for then. Then I quit and answered an ad for a job in Swarthmore. I was offered a job for $30 a week. I remember walking home from the interview through the fall leaves and thinking how discontented I was just to go to work every day. Art was at the back of my mind, always. So I wrote the interviewer that I didn't want the job.

I then enrolled in the Philadelphia School of Design for Women, now called Moore College of Art. I didn't want to go to the Pennsylvania Academy of the Fine Arts because I didn't want to be taught Impressionism, or learn yellow lights and blue shadows. I didn't see life as a Picnic on the Grass. *I wasn't happy like Renoir.*

The Philadelphia School of Design was only a women's school. I liked that better, because I was young and good-looking, and the boys were always chasing me. And here at the Philadelphia School of Design I wouldn't even be able to notice a boy. Because I liked boys. It's all right at sixty or more to say that men are unimportant, but at twenty-one they can be the most important thing in your life. I went to a school that was just a girls' school so I could concentrate on art.

At that point I could always handle men easily. I much preferred men to women. Women terrified me. I thought they were stupid

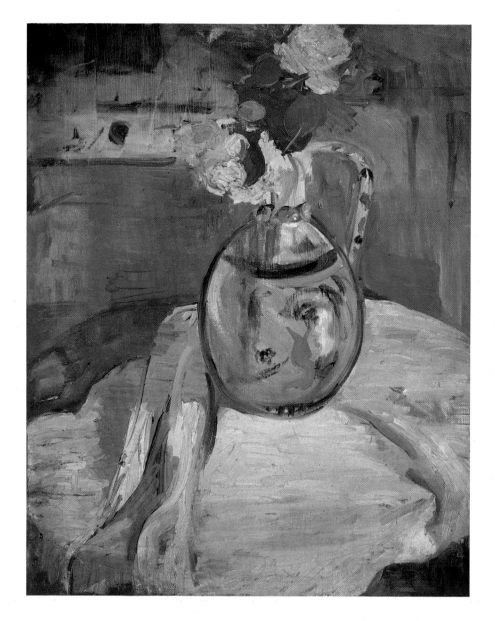

Still Life. 1926. Oil on canvas, 26 × 20″. Collection the artist and/or family

because all they did was keep children and dogs in order. Even though they were "the conscience of the world," I didn't think they had all the brains they should have, nor all the answers. I thought the most they ever did was back some man they thought was important.

Miss Emily Sartain was the dean of the school, a very conventional lady. And of course I got in all right. I paid the first year's tuition. It was only $100, I think, and I had saved a little money. They taught fashion there, too. I enrolled first as an illustrator, but that was a mistake, so I changed to fine arts before the end of that year. After that they gave me the Delaware County Scholarship because I was very good.

It was a conventional school. First you drew plaster casts. They had a wonderful collection including Michelangelo's Moses *and the* Frieze *of the Parthenon. I have always thought it very important to learn to draw. Drawing is the discipline of art. I drew plaster casts for about six months, and then went into the life class. There was usually a nude model, occasionally clothed. I remember taking a large canvas when I first went into the life class. The instructor, R. Sloan Braden, told me he was glad to see I was ambitious.*

There was one good woman teacher, only one, and a lot of bad men teachers, and other insipid women teachers. The good teacher's name was Paula Balano, who taught drawing. She was married to a Greek, who used to write on her apartment walls, "I love you, Paula." Also, she had a young daughter, and she made her living doing stained-glass windows.

She was wonderful! I was then incapable of seeing a head as just an egg. When I drew a head, it had expression, it had eyes, it had everything. When she criticized your drawing, even though it was from a plaster cast, she would explain that the body turned only at the neck and the waist; that the nose was just a little bone and then it was gristle; and then she would explain how the mouth is like a rubber band, which is why old people have all those little wrinkles around the mouth.

I had a teacher of landscape, Henry B. Snell. Once I did what I thought was a great outdoor painting. He said: "The trouble with this is it's too horizontal." But that was the point of the whole painting. He said: "You need a few verticals," and drew them in with charcoal. Of course I took them out immediately.

They had a man there teaching illustration. His name was Harding. He was a great follower of George Bellows. There was some woman in that class who later became very important in New York. She had a big gallery on Madison Avenue. Even in art school she sold cute little drawings to the newspaper. And Harding said to her: "Now, if you could add to your clever drawing this girl's feeling—meaning mine—you'd be really good." I was *the feeling, but that didn't entitle me to anything, you know.*

When I came to lettering—which I couldn't do, that's why I dropped out of illustration—I lettered, "Full many a flower is born to blush unseen,/And waste its sweetness on the desert air." That's from Thomas Gray's "Elegy in a Country Churchyard." And the teacher said to me: "I don't care about the sentiment, I just want good lettering." But my lettering was frightful.

When I was in art school, I used to go look at Matisse. He didn't satisfy me. He is a wonderful artist, but there was no character there,

no psychological impact. That I found out when I was twenty-two. For me he was therefore of just limited importance. You see, Picasso, no matter how destructive he is, he does have the human race torn to pieces. He has a great importance because he sees—he dismembers it. Matisse, beautiful as his work is, remains more or less decorative. Persian, really.

I was too rough for the Philadelphia School of Design. I didn't want to pour tea. I thought that was idiot's work. And I once painted a sailor type with a lighted cigarette. And, you know, when you paint a picture, there is a certain range. So having this lighted cigarette made the range different—from bright fire to the shadow—and it was very hard to paint. But none of them realized that. This shocked them. They liked pictures of girls in fluffy dresses with flowers better, so they didn't

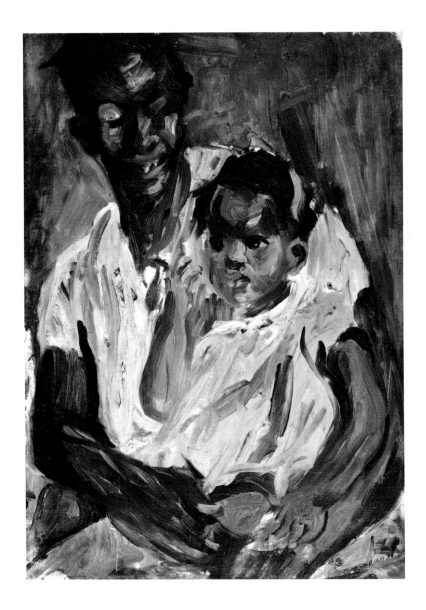

Mother and Child, Havana. 1926. Oil on canvas, 26 × 18″. Collection the artist and/or family

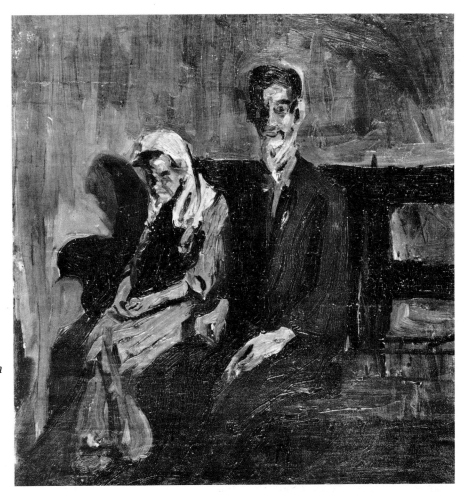

Beggars, Havana, Cuba. 1926. Oil on canvas, 20 × 18″. Courtesy Grimaldis Gallery, Baltimore

We hired these people—beggars—to sit in the lobby of a big office building in Havana. One was mentally deficient and the other was almost blind. Extreme poverty and showy wealth were right next to each other in Havana. Men used to cut sugar cane for 50 cents a night. It was too hot by day.

give me a European scholarship. I stayed until I was twenty-five and got a diploma, equivalent today to an M.F.A.

In the summer of 1924 I had attended the summer school of the Pennsylvania Academy in Chester Springs and met Carlos Enriquez. When they expelled him for doing not much more than taking walks with me in the evening, I left also; and the next year we were married.

Carlos was an upper-class Cuban. In 1925, I was twenty-five years old and the most repressed creature that ever lived. I was in love with him. He was gorgeous. Not only that, he was an artist. That was one of the best loves I had, really.

We went to Havana in 1926. Now you see, Carlos was a bohemian. He was not bourgeois. His family wasn't bourgeois. They were much higher than that. They had owned provinces. He had an uncle who was the richest man in Havana, who brought hundreds of people from Galicia to work his sugar plantation, and who had a house on a mountain. He had a chapel inside the house, and the priests used to all come. Carlos's father was the most famous doctor in Havana, Doctor Carlos Enriquez de Gomez. You can't imagine how they lived. Carlos's

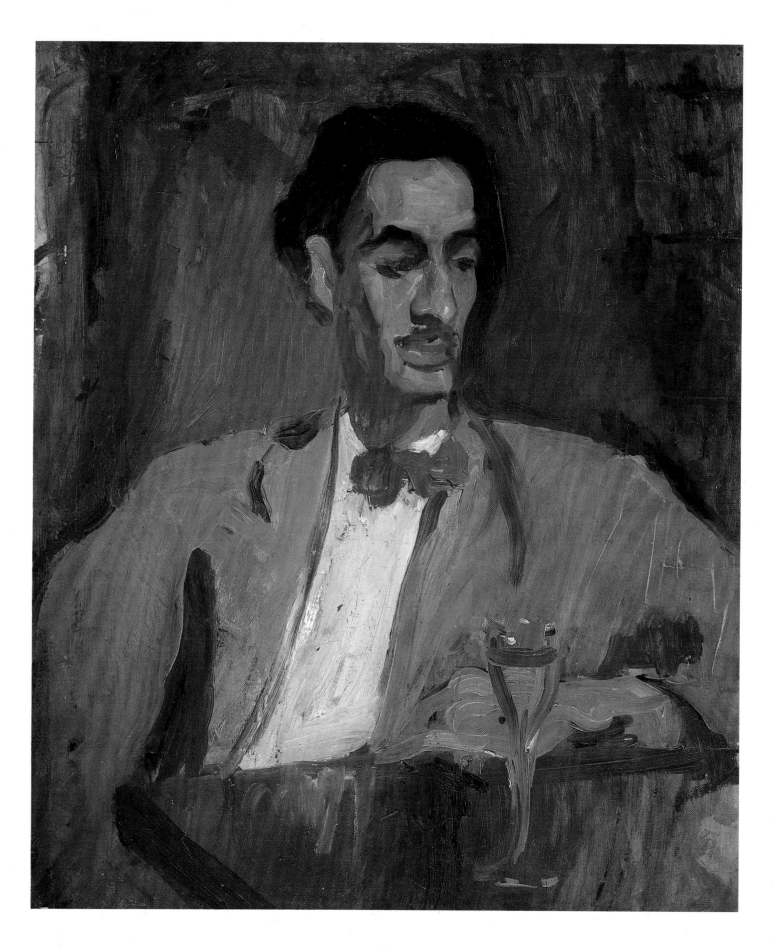

(opposite) *Carlos Enriquez.* 1926. Oil
on canvas, 30¼ × 24″. Collection the
artist and/or family

The Grandchild. 1927. Watercolor, 9½ × 8″.
Collection the artist and/or family

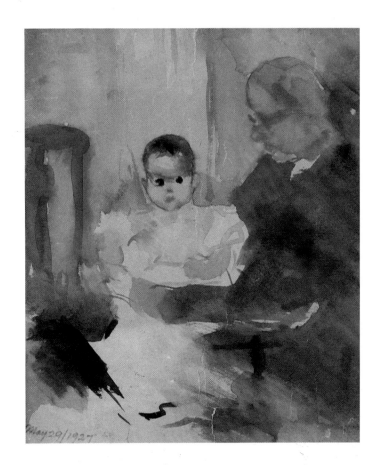

The Family. 1927. Watercolor, 14½ × 9¾″.
Collection the artist and/or family

*My brother is upstairs studying French. He
was going to Temple University. I had just
come home with this baby, and I'm sitting
holding the baby. My mother is frantically
cleaning the floor, and down in the cellar my
little, gray father is carrying up coal for the
stove in the kitchen. My mother couldn't stand
the confusion. She has a wild look; no doubt
she saw the future. I was too goofy to see it.*

family had seven servants. One was a cook who just cooked all day. She did nothing but cook—Josephina. I remember going out in the kitchen and eating fried banana before dinner. At lunch they had their big meal. We'd start with soup, fish, well, you never saw anything like it. It was just fantastic. On the grand scale, you know.

His mother as a girl was dressed by slaves. And they lived in this white palace in El Vedado, with peacocks walking in the garden. I had a room like Romeo and Juliet's, with marble floors and a balcony. My god, it was fantastic. But still, I didn't like the heat and the sun.

At their home I lived about seven or eight months. Then we had an apartment on the waterfront. When American ships came into the harbor, a Cuban band would play The Stars and Stripes Forever. After that we rented a little place outside in La Vibora, which means "the viper," a place on Revolución Cinco, with walls a yard thick. And we just painted like mad all the time. There a woman and her child posed for us, which is the picture Mother and Child, Havana, of 1926. My Still Life of the same year was an effort to understand the tropical light of Cuba, a light very different from the light I had been accustomed to. We also used to go around like Van Gogh with our paint boxes.

You know what we used to do at night? I remember I was pregnant with the first baby. We'd take a bus and go out to the outskirts of the city, and there the Afro-Cubans would be dancing; they'd dance like mad and run into the bushes—you know for what. They'd use this strange language, part African and part Spanish. And what dancers! Wild, you know. Nicolás Guillen, a Latin-American writer, claims "that the spirit of Cuba is mulatto." You know the song, "Echa la bruca, Manigua"? That was Afro-Cuban.

Cuban women often dance with each other. They just don't have to hang around a man's neck the way American women do. They have more self than American women. They are highly sophisticated. The American woman was weak compared with the womanliness of the Cuban woman.

We painted every day and we went out sketching every night. We were completely concerned with art and we knew quite a few artists. I had an exhibition in Havana in 1927.

When I was young I read an awful lot of poetry. I wrote also, so I took my poetry to Havana. Carlos said the English poets were too metaphysical—that was not to his liking. He liked poems like "a troop of elephants by the seashore." That, to me, was just crap. I don't care anything about "a troop of elephants by the seashore." But when Percy Bysshe Shelley says, "Men of England, wherefore plow?"—that I love, when he calls them to revolution.

My life in Cuba had much more to do with my later psychology. It conditioned me a lot. The writers didn't snub the artists, like in America. The artists and the writers and the poets all got together. I knew Alejo Carpentier, a very wealthy French-Argentine writer. I gave him my copy of Robert Henri's The Art Spirit.

I should have had some birth-control thing, because I was then simply an ambitious artist. When people would mewl over little kids, I just wanted to paint them. But anyway, when I got pregnant in Cuba, that was it. Of course, Carlos's father was 100 percent against abortion.

I had my first baby, Santillana Enriquez, on December 26, 1926, in Cuba, without anything to alleviate the pain. It was frightful! Eight hours of intense agony.

During the summer of 1927 I returned to my family's home in Colwyn, where I painted the watercolors The Grandchild, *showing my father in his smoking jacket holding Santillana, and* The Family. *My father's life was a complete sacrifice. You know what Thoreau said: "The mass of men lead lives of quiet resignation." Oh, it's "quiet desperation." That's even better. It's sharper.*

In the fall of that year Carlos came back, and we rented a place in New York on West 81st Street, a great big room. It was there that I continued to paint a great number of watercolors.

The baby died before the end of 1927, just before she was a year old, of diphtheria. Santillana was a very healthy, beautiful child. That was the year before they gave the shots for diphtheria. In the beginning I didn't want children, I just got them. But then when she died, it was frightful.

[Neel's mourning found some release in the creation of art. Her water-color *Requiem,* 1928, has the quiet intensity of numbing grief found in some of Edvard Munch's work. The cadaverlike figure lying in the water's mud and hugging the amorphous form of a smaller human is hovered over by the black-cloaked skeleton of death. Rotating primitive fish forms continue the elegaic rhythm in this dense bottom layer of sorrow. Above and beyond are layers of thin watery washes drained of color, punctuated only twice by lifeless boats. The faint rays from the sun on the horizon offer no warmth to this desolate scene.]

After Santillana's death I was just frantic. Then I was already in a trap. All I could do was get pregnant again, which I did. I was also working at the National City Bank, as well as painting. That other little girl, Isabella, was born on November 24, 1928. We called her Isabetta. Several weeks later I did the Well Baby Clinic.

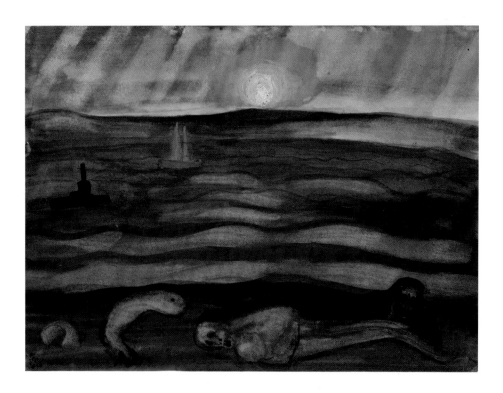

Requiem. 1928. Watercolor on paper,
9 × 12″. Collection the artist and/or
family, courtesy Robert Miller Gallery,
New York City

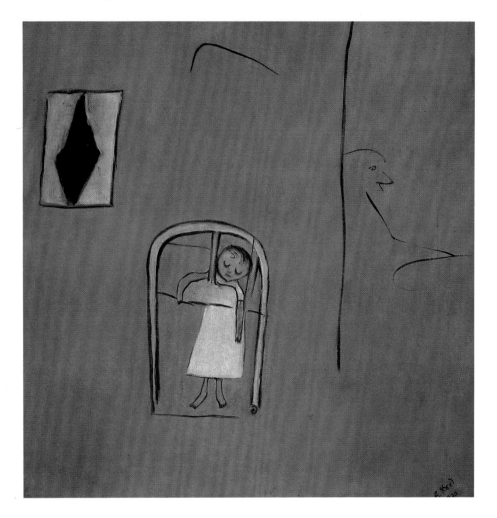

Futility of Effort. 1930. Oil on canvas,
26¾ × 24½″. Collection the artist
and/or family

I painted Futility of Effort *in 1930.
It related to the experience of having
a child die of diphtheria, but it also
referred to another event. I read a
notice in the newspaper about how a
child crawled through the end of a
bed and got strangled through the
bedposts. The mother was ironing in
the kitchen. The black line in the
picture is like a fate line. It was
reproduced with the title of* Poverty
in Art Front, *the monthly newspaper
for the Artists' Union. But* Futility of
Effort *is a better title.*

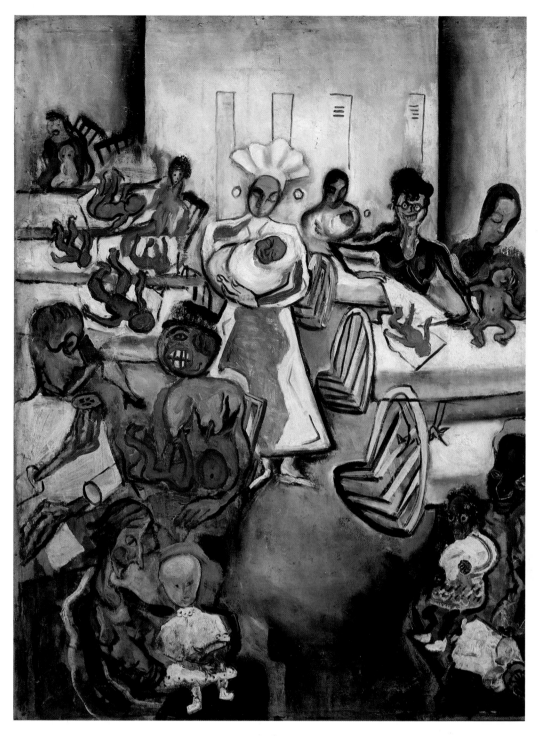

Well Baby Clinic. 1928. Oil on canvas, 39 × 29". Collection the artist and/or family

 Well Baby Clinic *makes my attitude toward childbirth very dubious. I wondered how that woman could be so happy, with that little bit of hamburger she's fixing the diaper for. That nice-looking one to the right of her is me. And you see the doctor. Look at that woman talking like mad, with that baby on her lap. And then you know another reaction I had? The purity of the nurses' outfits, and the white walls of the hospital, so neat, and then sloppy humanity there, all ragged at the edges. And see that woman talking to the doctor, and he's holding a few pills in his hand. This was done in the winter of 1928–29 from memory.*

[Confined to her bed with the phlebitis she contracted after childbirth, she pursued her own intellectual preoccupations by writing "The Dark Picture of the Kallikaks." The short story addresses the issue of class as well as gender, and heightens the contrasts between the privileged and the dispossessed; in the context of 1929, the brief prologue pokes fun at the scientific racism of the eugenicists. It is the story about how the atavistic Nona, the reverse of *anon.*, anonymous, of female gender and of the working class, is brutalized by the self-important pedant, the emotional eunuch, Unik.]

The Dark Picture of the Kallikaks

Martin Kallikak, a youthful soldier in the American Revolution, met a feeble-minded girl, who bore him a son of low mentality. In 1912, there were 480 known direct descendants of this union. Of these 143 were of such low mentality as to be classified as feeble-minded, and most of the others were of relatively low mental ability. In addition, 33 of the latter were sexually immoral, 36 of illegitimate birth, and 24 confirmed alcoholics. Contrast the dark picture of the Kallikaks with the accomplishments of the 1,394 identified descendants of the Edwards family. Of Jonathan Edwards, born in 1703, there were in 1900, 1,394 identified descendants, of whom 13 were college presidents, 65 college professors, 60 physicians, 100 clergy-men, 75 Army or Navy officers, 60 prominent authors, 100 lawyers, 30 judges, 80 prominent public officials, and a great many successful bankers, business men, landowners, etc. None was known to be of feeble mentality and none was known to have committed a crime while many achieved great eminence in their professions.

It was a lovely spring morning. Nona Kallikak, the last scion of her disreputable family, sat pensively among the boat houses. The natural generation of generation after generation degenerating had culminated in Nona. Boat houses and swampy places were the bloodbaut heritage of the female Kallikaks. When she stood, as with all ladies who prefer boat houses to tea parties, she stood with her legs too far apart, awakening suspicion and destroying such poetic allusions as sapling reed, although her affinity for the water would have made these especially fitting only, as I have said, for the unfortunate angle of her legs.

Now it happened that Unik Edwards, in every way worthy of his name, both first and last, came with a bevy of his spring-time students to study wherefore and why the bull frog likes mud and to observe him in his native haunt. Neither Unik nor Nona knew that he was hope eternal and she despair forever, standing near each other on the purple slimy mud beside the green water. And now the bevy coquettishly fluttered off in pursuit of butterflies, leaving Unik and Nona, children of destiny, light and shade of 150 years, face to face among the thick swampy smells.

The 150-year monopoly of health, wit, and virtue filled Unik with shame. Falling upon his knees he kissed the feet of this last Kallikak, worshipping the word made woman of sorrow, despair, and sin of all mankind. The bevy chirping among the flowers with tinkle glass giggles filled him with contempt. Here in the maroon mud his hand caressed the dark red cylinders of Nona's legs. He kissed her loose blouse where he thought her belly button must be. He thought of a naval orange folding of quicksand and slowly sucking. He kissed the arch of her breast bone, slowly and sluggishly churned the dark passion of Nona. He seemed to her frivolous in his loving, but wonderful and clean. His fresh smell was like crab-apples and lemon around the purple mud and yellow rubber water lilies. His eyes were clear blue ringing blue bells.

Nona bent more and more backwards and then leaning against the bank gradually lay down, her black eyes more sad and strange than before. Unik Edwards didn't care. He unbuttoned her loose blouse. He kissed her white stomach, her round white breasts one in each hand he pushed them together. They looked like white birds then and he kissed their pink beaks. The flat thick slit of Nona's mouth was working in and out rhythmically with primitive emotion. And now the sharp clean shaven lips of Unik fell into the soft red jelly of Nona's lips. She felt his watch ticking on her bare white belly, the buttons of his vest hard places in his soft wool suit. She felt his motions were too jerky and did her best to mold him with the slow passionate movement of the purple mud.

Now it was over and Unik Edwards had planted the seed of his clean and virtuous people along this morbid river bank in the exhausted white body of Nona Kallikak. He looked at her white mask face with no eyes and 150 years of Edwards felt nauseating disgust. He saw a child half Edwards half Kallikak, and his professor's soul, his successful soul of successful people, longed for its proper home. The slimy mud, the rotting yellow rubber water lilies, the rumpled dark red shirt, the white belly like a pale sun under the grey sky, the slow lap of the sensuous green water—-they were too strong for him. He was crisp and brittle, these things would smother him.

He felt his feet sinking in the mud. Looking down he saw that Nona's arms, legs, and hair were all sucked in. The sight of her white face, breasts, stomach, and sex presented like this without eyes was too much for him. Once more he lay upon her, once more he moved in an eternal rhythm with this last daughter of the Kallikaks.

His thick disgust now let Nona sink forever into the mud. The vacant eyes of all the boat houses reproached him. Their rectangles reminded him of Nona's beautiful red cylindrical thighs. The dark grey sky, the morbid wind, and the sinking mud all loved Nona Kallikak. Well, he too, he loved Nona Kallikak. He dug in the mud but she was gone. Then to prove his love he filled his mouth with mud—he chewed it, he kissed it, he sat all night along the sad river calling Nona with his fingernails full of dried mud. This was a real penance as it irritated him horribly to feel the dried mud under his fingernails. While it was still dark he ran from the place knowing its fatal fascination.

[Neel's comment today: "You know how the upper classes hate to have dirt under their fingernails."]

Harlem River. 1927. Watercolor, 14½ × 19½″. Collection the artist and/or family

Intellectual. 1929. Watercolor, 10½ × 15″. Collection the artist and/or family

She was a friend of mine, Fania Foss, the pretentious lady with the breasts hanging out, which is artistic liberty on my part. She did grade B movies. Her first husband was Edward Dahlberg and the second was Mark Lawrence. And next to her is her friend and they were avidly talking of intellectual things. I am at the left with the little girl. You see I gave myself an extra arm because I was so busy with the little girl, and also an extra leg because I had to chase her.

La Fleur du Mal (Nadya). 1929. Watercolor, 20 × 14¾″. Collection the artist and/or family

Harlem River at Sedgwick Avenue.
1928. Oil on canvas, 24 × 26″.
Collection the artist and/or family

[Times were difficult. Carlos's family sent money, but never enough, so that Carlos tried doing commercial art. The difficult times put a strain on the marriage. Two poems that Neel wrote at this time, 1929, survive. The poems are distinctly feminist, revealing her situation as a woman artist.]

Oh, the men, the men
they put all their troubles
into beautiful verses.
But the women, poor fools,
they grumbled and complained
and watched their breasts
grow flatter and more wrinkled.
Grey hair over a grey dishcloth
and no one loves their grumbling
sad, sour, dry with red and shiny knuckles.
Oh, for the words
separate from reality.
Something to read, stretched out
in a little green book.

*　　*　　*

my house is beside a river of lead
i build a snow woman
and hold her breasts
my brown fingers dream of blood red
 warm earth in cuba

i burn my snow woman's
black coal eyes
 and still i am not warm

water has mixed with the marrow of my bones
my spine a ramified icicle

my snow woman told me of a saxon milk white doe
i thought she meant a dough to make bread
or the milk white do of the piano

 the grey of this sad house
 beside the river of lead

 my tropical soul
 frozen in ice
 molded with pain

On May 1, 1930, Carlos took Isabetta and himself back to Cuba. His parents promised to send us to Paris, and he was taking her there for a visit. Meanwhile, I began to paint like mad at 1725 Sedgwick Avenue in New York, just across the Washington Bridge at 168th Street.

You see, I always had this awful dichotomy. I loved Isabetta, of course I did. But I wanted to paint. Also, a terrible rivalry sprang up between Carlos and me. Because he had to make money any way he could—stupid jobs like drawings for newspapers, on a very low level, although some of the drawings were elegant—upper-class girls riding horses for Saks Department Store.

At first all I did was paint, day and night. But gradually I began to wear down. My parents came to visit me in New York and I went with them to Coney Island. Back in my studio I painted Coney Island Boat *from memory. Then I visited them in Colwyn and saw a couple on a train, which I also painted from memory. You see how his arm looks like a speckled trout. You see how miserable she is, but how happy he looks.*

Coney Island Boat. 1930. Oil on canvas, 27 × 24″. Collection the artist and/or family

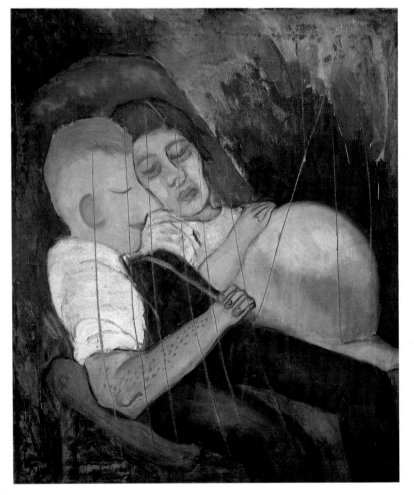

Couple on a Train. 1930. Oil on canvas, 27 × 22¼″. Collection the artist and/or family

(opposite) *Ethel Ashton.* 1930. Oil on canvas, 24 × 22″. Collection the artist and/or family

Don't you like her left leg on the right, that straight line? You see, it's very uncompromising. I can assure you, there was no one in the country doing nudes like this. And also, it's great for Women's Lib, because she's almost apologizing for living. And look at all that furniture she has to carry all the time. There was another great one of Ethel that later was slashed up.

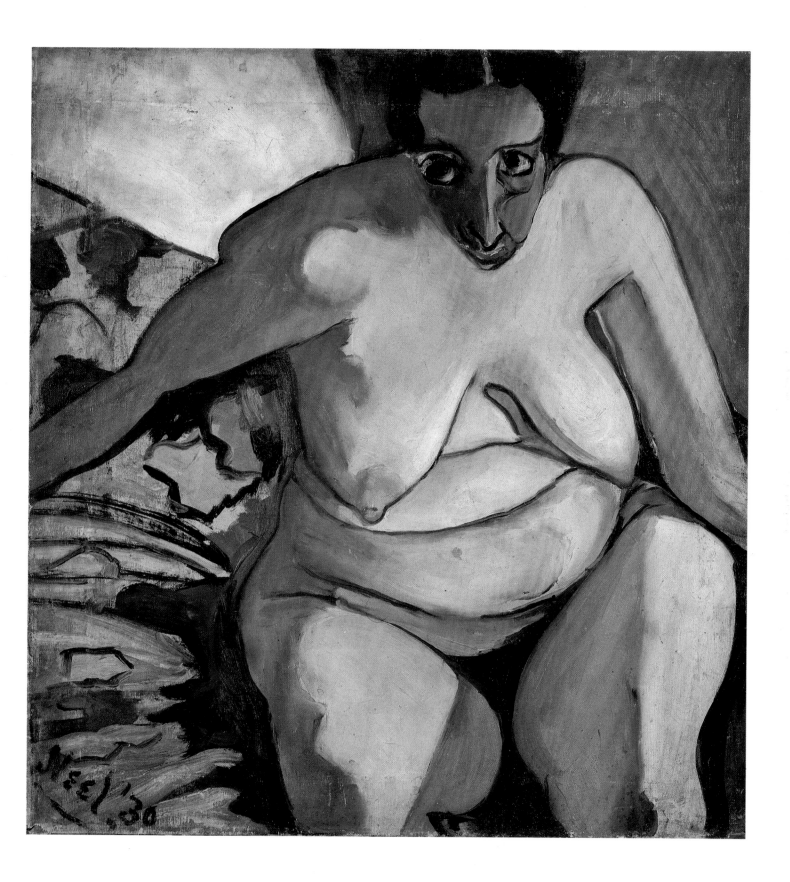

My visit was a disaster. My mother couldn't understand all this. It was beyond her. Then I came back to the apartment in New York, because I wanted to paint some more.

You see, Carlos just went down to Havana for about a month, and then we were going to go to Paris. The family was going to send us. But the Depression had just hit, and they had lowered the price of Cuban sugar, so the people who were rich weren't quite as rich as they had been. The family didn't want to give the money. So then Carlos's friends told him he was being a petit bourgeois, to try to work for his own family and all that. I then got a letter from Carlos saying that although his parents didn't have enough money for us to go, his friends had raised enough money for his passage, so he had gone to Paris. I got the letter in the summer. I realized that was just the end of everything. I was left with the apartment, the furniture, a whole life, and it was finished. Because he was very weak, I was abandoned.

Once when I ran out of money, I sublet my apartment. I went to the Philadelphia studio of Ethel Ashton and Rhoda Meyers. I worked at their studio every day. You can't imagine how I worked. I wouldn't have carfare; I wouldn't have enough for lunch. I had a terrible life. But in a very short space of time I turned out any number of great paintings, including Ethel Ashton *and* Rhoda Meyers with Blue Hat.

I came home to my mother's one day from Ethel Ashton's studio. You see, I didn't eat enough. I had weighed 148 pounds. I went down to 120 pounds again, my usual weight. I came home this day, August 15, 1930, and I had a chill that lasted at least eight hours, and at the same time I had some sort of diarrhea. And they would say to me: "Did your legs get weak?" But my chest screwed up. You can't even imagine a nervous breakdown like mine, although the final diagnosis was "no psychosis." So I was never out of my mind.

One of the reasons I had the breakdown, I never showed any grief. You see, I asked my mother if I could keep the little girl there with me, because they would have brought her up, and that would have meant my giving up painting because I would have cared for her. But my mother wouldn't do that. She said: "No, I've raised my own family." She wasn't like these good mothers. If she had taken Isabetta for a couple of years, everything would have been simpler.

I just opened up and everything let go. Then I had Freud's classic hysteria. I died every day. You see in his case study of Anna O, Freud doesn't mention dying every day. But that's what I did.

You die every day. You don't know. Sweat breaks out. You are positively sure you're dying. It's a complete breakdown of the nervous

system. And you get weaker and weaker and weaker. And I would say to the local doctor: "Oh, keep these horrors away from me. You know, the dying every day." I lost weight. I would lie there perspiring, dreading this falling apart, which happened every single day. It's an unknown terror. You're absolutely convinced you're dying. But I never made a sound. You see, one of the reasons I had this frightful breakdown—I never gave normal vent to my emotions. I was hypersensitive; at the same time, to be an artist all these years I had built up this iron will so I wouldn't show any of this sensitivity. So I just went down and down and down, and finally I went to the Orthopedic Hospital, in October, and there they tried to discipline me.

My poor mother. I remember my father fell downstairs, he was so worried about me. It was horrible. You can't even imagine what it was like. It was just torture. By the time I went to the Orthopedic Hospital, I think the dying spells were over. But then I was left with a frightful depression. And when I got there, they didn't know my history. My sister was ten years older than I was, and she was very wonderful at sewing. I always tried to sew when I was little. I remember sewing things to my stockings and everything, but I didn't like sewing. So they wanted me to do something different from art, because there's a theory about changing the profession. And they tried to make me sew. But I didn't tell them. They weren't subtle enough to see that. I wouldn't sew. Instead, I saw great masterpieces in that hospital. I was still utterly creative, you know. But I wasn't allowed to draw or paint or anything.

I just lay in bed all day, in this frightful ward, where there was a little girl chained to the bed and an old woman dying.

I couldn't think of getting well. I only wanted to die. I remember the psychiatrist in the Orthopedic Hospital saying to me: "What do you want?" And I'd say: "Nothing but the peace of the grave." And do you know what I'd do? When he was psychoanalyzing me, I was looking at his hands and wondering if he was still potent. I don't think he was. They looked impotent, those hands.

I got worse and worse there. I went through Christmas 1930 at the hospital. I remember Christmas carols and how I hated them. I hated everything normal. Another thing, this Cuban husband had given me a Latin-American mentality. I hated everything American. I saw us as the "colossus of the North." The great Cuban leader, José Marti, who had led the revolution, said that. They put him in jail. He later wrote stories when he was in exile in New York. He called us the "colossus of the North."

My sister sent Carlos the fare to return from Paris. And he came

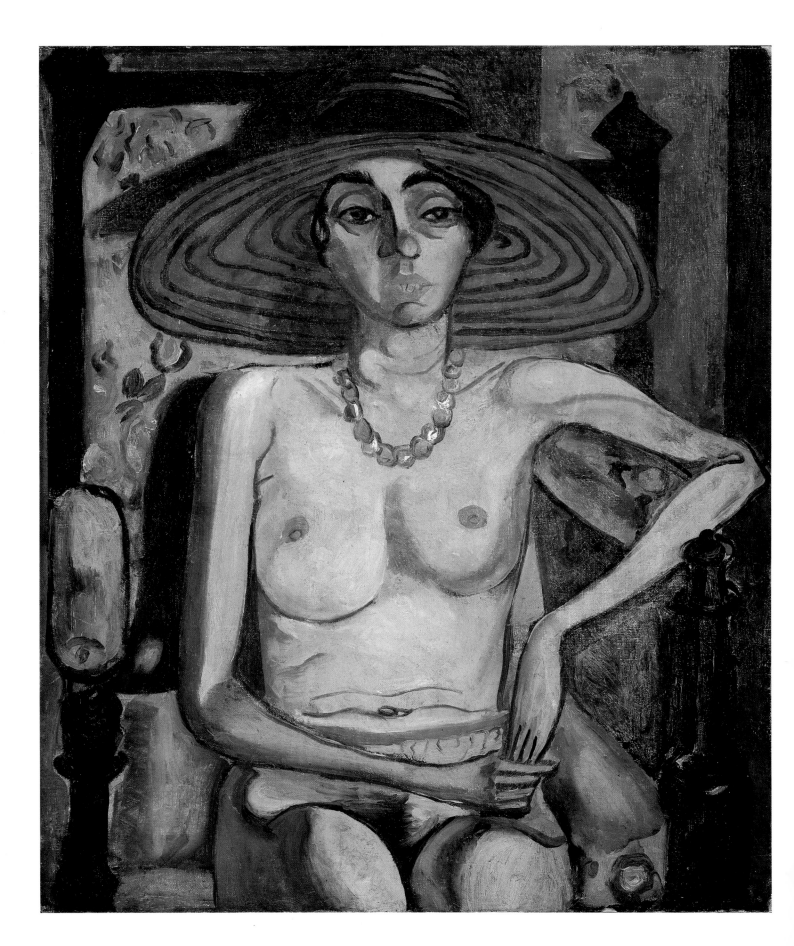

Rhoda Meyers with Blue Hat. 1930. Oil on canvas, 27½ × 23½″. Collection the artist and/or family

This is a strip tease painting in a sense, as she took her clothing off piece by piece.

back in the winter. He came to see me once or twice at the hospital. Carlos wanted to return to Paris; he wanted to take me; he wanted everything. But it was too late. I was too far gone. It took me a couple of years to get over that breakdown. You know, at a certain point you can't do anything. It's just beyond the pale. Before it could've been all right. Three months before, it would've saved me—going to Paris. But then it was just too late. The disease was on its way, whatever the disease was.

In my weakened, nervous condition I left the Orthopedic Hospital. I went home to Colwyn in a taxi with Carlos. But when I got home I felt as though I was being thrown against a wall all the time. The overreaction to the taxi ride. And that night I woke up and I felt very strong. All of a sudden it occurred to me that it wasn't just nerves, that it was mental, that I was going mad.

And then I woke up and I thought I heard my mother and father talking, and I went and looked. Now here's another thing. I used to hear my mother say to my father: "I'll turn on the gas." Because she got bored with her life in a little town. It was a frightful life for her. She was so intelligent, oh, it was awful. The psychiatrist had tried to turn me against her, but I said: "Give it up." He began to think I was peculiar, sexually. I said: "Don't try to turn me against my mother, because everything she did was induced by the fact that her whole life was so frustrated, you know."

Anyway, I went into their room. They weren't talking. So suddenly it occurred to me that this breakdown was mental. I thought, well, I'm just going off my rocker. And I also felt very strong, when all the time I had felt very weak. So I crept downstairs, and I turned on the gas oven and put my head in it. I stopped up all the doors. I wasn't going to return to the hospital I just left. I forgot the cellar door, so some air came up there. They discovered me about eight in the morning. My brother said a very important thing: "I didn't know if it was Mama or Alice."

I came to in an ambulance; the wind brought me to, going to the Wilmington Hospital. I was then a dangerous suicidal. And the driver said to me: "It's no use, baby." Isn't that literary?

After a day or so the Orthopedic took me back. Of course there was just no hope for me. So then I decided I was going to be like that for life, so I smashed up a glass and was going to swallow it. But they heard the smash and they came and investigated. And they strapped me to the bed. I have awful claustrophobia. I almost died strapped to that bed. They strapped me to the bed until the next day, when my

mother came. And then we went to the Philadelphia General Hospital, and they put me in the suicidal ward.

My mother had never come to see me when I was sick at the Orthopedic Hospital. She couldn't bear the idea. And also, you don't know what she was like. I admired her because she could not compromise. Anything can happen to me, because I can go the full distance. She could not compromise. She stood up to everything, and she had her own ideas and stuck to them. This to me was a great virtue. I understood why she didn't come to see me. But she had to take me to the suicidal ward of the Philadelphia General. This filled her with horror, you know.

Carlos tried to comfort me, but he eventually returned to Paris. He had a girl friend there. He was a frivolous character.

The first thing they did in the suicidal ward was to give me a spinal, which immediately made me stiff for about six days, with the most awful pain I've ever had in my life. You know, to find out if I had a venereal disease.

I was there a month or two. This was just the clearing house. From here they sent you to real insane asylums. It was a weird ward, you know. At night people would walk up and down. They had lights under all the beds.

We got up at five in the morning. We wore old shoes, horrible old stuff. I got athlete's foot there that I've only gotten over recently. We went out to breakfast, and all the knives and forks were rubber. The windows were all screened, for the suicidals. You know, I can still see a schizophrenic standing in front of a door, pushing a button. There's no elevator, but they think there is. And an old woman walked up and down the whole day and night, going OOHHhhhh . . .

I figured the only way to commit suicide in that suicidal ward would be to jump down the dirty clothes chute, and then, of course, you'd finally stifle amidst the dirty clothes.

But you know what I did? Every night in bed I'd choke myself with a stocking. But you can't do it. Because I couldn't pull it long enough or hard enough. You cannot commit suicide unless you—in a moment of frenzy—you do something irrevocable. For three years I had big veins in my neck. I think they've gone away, I've lived so long.

It was so awful there. On Easter morning, I remember, they brought a woman in. In those days, for schizophrenia they gave them malaria. And then to cure them of the disease, they gave them liver. But this woman was dying of malaria. So they pushed her cot into our room, and she was right next to me. She was dying, and they said:

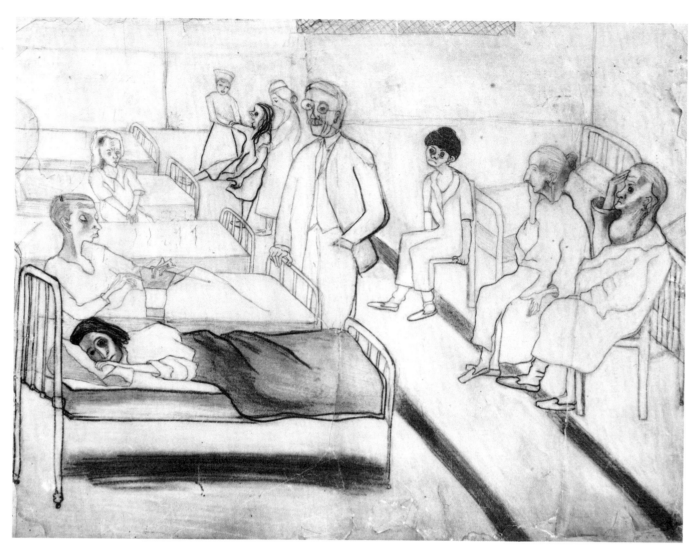

Suicidal Ward, Philadelphia General Hospital. 1931. Pencil on paper, 17 × 22″. Collection the artist and/or family

The drawing of the Philadelphia General Hospital suicidal ward was done from memory after I had come home, in 1931. The woman on the left is from a private sanitorium where I went finally and where I recovered. She had been in her room for ten years and did not dare go out. The next woman on the left had a bad breakdown like mine and in the process one of her organs collapsed and she never got over it. The third one back was all right here, but she used to throw flowerpots at you. She was wild. And the one in the very back is having an attack. Then the woman holding her chair refused to eat and had to be force-fed with a tube up her nose. It was very morbid. The two old women on the right, including the one with the goiter, were not mentally ill, but they had nowhere else to put them. And then the man in the middle is the happy, smiling psychiatrist—his name was Breitenbach. See, that shows you're mentally healthy, when you smile like that.

"Should we change her nightshirt, Dan?" The other nurse said: "Oh, why bother, she's going to be gone in an hour or so." And I heard the death rattle Easter morning. Now is that a place for a depressed victim to be?

A social worker came in. I was still very good-looking. I had beautiful hair and everything, although I had become a rail. I only weighed about 100 pounds. Still, I had this beautiful hair and a nice face. She said to me: "My god, why are you here?" And I told her: "Well, I'm a famous artist, but they don't believe it." They never believed I had a show in Havana. They thought that was my Napoleon complex. I told her and she believed me. And she brought me a pad. And the psychiatrist, when he saw the first drawing I made, said: "Oh, you must draw me." And I said: "I won't draw you, you're the enemy."

One day the psychiatrist came to where we were eating breakfast with our rubber forks. I said: "Oh, specimen A." He said: "Why A?" I said: "Well, then Z." He said: "Always extreme." I said: "Well, then M or N." I didn't care. They were horrible. All they did was insult you. And the minute you get into a mental hospital, you know what they do? All of these people are like our art world. They think they're better than you are, and they treat you like a dog. Because you're mentally suspect. Just the way they look at you—different. It's to put you down.

The social worker had me sent to a private sanitorium. My family paid $40 a week. This was a lot of money that they could ill afford. I went to Dr. Ludlum's Sanitorium, in Gladwyn, near where I was born. He was a wonderful experimental psychologist.

They put me right away into the suicidal ward at Ludlum's. The first night when I arrived somebody was playing the song, "Just a gigolo, everywhere I go." They put me in a room with a woman who put her corset to bed in a drawer all wrapped up just like a baby. And she'd sing it to sleep. I made a great drawing of one of the inmates there and she tore it up. She said: "It's the work of the devil."

Dr. Ludlum came around to see me, and he said: "You wouldn't have to be here if you would swear not to commit suicide." So I gave him my word, and he put me in this big house where they had mental patients, not suicidals. I slept in a room with one of the nurses. Although she was fairly young, she had false teeth and she used to put them in a cup. That filled me with horror then.

They used to have parties. I danced with one man there and he said: "Am I your baby?" He had been a genius student at the University of Pennsylvania, studying medicine, and he overstudied. Now his family was just hoping he'd be able to be a golf pro. Oh, it's awful, you know, the mind.

These wretched mental cases. One had been a court stenographer, the one I have the drawing of. When people went by she'd kick at them. When some people go off the rocker, they're vicious. Others aren't. But they once let out a man who was in the violent ward because he was such a good tennis player. And he won over everybody. But just as they were leaving the court, he took his racket and hit one of the psychiatrists over the head with it. So they had to take him quickly and lock him up again. But this concept of the violent, romantic madman isn't true. They're all sick, they're very sick people, the mad. Very few of them are violent like that, you know, the romantic madman.

Dr. Ludlum was a wonderful person. The sanitorium had been a farm with farm buildings. We sat out on a terrace with wisteria, the most beautiful place. Ludlum used to hug me and he'd say: "Why don't you look in the mirror and get well." I was very pretty with golden hair, and he said: "You are so foolish, you can't imagine."

It was a lovely place, and there I got as well as I could. Although even there, to take a bath was doing the hardest thing I can do. Your volitions get frozen. You can't do anything. But I found that lying in a bathtub of warm water, that was one of the things that cured me. To just lie there for about an hour, and relax, completely.

I recovered Spanish. I was able to read. I forced myself to read the installments of The Harbor *by Ernest Poole. They had magazines all in stacks, and every day I would hunt for the next installment.*

Dr. Ludlum had a wonderful house, and he said: "I'll make it into a wonderful studio for you. And you can live here." You know, like Van Gogh. But I have always had a perfect horror of being in a little group apart from the main group. In fact, I never went to Woodstock or any of these artists' colonies because I thought there was a certain sappiness. I thought it was getting away from the real facts of life. Also, you have this stupid snobbism there. So I called up my family and said I thought I was well enough to come home.

[In September, 1931, Neel was dismissed from Dr. Ludlum's Sanitorium. In late 1931 or early 1932 she wrote about her stay in the suicidal ward of the Philadelphia General Hospital:]

and so i found myself in the suicidal ward of the Philadelphia general hospital
 slowly so slowly a day
 then night
 in a bed next to Janet White
Janet White seventy-two. She'd tried to set fire to herself so her family sent her there. She used to say to me, "do you know I smell like a carrot."

oh my god if only i can make words tell you the horror of it all—if only i can warn you not to push yourself or let anyone push you until your mind breaks. I used when i was well to think it somehow sounded romantic to hear of someone insane—i always pictured them wild, dangerous—but i am so quiet and it is such a cruel disease. if you could see what i have seen. Alfonsia—probably 50—weeping and wailing all night—ai-yah-yah-yah. one eye white with a cataract—no teeth in front—nearly every day strapped to a bed, with a long red tube up her nose down into her stomach—tube-fed or, worse yet, getting a Hydro democlasis—needles in the veins of her leg—water injected thru a little red rubber tube—anything to keep these poor wretches who want to die alive. Lena Medman maybe 55—fierce—a fighter—wanting to die—beating her head on the floor. Oh, god help all us poor devils. I long all day for night—long dark night when no one expects you to move, when sometimes between the cries and groans there are intervals of silence. a March wind howling outside—the stiff figure of the attendant wrapped in a blanket sitting by the locked door watching-watching—the little lights at the foot of the bed so she can see everyone. i hardly ever sleep but i enjoy the darkness—i enjoy lying perfectly still—i will not have to move until five o'clock and then i'll be forced to get up and dress. If you could know how i have to force myself to dress—to move—how i dread the effort of taking a bath—how my one desire is to lie on the bed—and they have decided that is what i should not do—so all day i must force my tired to death body to sit upright in a stiff chair—but night will come—sometime the earth must turn and it will grow dark and the starchy white immaculate nurse will unlock a little metal box and click out the big white light in the ceiling that hurts your eyes so—then is my one relief—to lie unnoticed—unforced there in the darkness. to get up sometimes to look thru the barred window at the clock in the hall to see how many more hours of darkness—of oblivion—i still have before the dreaded light at five.

It is such a fine building too—so clean—sort of officelike and governmental in character—with records so neat and well arranged—an elaborate little room to sterilize a snow-white metal bed pan, marble floors—splendid—but cold and repelling—a shiny metal shower—but oh my god what a contrast between the building and the patients. Poor scraps of humanity in grotesque gingham dresses and violety-dun-colored bathrobes. how horribly lonely my soul is on this last horrible adventure. i who always needed companionship so.

[Did you ever come close to having another breakdown?]

Once you go through one of those things you have to be a fool to go through it again. I learned to realize it was my own fault. I pushed my brain back; then, after it got back there, I was much worse off. Then I trained myself to come back. I am now more normal than normal. I am a highly trained neurotic.

[When Neel left Dr. Ludlum's, she went home and then to Stockton, New Jersey, to visit friends, Nadya Olyanova and her husband, Egil Hoye. They were subjects for several of her paintings. Neel had already, in 1929, painted Nadya as the subject in *La Fleur du Mal*.]

All the family came to see me. I had a cousin, Charlie, who would look at me. I'd make a face so he would have something for his money. I hated to sew, but I forced myself to buy a good pattern and to make a dress with scallops. You don't know the dress I made. It was in ashes-of-rose linen. I wore it for years. The skirt had eight gores and the jacket was scalloped. You can't even imagine what it was to make. This was self-discipline.

About this time I wrote a poem, "the great renunciation," because then I had nothing.

now is the great renunciation
now i know i'll never be strong enough mentally or physically
to put the things i see and feel in any concrete form
they'll just be grey and yellow shadows in my skull
self-realization—i was just on the point of it
all the little threads of my heart and spirit were
somehow connecting themselves with the classic beauty of washington bridge,
somehow i saw so clearly the sick unhealthy beauty of nadya olyanova
saw her as a new york olympia—with paper flowers from the five and ten
a subway under her bed—a city of hills and bridges
a sickly sexual olympia
and the sad grey wood houses of sedgwick avenue
some red brick ones with classic fronts
i know these are all subjects—paintings with a story
but does it make any difference what sets you into action
oh i was full of theories
of grand experiments
to live a normal womans life
to have children—to be the painting and the painter
but now i have no strength
my mind is weak and tired, my body sluggish,
my belly's fat—my gums receding
i've lost my child my love my life and all the god damn business
that makes life worth living

In the early winter this friend of mine, Nadya, called me up. She and her husband, Egil, were out in the country. He was a mad Norwegian, about fifteen years younger than she. They invited me out. I went there and I began to return to real life.

Nadya was a graphologist. She wrote a book on graphology. She got a thousand dollars a week for sitting in a big movie house, reading people's handwriting. Her real name was Edna Meisner from Brooklyn, but her name was Nadya Olyanova. She represented decadence to me.

Nadya and Nona, which I also called Two Little Tarts, *I painted later, in 1933. Once some doctor said to me: "What a wonderful rear to*

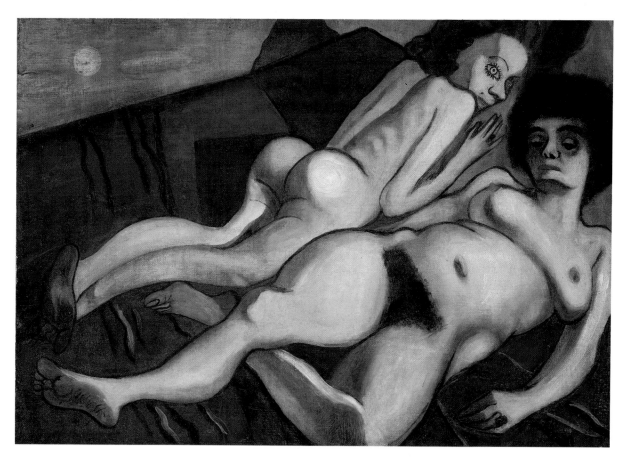

Nadya and Nona. 1933. Oil on canvas, 26 × 35½″. Collection the artist and/or family

sit on," that rear, on the far one. And I thought he meant for him *to sit on, and I said: "Why, doctor!" But he meant for* her *to sit on.*

Also in 1933 I painted her nude, Nadya Nude, *lying on a white bed. I always said that there was a struggle between her head and her central section, and the head is losing.*

Still, do you know that Robert Browning was the one who exploded the myth of the centaur? Where they always said: "A horse's body, that was your emotions, but the human head was the rational part." But he said actually the animal and the head are all one. He was the first poet to introduce that idea into English poetry. In another poem Robert Browning wrote:

Let's contend no more, Love,
Strive nor weep,—
All be as before, Love,—
Only sleep.

That was Robert Browning, when a marriage is going downhill and they're just starting to argue.

I met the sailor Kenneth Doolittle out there in Stockton, and I

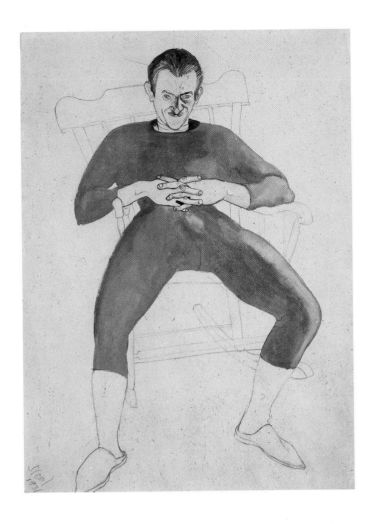

Kenneth Doolittle. 1931. Pencil and watercolor on paper, 13¾ × 10″. Hirshhorn Museum and Sculpture Garden, Smithsonian Institution, Washington, D.C. Gift of Richard Neel

Egil Hoye. 1931. Oil on masonite, 16 × 12″. Collection the artist and/or family

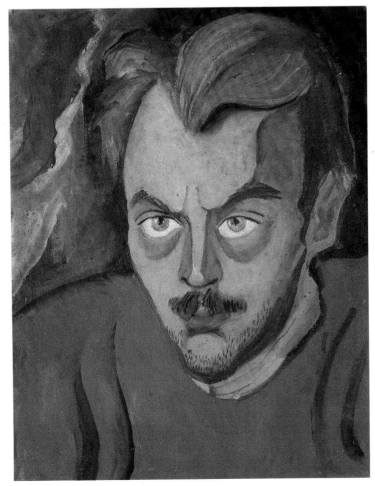

finally slept with him. He was very clever and his expression in my watercolor, Kenneth Doolittle, *is slightly mephistophelian. He played a banjo and sang interesting workers' songs, such as "Old Rock Candy Mountain." He had been a Wobbly and traveled across the country.*[2]

We were in Stockton in the dead of winter. I painted Egil Hoye *and* Nadya and the Wolf. *It was great for me. Though my mother said to me: "Why don't you go stay with your sister in Teaneck, instead of out there with that dirty old sailor?"*

Doolittle was an able-bodied seaman, but he was very much a character. He was once going to be in a film as a member of the Foreign Legion. But he couldn't wait. His money ran out so he went back to sea and he didn't get into the movie.

Finally, early in 1932, we came to New York and rented an apartment at 33 Cornelia Street in the Village.

Nadya Nude. 1933. Oil on canvas, 24 × 31″. Collection the artist and/or family

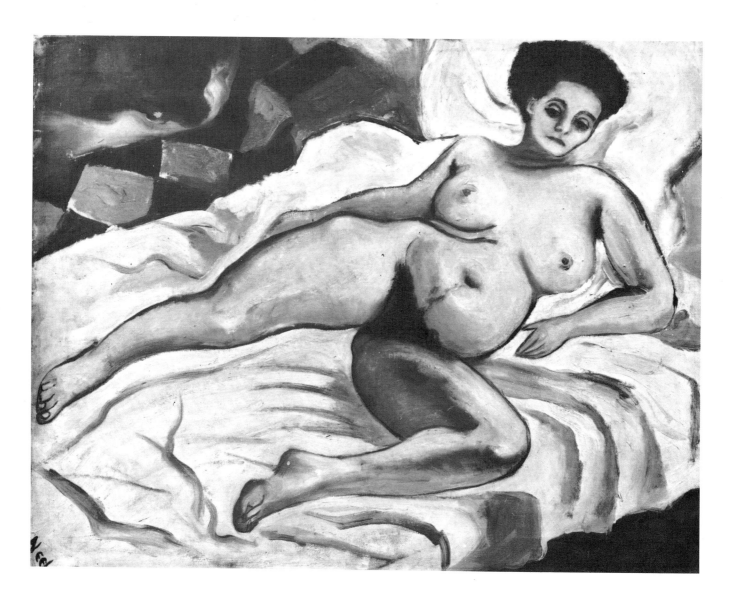

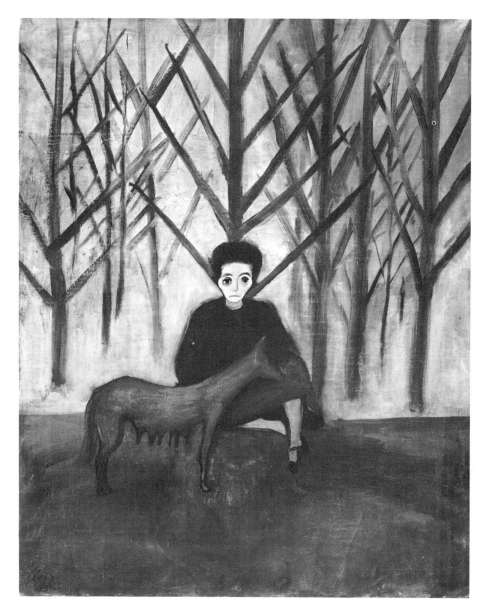

Nadya and the Wolf. 1931. Oil on canvas, 30 × 23½″. Collection the artist and/or family

I painted Symbols *in 1932. A short time before, Roger Fry had written a book where he gave Cézanne's apples the same importance in art as the religious madonnas. The doll is a symbol of woman. The doctor's glove suggests childbirth. The white table looks like an operating table. And there's religion in this, with the cross and palms. In my opinion all of this is humanity, really. This wretched little stuffed doll with the apple, and you see we're still a stuffed doll. Look what's happening to us. Do you think we want to die of a nuclear thing? Do you want your son to go to war? We are powerless. I can't bear that. I hate to be powerless, so I live by myself and do all these pictures, and I get an illusion of power, which I know is only an illusion, but still I can*

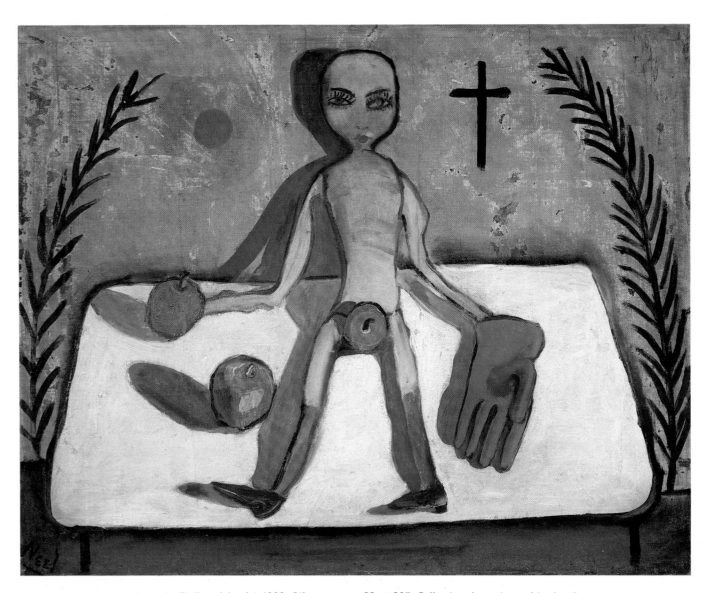

Symbols (Doll and Apple). 1932. Oil on canvas, 23 × 28″. Collection the artist and/or family

have it, because I'm not confronted with this grim reality. You see all of
the artists of yesterday, none of them have two cents of importance
beside the great structure. The Pentagon is here. It's not the art world,
it's the Pentagon. But you see, one thing they're learning here, maybe, is
the importance of art, because the socialist countries always gave
importance to art. They saw it as a great propaganda weapon. Here,
they're finally learning that art has some importance. They never knew
that before. They were too dumb.

[In 1932, Neel's painting *Degenerate Madonna,* done in 1930 with Nadya as
the model, caused a stir among Catholic Church officials when it was shown
at the Washington Square Park annual outdoor art exhibition. She was

forced to withdraw it from exhibition. At that show she met John Roth-schild, a travel agent, and had a relationship with him that lasted until his death in 1975.]

John just came walking by and saw my art. He especially loved Well Baby Clinic. *He invited us to come to his house. I remember Kenneth Doolittle picking up the cat's tail to see what its sex was.*

[During 1932 and 1933 she painted besides the nudes *Nadya and Nona* and *Nadya Nude* such Village characters as Christopher Lazar, Joe Gould, and Sam Putnam.]

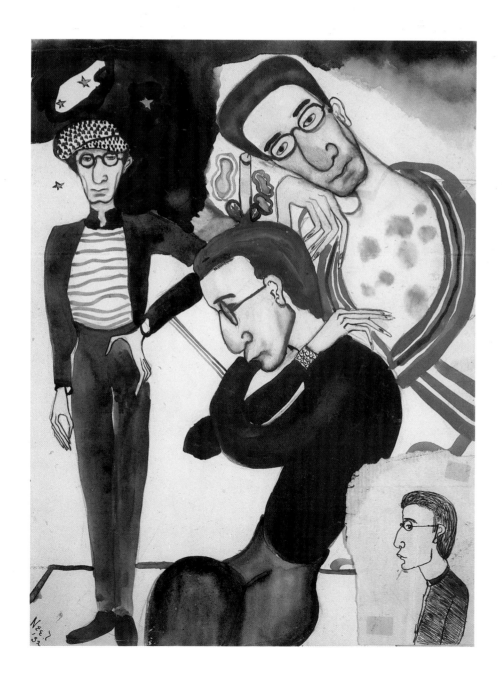

Christopher Lazar. 1932. Mixed media, watercolor, and collage, 12½ × 9¼″. Collection the artist and/or family

He was out hunting for "rough trade." Christopher Lazar was the queen of the homosexuals. There was a bigger queen than he was, but I can't remember his name. Lazar was a very intellectual homosexual. He wrote an article on Lorenzo da Ponte for The New Yorker *magazine. It was such a great article. Everybody was talking about it. He then received an advance from* The New Yorker *to write a book. However, he never could write the book. He just used up the advance and that was it.*

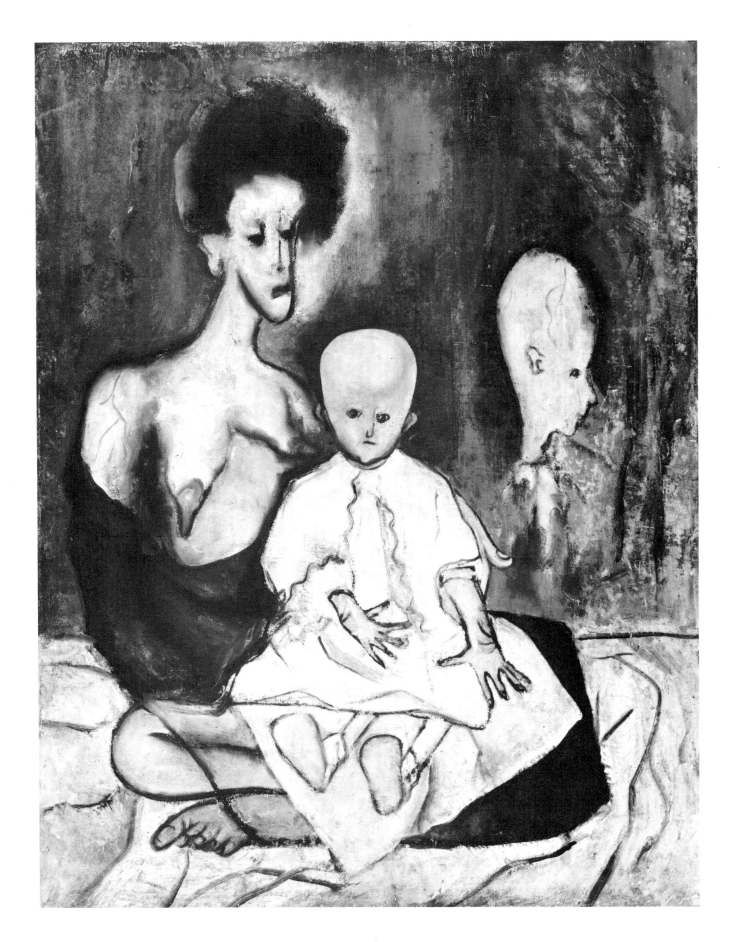

Degenerate Madonna. 1930. Oil on canvas, 31 × 24″. Collection the artist and/or family

I painted Joe Gould *in 1933. His father taught surgery at Harvard. They were an old, intellectual Boston family, a Brahmin family. Joe went to Harvard and studied anthropology, and then lived briefly with an Indian tribe.*

Joe was compiling an oral history of the universe. He was just a little off his rocker, of course. He'd say: "Workers of the world ignite, arson and fire buggery. You have nothing to lose but your Janes." This was a satire on The Communist Manifesto, *you know, "Workers of the world unite." And he'd knock on the door and he'd say: "Ship Ahoy! Joe Gould!" Then people wouldn't let him in, but I used to feel sorry for him.*

He told me about his love for the sculptor Augusta Savage, and one Sunday he took me to see her. She arose from her couch like a lioness and snubbed Joe Gould so badly that he really suffered. She was nice to me as I was another artist. When we got back to my apartment he covered his face with his little dry hands and wept. He had told me he would marry Augusta even though he was sure his mother would disapprove as Augusta was black. But obviously this was imagination as she despised him. He told me once that Negroes were beginning to accept him, since they invited him to funerals.

When his mother died and left him a little money he bought a radio and a typewriter and publicly smashed them on the sidewalk.

I used to shorten his sleeves—you see he got handouts, and they were always too big for him. He'd come to the house, and I'd say: "Joe, what would you like?" And he'd say: "Spinach with vinegar." Because he would just eat leftover rolls and what he could find in a cafeteria, he was starved for minerals.

Joe wanted this painted, and I was still imaginative enough to give him a whole tier of penises. I thought that was so clever, hanging that one set from a stool. He was uncircumcised. This could be a propaganda picture against circumcision.

Malcolm Cowley saw it one time, and he said: "The trouble with you, Alice, is you're not romantic."

In 1933, a meeting of writers and intellectuals was held at the Gotham Book Mart. (Maybe you read Exile's Return *by Malcolm Cowley.) They all got up and said how they had gone to Paris just because the rate of exchange was so favorable, until it came to George Antheil, who wrote* Ballet Mécanique, *a musical composition. Well, he said: "I went to Paris because I liked it better there. That's where culture was."*

Now, however, they were all studying Marxism. Sam Putnam had been a friend of Jean Cocteau and had written a little book called

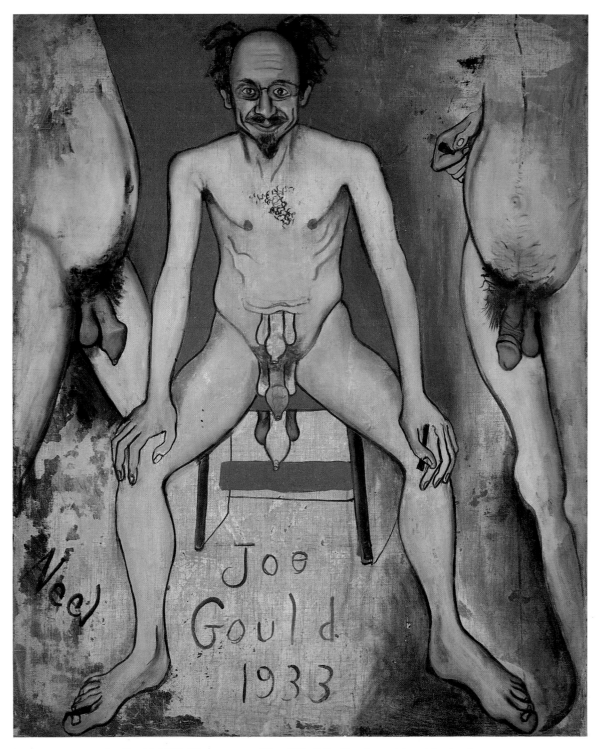

Joe Gould. 1933. Oil on canvas, 39 × 31″. Collection the artist and/or family

(opposite) *Isabetta.* 1934. Oil on canvas, 43 × 25¼″. Collection Jonathan and Monika Brand, Philadelphia

My mother and father spent the summer with me in Belmar, and Isabetta came from Cuba to visit. She would be six in November. She is standing on a handmade Bulgarian rug. The galleries would not show it, as they said it was indecent; by the time they showed it, they said it was Lolita.

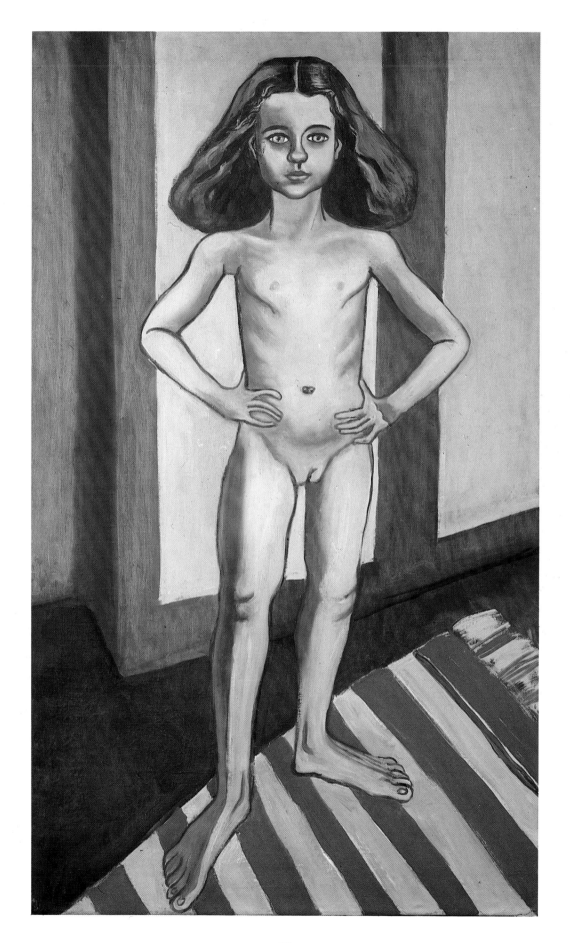

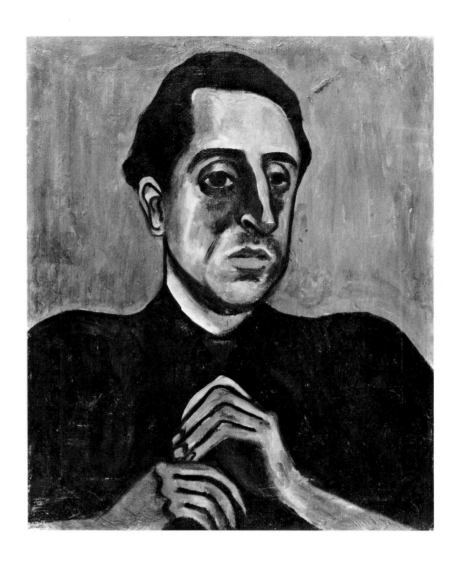

Sam. 1940. Oil on canvas, 24 × 20″.
Collection the artist and/or family

Illuminations. *He was working as a rewrite man for* The New York
Times *for $75 a week—a good salary for then. He was selling his
bourgeois library and soon became the Latin American expert for* The
Daily Worker. *He worked very hard and lived on next to nothing.*

*I did his painting in 1933 from memory. At 33 Cornelia Street,
there was a small extra bedroom and Sam Putnam stayed there for a
while. He had a commitment for giving lectures on art at the Henry
Street Settlement. I used to try very hard to get him to go there. It was
so hard because he was always drunk.*

*Later he used to come to my house on West 17th Street, around
1937 or so. Riva, his wife, would send their son, Hilary, with him so he
wouldn't get drunk. I'd give him money for breakfast and he'd never
come back. So I would have to take Hilary out. He'd come back at
night, drunk as a lord. It's a wonder anybody lasted as long as he did.
He was intelligent, but his character was always leaky.*

*In 1954 or '55, he left the Party and delivered a series of anti-
Communist lectures in Brazil. This was before the revelation of the
20th All-Union Party Congress of 1956, where Khrushchev told how*

Stalin had murdered over half the Politburo. Many Communists left the Party then.

After that, Sam Putnam translated Don Quixote, *had a big bourgeois success, and died a few years later.*

I started doing revolutionary paintings when I lived on Cornelia Street in 1933. Philip Rahv and his sidekick, Lionel Phelps, both radicals, came to my place. Rahv and Phelps said: "The easel picture is finished." And: "Why paint just one person?" And I said: "Don't you know that is the microcosm, because one plus one plus one is a crowd." But still they said: "Siqueiros paints with duco on walls." But I said: "We're not up to that, duco on walls." And today the easel picture is still going strong with Julian Schnabel throwing plates at it.

[The country was in the throes of the Depression. Private and government relief agencies sprang up, including the Public Works of Art Project. Organized in December, 1933, the PWAP was directed nationally by Edward Bruce under the auspices of the Treasury Department and funded by the Civil Works Administration. Juliana Force, the Director of the Whitney Museum of American Art, directed the New York region. The PWAP lasted until June, 1934, and employed 3,749 artists nationally.[3]]

In order to alleviate the position of the artist, we had one free meal a day in the Village. Some screwball organized it. Then, at the end of 1933, I got on the PWAP. I received a letter to come down to the Whitney Museum, and there I was interviewed by a very nice young man who said: "How would you like to receive $30 a week for painting pictures." "Oh," I said, "I'd love it." And I came home and I felt so happy that I painted Snow on Cornelia Street. *When I had $30 a week I didn't need a free meal.*

[Although Neel led a bohemian life in New York, her family was important, and she returned to Philadelphia for frequent visits. In the summer of 1934 she rented a house in Belmar, on the Jersey shore, where her parents and daughter, Isabetta, visited.]

My mother and I rented a house in Belmar. When I was a child we'd go on vacation to Ocean Grove. And you know why my mother liked it so much? Because it was also the sea and green, you know, trees. That's why Spring Lake is so nice now.

My Cuban in-laws would have brought Isabetta up to stay with me after Carlos left in 1930, but I asked my mother and my mother said: "No, I've raised one family. I am not going to have anybody else." And I was much too proud to ever ask her again. Now that year, 1934, Carlos wanted to come back. His mother had died. He had just returned from

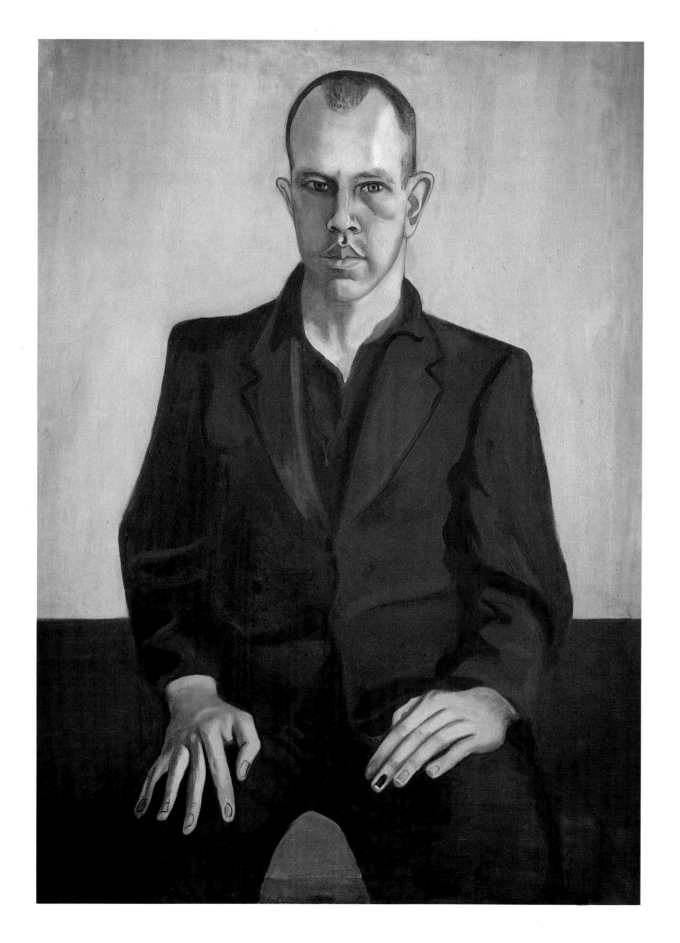

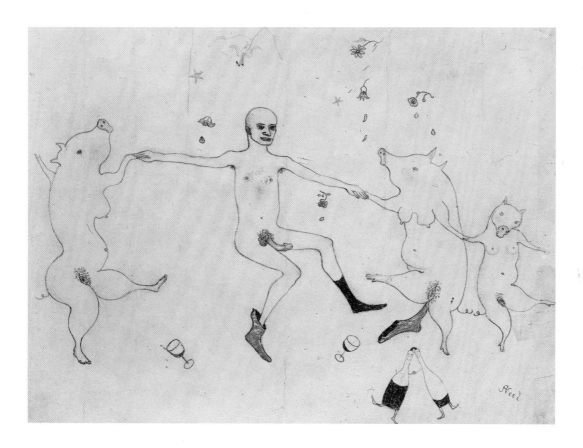

Joie de Vivre. 1935. Pencil and crayon on paper, 11½ × 15½". Courtesy Yale University Art Gallery, New Haven, purchased with the aid of funds from the National Endowment for the Arts and the Susan Morse Hillis Matching Fund

Joie de Vivre *shows John and me. We were staying at a hotel on West 42nd Street after I left 33 Cornelia Street. I was only there for a week and did a snow scene from the window, with a church in the foreground. You look up 42nd Street and see all the people.*

(opposite) *Max White.* 1935. Oil on canvas, 36 × 26". Collection the artist and/or family

Max White resembled the Olmec people and their ancient sculpture in Mexico. He was a writer, and at the time of this first painting was twenty-seven. Later, I did two other Max Whites, one in 1939 and the other when his body was ravaged by arthritis in 1961.

(right) *Alienation.* 1935. Watercolor on paper, 10 × 8¾". Collection the artist and/or family

I did Alienation *down in Spring Lake, in that little house we rented in the summer of 1935. I didn't realize what it was when I painted it. I didn't realize until just lately, until 1978, when I had the show of my watercolors at Graham Gallery, what the title should be. It had nothing to do with sex. It was alienation. He had just left his wife and a couple of children.*

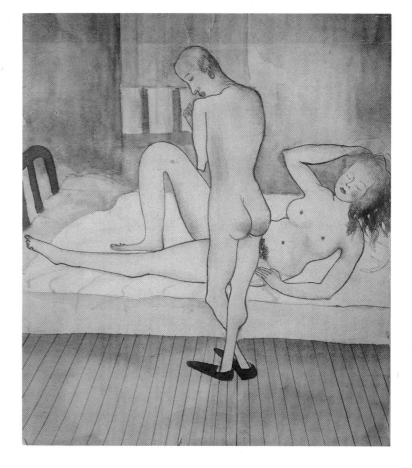

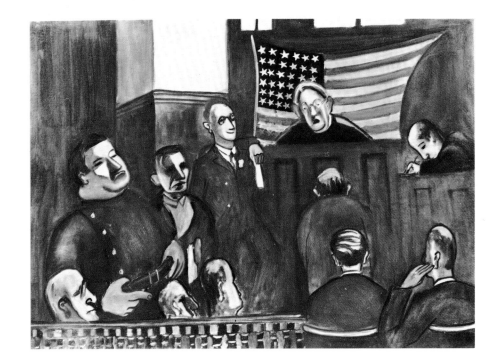

Paris, and he wanted to come back. But here I was. I was living with Kenneth Doolittle, pursued by John Rothschild, and I was too stupid to see that I could have had Carlos back. I really would have liked to have had Carlos back. But I couldn't.

In the fall, Isabetta returned to Havana, and I didn't see her again until 1939, when she was ten. My sister, who lived in Teaneck, was so shocked by my life that she turned these Cubans against me.

In the winter of 1934, Kenneth Doolittle cut up and burned about sixty paintings and two hundred drawings and watercolors in our apartment at 33 Cornelia Street. Also, he burned my clothing. He had no right to do that. I don't think he would have done it if he hadn't been a dope addict. He had a coffee can full of opium that looked like tar off the street. And it was a frightful act of male chauvinism: that he could control me completely. I had to run out of the apartment or I would have had my throat cut.

This was a traumatic experience as he had destroyed a lot of my best work, things I had done before I ever knew he existed. It took me years to get over it. The level of the watercolors in this book show the level of the watercolors he destroyed. They were also personal history.

Since all this had been a major disaster for me, I was in a very rational mood when I painted Max White. Because of the irrationality of Doolittle's actions, I began to think rationality was the most important thing. Anyway, I've always had a rational streak.

[In the early months of 1935, between Neel's leaving 33 Cornelia Street and finding her apartment at West 17th Street, she lived in a number of places. Her less than romantic relationship with John Rothschild is satirized

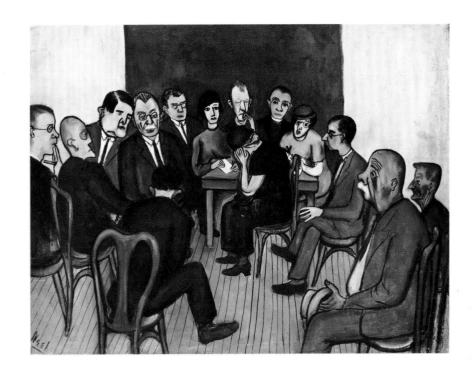

Investigation of Poverty at the Russell Sage Foundation. 1933. Oil on canvas, 24 × 30″. Collection the artist and/or family

My picture, Investigation of Poverty, *is about the Russell Sage Foundation investigations. Harry Liss, head of the Unemployment Council, wanted to take me with him to see what was going on there, because I was so interested in politics. The woman seated in a chair in the middle was living with her seven children under an overturned automobile—that was their house. She had a rash all over her chest. And these two men at the side were just a couple of old wretches from Bleecker Street. In reverse proportion to their position in life are these people's sympathies. The secretaries do look sympathetic. The priest looks a bit sympathetic. The others are just listening. The Russell Sage Foundation never gave a penny to the poor, but they investigated the poor. Out of that came social security and welfare, but before that, you just starved to death.*

in a series of watercolors, *Joie de Vivre, Alienation,* and *Bathroom Scene.* These watercolors were private records of her life: light and lyrical in their form, but bitingly sardonic in their content.]

John had thought that I was going to live with him, and John's wife thought that she should fix an apartment for me. And there was so much chit and chat about it, I finally left the hotel where I had been living at 14 East 60th Street, and I thought, what the heck, I'm not going to bother about any of this.

[In October, 1935, the Works Progress Administration organized four cultural projects: Theater, Music, Writers, and Art. Holger Cahill was appointed National Director of the Federal Art Project, and Audrey McMahon was the New York Regional Director. Neel later painted a memory portrait of Audrey McMahon in 1940, a portrait included in *Nancy and the Rubber Plant* of 1975. Neel was on the project for the duration of its existence, from 1935 to 1943.[4]]

In the fall I got on the WPA as an easel painter, and that gave me an income of $26.88 a week, so I went right out and found that apartment on West 17th Street. It had no heat. In the beginning I had stoves, but later on they put heat in and then it was a very nice apartment. John used to come there for dinner and he took care of the laundry. He loved to take care of laundry. John moved for a while to West 20th, but when he realized I wasn't going to live with him, he moved to V. Henry Rothschild's elegant apartment on Gramercy Park. He was a well-known lawyer who wrote a book on taxes.

I used to work at West 17th Street all day, painting things like

West 17th Street. 1935. Oil on canvas, 24 × 30″. Collection the artist and/or family

I did West 17th Street *about 1935. There's a funeral going on, and they hung the funeral wreath on the door. That's a mourner going in. You see the "For Rent" sign, and far down the street children playing. And that's the river down there, with a top of a boat even; and the Ninth Avenue El. The Puerto Rican people I knew later were delighted to see someone reaching into a garbage can because they were always accused of being poor. So they saw that in the 1930s people went through garbage. And ice has fascinated me all of my life. In those days it was loose, like that.*

When I was in Harlem, I would almost rather have the opinion of a Puerto Rican than of an art historian, because they were completely against my kind of art.

Synthesis of New York (The Great Depression). 1933. Oil on canvas, 48 × 38¾″. Collection the artist and/or family

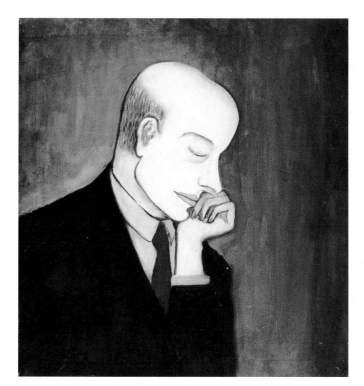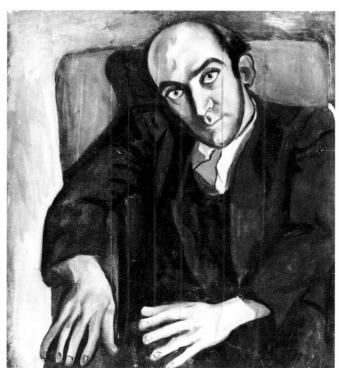

(above left) *John.* 1933. Oil on canvas, 26 × 23″. Collection the artist and/or family

(above right) *Ed Meschi.* 1933. Oil on canvas, 26 × 24″. Collection the artist and/or family

Longshoremen Coming Home from Work, *the union organizer Pat Whalen, and* Magistrate's Court. *Then I'd go to V. Henry's for dinner. He had a Filipino cook, so I had my upper-class evening.*

[Like many other artists, writers, and intellectuals during the 1930s, Neel turned toward the critical and revolutionary ideology of the Left, particularly of the Communist Party. She attended one meeting of the John Reed Club, picketed with other members of the Artists' Union, and briefly joined the Communist Party at the time of the Spanish Civil War. Her portraits of left-wing intellectuals, organizers, and Communists, such as Pat Whalen and Kenneth Fearing, and her street scenes of Depression-era New York, such as *Investigation of Poverty*, 1933, *Synthesis of New York*, 1933, *West 17th Street*, 1935, and *Nazis Murder Jews*, 1936, are vivid reminders of her political and social concerns at that time.]

I thought the election of Roosevelt was great. He saved everybody. Stalin thought Roosevelt was the smartest bourgeois living because he made all these concessions to keep the country from disintegrating. In those days there was no welfare and no social security. Of course, Roosevelt had one defect—he didn't lift the embargo against Spain. So the Abraham Lincoln Brigade went into battle with one gun for six people.

I went once to the John Reed Club and I was such a beginning revolutionary that I was scared to death that there was some kind of criminal under my seat. I was terrified. The criminal was somebody who was against the Left—who was going to blow it up.

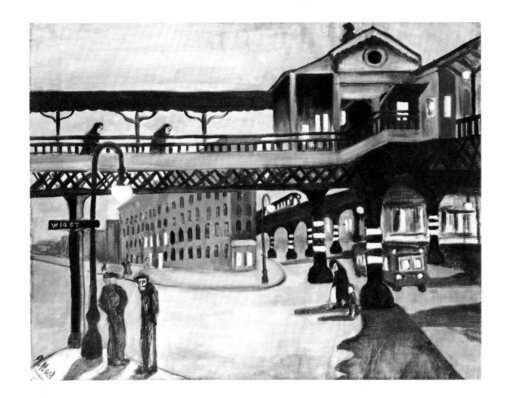

9th Avenue El. 1935. Oil on canvas, 24 × 30″. Collection the artist and/or family

The first time I joined the Communist Party was about 1935, around the time I painted Pat Whalen. *But I was never a good Communist. I hate bureaucracy. Even the meetings used to drive me crazy. I didn't participate in the meetings because I was too timid. I didn't dare to speak out. But it affected my work quite a bit.*

I got an important critic on the WPA by lending him two pictures. The reason I loaned them to him—it was obviously dishonest—was because of left-wing influences. I had reached the conclusion that to eat was the most important thing in the world, and also I thought he knew so much about art that even though he couldn't paint he had a right to be on the project. Once he got in there he became a supervisor and a big theoretician and a great dictator. When he brought Elaine de Kooning up to my house in the early fifties, I got drunk, and I accidentally told this story. And of course he could have killed me.

I went to the demonstrations of the Artists' Union. We cooperated with the picketing workers of May's Department Store. We picketed, and an Irish policeman arrested a big batch of people. He walked up to me and said: "No, I won't arrest you. You're too Irish." And he didn't arrest me. But many people were in jail overnight. I hate to tell you that I was glad not to be in jail, because I had claustrophobia.

I was a Communist when I painted Nazis Murder Jews, *about a Communist torchlight parade in about 1936. The people in the front are Sid Gottcliffe and others who were on the WPA project. I showed the painting at the ACA Gallery. A critic wrote: "An interesting picture, but*

the sign is too obvious." But if they had noticed that sign, thousands of Jews might have been saved.

[Do you think that painting can be in the service of the revolution?]

Look at Goya, look at the Mexicans! If it is real enough, it can be. Do you know to how many lectures I went on this question? At least fifty. In the 1930s, this was the big *question. The Communists said then—the big Communists—when there is socialism there would be no need for art. I thought they were just stupid. They meant that everything would be so good you wouldn't have to correct it. Now I always hated being dictated to, although I myself painted these things. I thought* Pat Whalen *was important.*

The Soviet Union puts great importance on art and music as propaganda. Now, for it to be good propaganda you have to admit that the Mexicans were the best and Goya. Goya's The Third of May, 1808, *is a magnificent picture—deeply felt. When Napoleon invaded Spain, Goya saw the horrors that the Napoleonic army committed. He did the* Disasters of War. *Magnificent! But here in the U.S. wars never took place. Revolution was largely mental.*

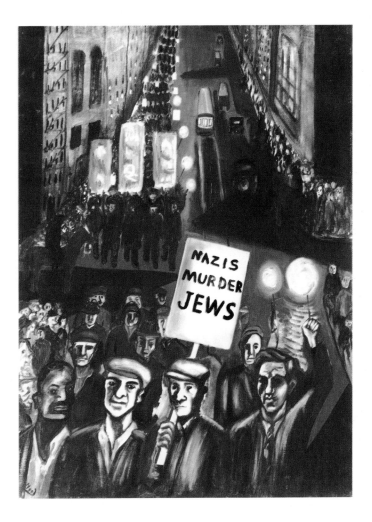

Nazis Murder Jews. 1936. Oil on canvas, 42 × 30″. Collection the artist and/or family

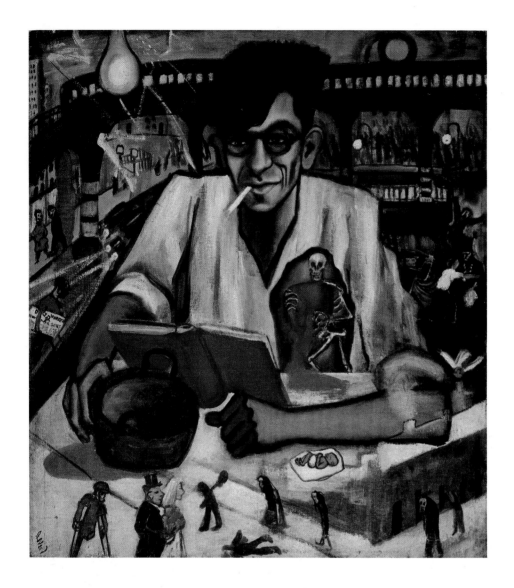

Kenneth Fearing. 1935. Oil on canvas, 30 × 26″. Collection the artist and/or family

When I first moved to the Village with Doolittle, I met Kenneth Fearing, an important American poet not sufficiently noticed today. He used to come and see me every week and thought I was a very important painter.

In 1935, when I finished his portrait, he said: "Take that Fauntleroy out of my heart," meaning the skeleton. But that was to show that even though he wrote such deadpan verse he really sympathized with humanity, that his heart bled for the grief of the world. You see, there in the painting is the material of his poetry. This is the Sixth Avenue El that he lived near, and that's the light bulb because he always worked at night. And the figures in the street are characters from his poems. You see the police knocking people down, and a man lies shot on the sidewalk, and one chap is selling The Daily Worker. *The baby is there because Kenneth's wife just had a baby boy in the hospital. Meyer Schapiro said about this: "Ah, the empty pot of the Depression." In 1961, he died and they put this painting on the cover of the magazine* Masses and Mainstream.

Patty Whalen was the organizer on the waterfront. I painted him holding the June 16, 1935, issue of the CP newspaper, The Daily Worker. *Ryan's men used to really beat him up. Know what he would say? He'd say about my work, because he thought my painting* Well Baby Clinic *was a form of insanity: "Ya see what the system does to the intellectual. It drives 'em nuts."*

Look how he cut his hair—like a dope. He had that thing shaven off, right up to where the hair got thick. He was just an ordinary Irishman except for one thing: He was absolutely convinced of Communism, and he could convince other longshoremen. He'd say: "As V. I. Lenin says . . ." and you know, he'd have Lenin under his arm. But he had a wonderful power to make the longshoremen join the Party.

I painted another painting of him pulling down the swastika flag from the Bremen, *but I painted over it. I wish I hadn't, but I do have a photograph of it. A liberty ship was named for him after the war, but during the McCarthy era they changed the name of the ship.*

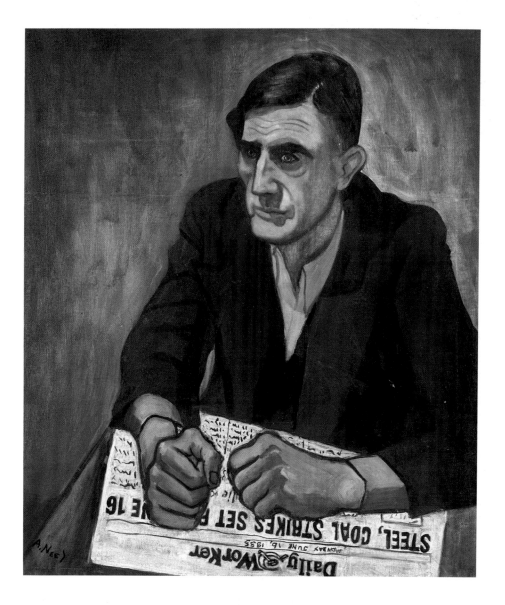

Pat Whalen. 1935. Oil on canvas, 27 × 23″. Collection Whitney Museum of American Art, New York City. Gift of Dr. Hartley Neel

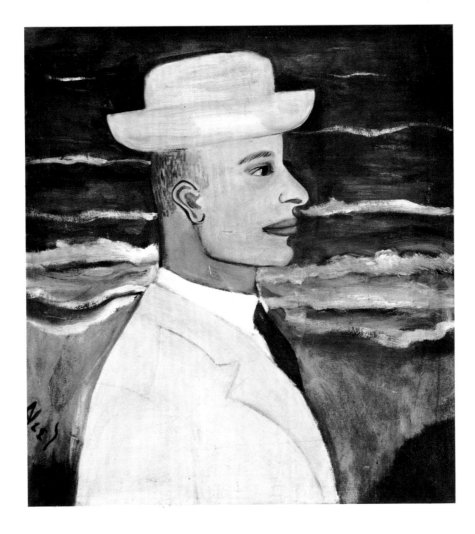

John with Hat. 1935. Oil on canvas, 23½ × 21½″. Collection Arthur M. Bullowa, New York City

George Myers told us a great story about when Patty Whalen was head of the port of Baltimore, a very important job. Patty Whalen would go into a bar. He would demand a drink for a black man who was with him. They'd say: "We do not serve Negroes here." So Patty Whalen would take his heavy glass of beer and smash the mirror. He would just wreck the bar. And finally the owners of the bar were so intimidated that they would sell to Negroes.

When I painted Patty Whalen, I had just recently painted Joie de Vivre, *that one with the man with his penis waving. You know, I adjusted myself to different aspects of life. You know what I loved? I loved to hit the depths and then at night to eat in the Harvard Club. I always loved the most wretched and the working class, but then I also loved the most effete and most elegant.*

I used to go with John Rothschild to the Harvard Club or to Longchamps. He was a great companion. I once said to him: "The only compatible life we have together is across the dinner table."

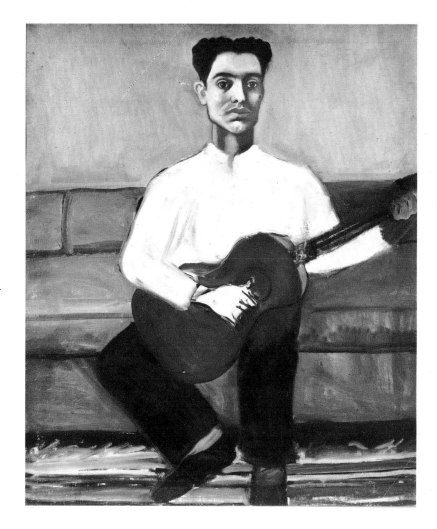

José with Guitar. 1935. Oil on canvas, 36 × 30″. Collection the artist and/or family

[In the winter of 1935–36 Neel met José Santiago, a Puerto Rican nightclub entertainer ten years younger than Neel. She lived with him until 1939.]

I met José in a nightclub. He was handsome, played the guitar, and sang. I wish I had a record of his playing. I went to the nightclub with John, and I had on a silver lamé dress which was beautiful. And José was charmed with all this wealth and elegance. With José I made my one aggressive action. Another night I went down to that nightclub alone. I knew José would want to come home with me, and he did.

When I was living with José, I was in the nightclub every night where he played. It was a wonderful nightclub, La Casita in the Village, founded by a man who was a pianist in Spain who had left because of Franco. Late at night, about one o'clock, after her night's work was over at another nightclub, La Argentinita came, who carried on the tradition of La Argentina. She got most of her dances from

whorehouses in Latin America, and had a troupe, and they would come and dance. She did wonderful footwork and castanets. She would dance there just for fun—for the musicians and the artists. I wouldn't get home until the light was coming up—about five in the morning.

José had a spiritual streak. I think you can see it in the way he holds the guitar. He had a reverential attitude toward music. José and I lived at West 17th Street. In 1937, I moved to 129 Macdougal Street in the Village, and in 1938 I moved to Harlem, to 10 East 107th Street. For a while José's family lived with me, but it was a disaster.

John Graham, the artist, came up in 1939 to visit me. He was married and he used to bring his wife sometimes. He gave me his book. He used to say: "They kill artists early in the United States."

I then had a lot of parties and things. I knew the Peruanos—they were little, short Peruvian musicians, and they came and played. They later played at the Museum of Modern Art. I made verdura, a mixture of Spanish vegetables—Spanish sweet potatoes, yucca—and on top I'd put a dried codfish, bacalao, and hot olive oil. John Graham just loved it.

He was somebody to talk to from the real art world. He took me to Frank Crowninshield's apartment on the East Side. Crowninshield was the former editor of Vanity Fair. In one room he had all these African gods. An African would have died seeing all of them there.

José Asleep. 1938. Pastel and crayon on paper, 11½ × 8¾". Collection the artist and/or family

He was sleeping during the day because he always worked at night. The arms coming out like that are like tropical plants.

Richard was born in September, 1939. I was in the hospital when England declared war on Germany. I was still on the WPA and could support us both. José made something in nightclubs, but not much. Also, I only paid $25 a month rent for my Spanish Harlem apartment.

A couple of months after Richard was born José ran off with a saleswoman at Lord and Taylor's. She was very young and glamorous.

[During her years with José, Neel did several paintings of him, one of his daughter from an earlier marriage, *Sheila,* and *T. B., Harlem,* a portrait of someone they were close to.]

[Neel continued to live in Spanish Harlem for the next twenty years, painting her neighbors, neighborhood children, street scenes, and portraits of people who would come uptown to her place. In January, 1940, she met Sam, a photographer and film maker, also on the Project. She lived off and on with him until 1958. In September, 1941, Hartley was born and shortly after that Neel moved to a bigger apartment at 21 East 108th Street. Neel's memories of life with Sam are ambivalent.]

I can tell you what Sam's pattern was. Intense interest in people.

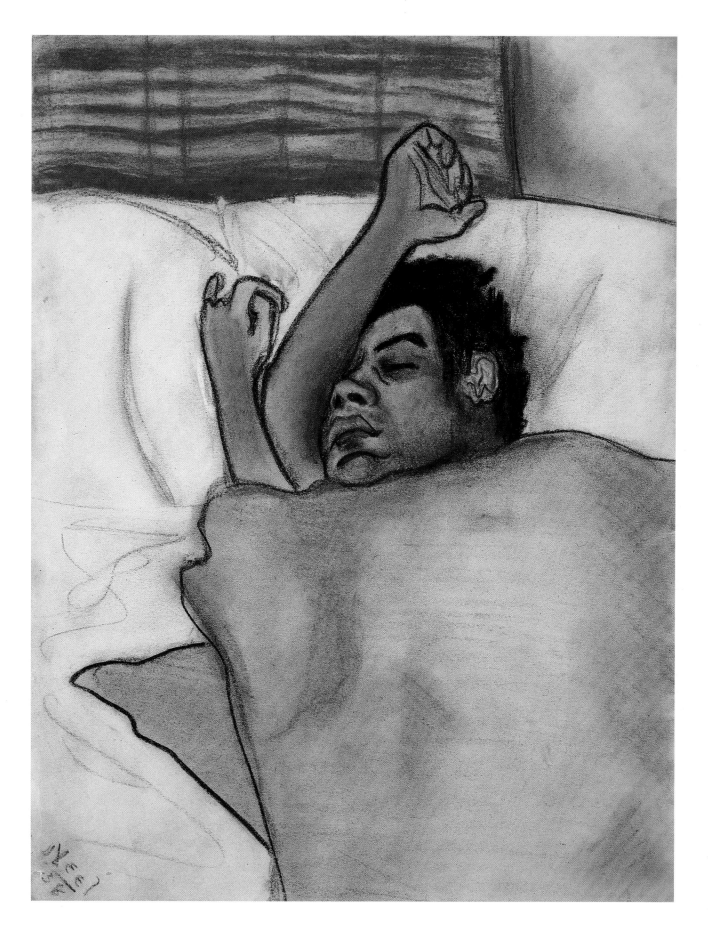

Then, after he'd see them two or three times, they'd begin to wear off. This was then succeeded by desire to destroy them, just get rid of them. He was so smart; when he'd pick on people, he'd know exactly the bad spot in them. There was something uncanny in his capacity to tear people down. He needed to be amused all the time, and he was very amusing himself. He was very clever and very intelligent. And the ladies loved him. He was good-looking, he was smart, he was terrific. And 100 percent an artist. He fascinated women, you know. And he wanted to fascinate them. He was left wing, but utterly egocentric and he thought everybody was a moron.

[Sam took a dislike to Richard, and, as time went on, he abused Richard. Neel painted Sam as a *Minotaur,* showing Sam with a monster's head and a human body. Neel recalls his violent temper when he discovered the painting, and then proceeded to break up the masonite panel it was painted on. She later rescued the painting from the garbage, glued it together, and hid it from him. Many of the paintings that Neel did in the early 1940s are of Sam or are associated with memories of him. Her *Still Life with Fruit* of 1940 is associated with an eye illness of Richard's.]

Childbirth. 1939. Oil on canvas, 30 × 39¾". Collection the artist and/or family

Sam's attitude toward Hartley was entirely different from his

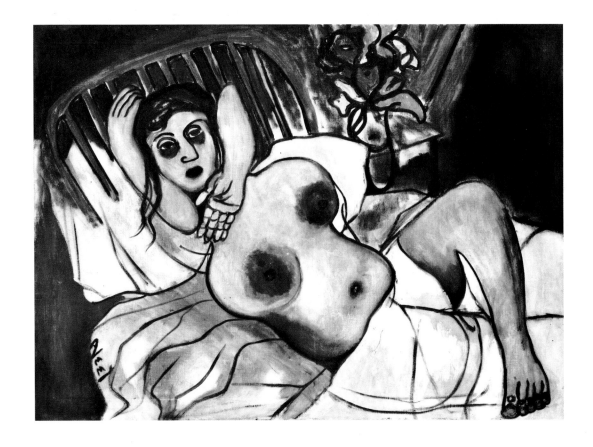

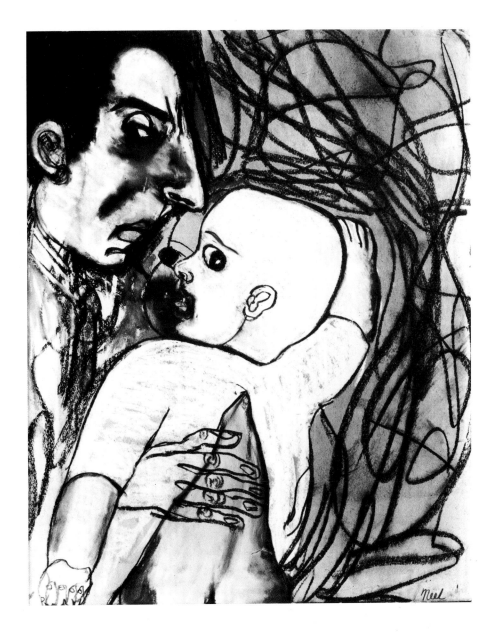

Sam and Richard. 1940. Photograph of drawing, original lost. Collection the artist and/or family

attitude toward Richard, and this created a very difficult situation. At times he went away, often for trips of many months.

In 1942, Sam joined a group of men who went west to work in a shipbuilding plant. He stayed out there for the better part of a year. I was glad he went. I painted Subconscious, *which refers to my situation at that time. I also painted* The Spanish Family. *I remember being glad Sam was away because he would have had fits if he ever knew I saw any of them. In the winter of 1943–44, Sam spent the whole winter having fun out in California. I stayed up in Harlem and I was glad to be alone, because it made life easier for Richard.*

Another year, maybe 1944 or 1945, Sam took Hartley to California because he had asthma. Richard and I had whooping cough together in

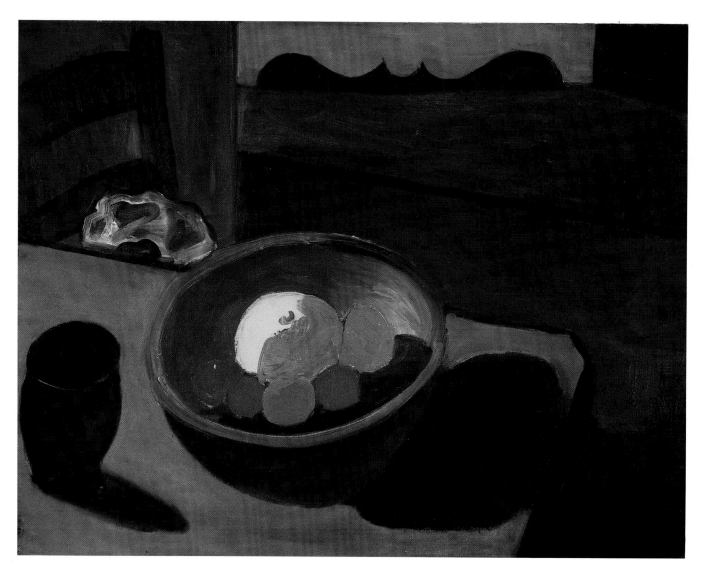

Still Life with Fruit. 1940. Oil on canvas, 24 × 30″. Collection Arthur M. Bullowa, New York City

Richard was ill with an eye infection and this bowl of fruit assumed immense proportions. I think one of Rimbaud's poems says:

In certain states of the
spirit which are almost
supernatural, the
profundity of life is
revealed in the
spectacle, however
ordinary it may be,
that we may have in
front of our eyes. It
becomes the symbol of
life.

I think this occurred in my painting of the wooden bowl with the fruit.

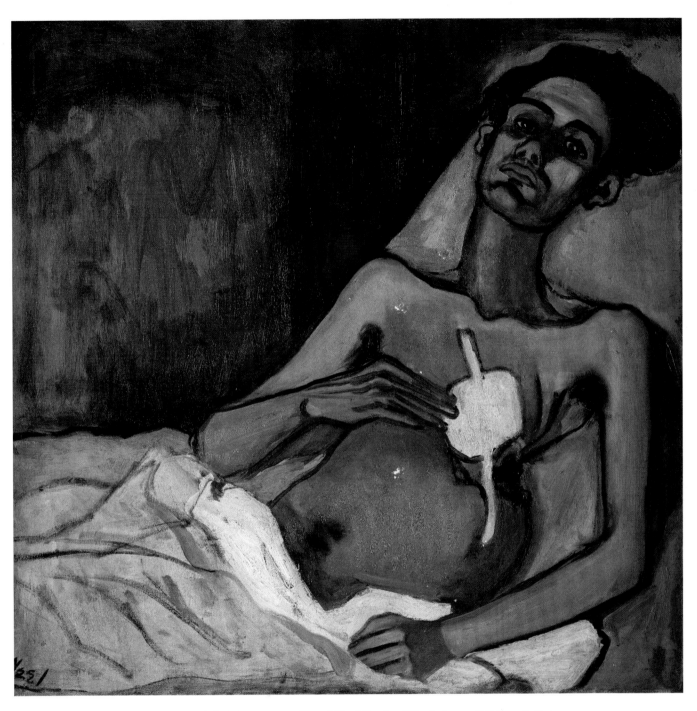

T.B., Harlem. 1940. Oil on canvas, 30 × 30″. Collection Wilhelmina and Wallace Holladay, Washington, D.C.

This young Puerto Rican, who was twenty-four at the time, had tuberculosis. In those days they collapsed a lung. Today, they'd give you an injection to dry it up, but in 1940 they removed eleven ribs. In the painting, he had just returned from the hospital, but would soon go back. What a crucifixion he went through. His body always leaned to one side because of the missing ribs. He got emphysema afterwards, and he finally became a drug addict because he had to take so much codeine for pain. When his original operation had healed, he had to return to the hospital to be cured of the drug habit. But he lived to be about sixty-seven.

Minotaur. 1940. Oil on canvas, 30¼ × 24″. Collection the artist and/or family

Harlem. And I read Pushkin. I was really with Pushkin all that winter. I remember that wretched Christmas when we had hamburger, but I put allspice on the hamburger to make it taste like turkey. I missed Hartley, but it was better for him and Richard.

As the war became more real the Art Project dwindled. In 1941, when Hartley was one month old, and Richard was two, I received a letter from the WPA saying I would have to spend fifteen hours a week teaching. I had never taught; I was always on the easel project. So I went to the Winifred Wheeler Nursery, where I took Richard. Later on Hartley was there too. About 1942 or 1943, I did the painting of Ralphie, *who was at the nursery. Then the Project ended in 1943. I was one of the last eleven people on the Project.*

The Spanish Family. 1943. Oil on canvas, 34 × 28″. Collection the artist and/or family

Two Girls in Spanish Harlem. 1941. Watercolor, 20½ × 15½". Collection the artist and/or family

John in Striped Shirt. 1958. Oil on paper, 28 × 22". Collection the artist and/or family

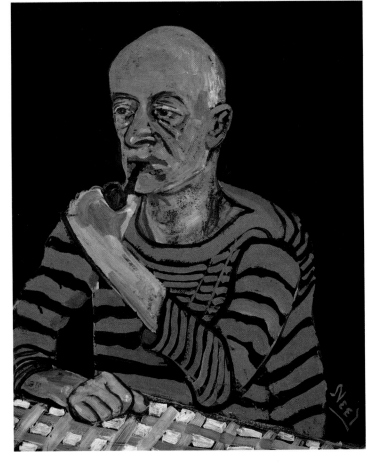

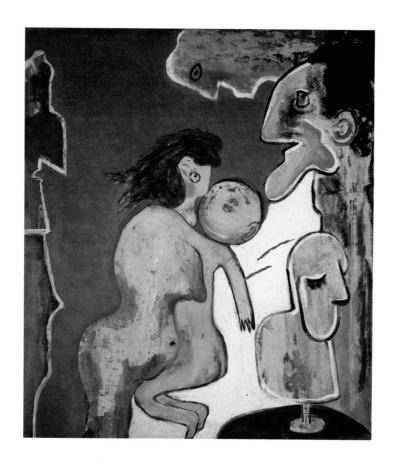

Subconscious. 1942. Oil on canvas, 28 × 24″.
Collection the artist and/or family

*This is how I felt in 1942 when Sam was
out West. I did this in the winter nights in
Harlem. I am holding Richard, whose head is
about to roll off. I then felt that children were
physically attached to you until about the age
of two. It was a definite physical attachment.
Right in front is Sam with that chin, reduced to
an idiot. At the right is John as a statue,
discreetly turning his head away. There are a
couple of little blood marks on the sheet. On
the edges of the canvas are the gods of
sickness. The color—lavender—means
insanity. Linda Nochlin showed this in a
lecture she gave at the Los Angeles County
Museum of Art after the opening of the
exhibition* Four Hundred Years of Women's
Art.

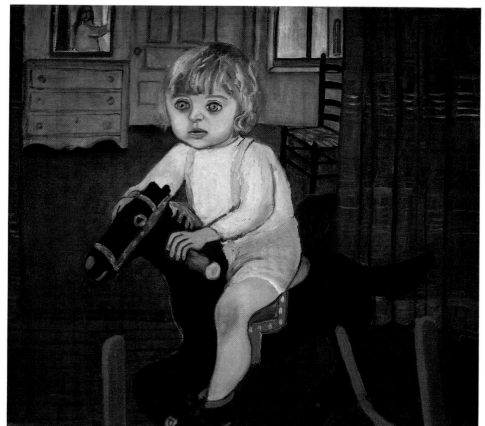

*Hartley on the Rocking
Horse.* 1943. Oil on
canvas, 30 × 34″.
Collection the artist and/
or family

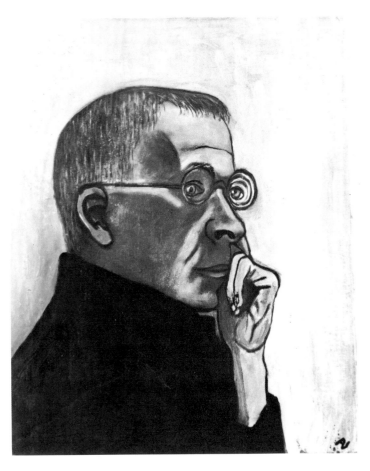

Edward Pinckney Greene. 1946. Oil on canvas,
20¼ × 16¼″. Collection Katherine H. Cole, San
Francisco

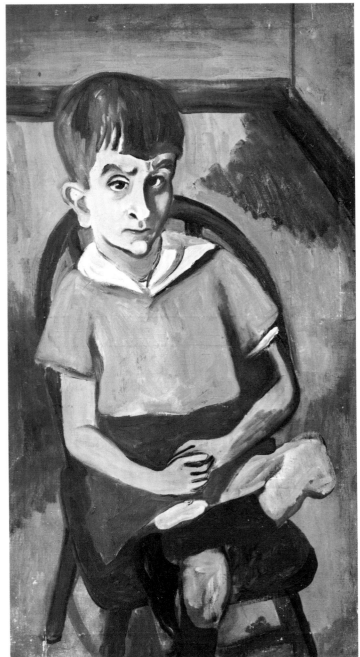

Ralphie. 1943. Oil on canvas, 32 × 18″.
Collection the artist and/or family

At the end, they set the artists to scraping armbands. People went around, guards at night, wearing these armbands, because you were not allowed to have lights. We expected the Germans to bomb New York. So they made the people on the Art Project, regardless of how good they were, correct little mistakes on the armbands. I never corrected one, because I thought I'm too good for that. So I'd simply take a bundle of corrected ones and hand them in at the end of the day; I just had fun all day talking.

I didn't let being a woman hold me back. There was a man on the Project: "Oh, Alice Neel! The woman who paints like a man!" And I went to all the trouble of telling him that I did not paint like a man but like a woman—but not like a woman was supposed to paint, painting china. I felt it was a free-for-all. And I never thought it was a man's world. I thought women were always there, even though they may not have participated fully.

Art doesn't care if you're a man or a woman. One thing you have to have is talent, and you have to work like mad.

I was in the exhibition The New York Group *in 1938 at the ACA Gallery—seven men and I.[5] They were so embarrassed because I was a woman, but I didn't feel any different from them. They didn't understand.*

I always needed Women's Lib. I had it inside of me, but outside, these people ran over me even though I was a much better painter.

[In New York, her subjects included the artist and doctor's wife Bessie Boris, the left-wing intellectual lecturer Edward Pinckney Greene, her own children, Sam, and neighborhood people. At this time she did *Woman in Pink Velvet Hat*, a memory portrait of a total stranger, whose compelling face and hat seared a vivid image into Neel's memory.]

I painted Woman in Pink Velvet Hat *from memory. You can't paint any good portrait unless you have a good memory, because there are tiny changes all the time. You know what the Chinese say: "You never bathe in the same water twice." And if you follow those changes you just have nothing. I deliberately set out to memorize, even in art school. Look at those paintings of Whistler's called* Nocturnes. *How could you paint in the dark in the failing light? You couldn't. You had to have a good memory.*

I read somewhere that John Singer Sargent had a class in London. The model was in one room and they worked in the next room. And they could go as often as they liked to look at the model, but could not just sit painting in front of the model.

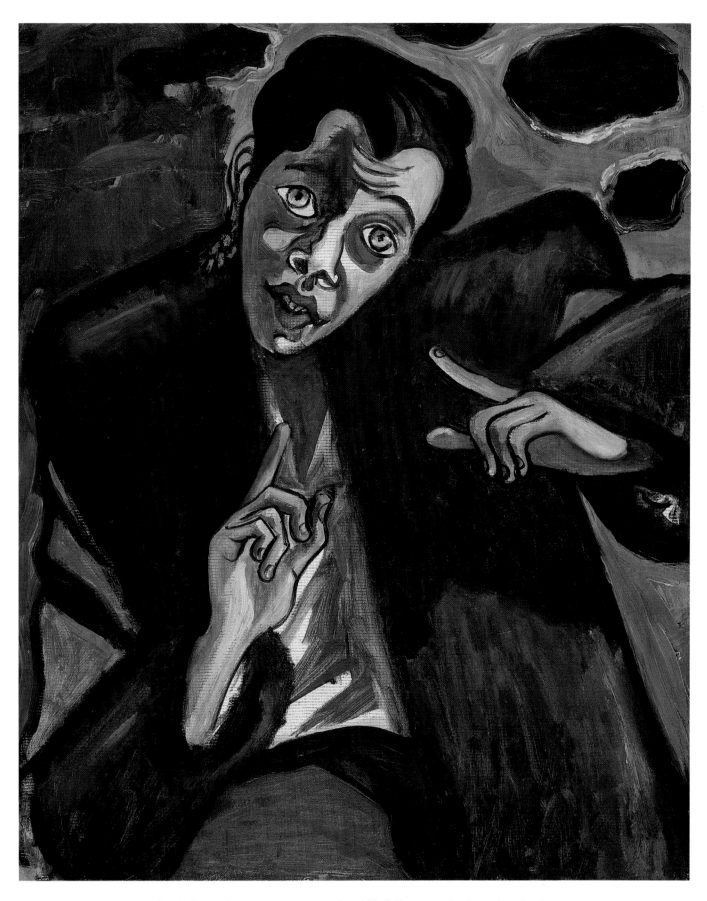

Bessie Boris. 1947. Oil on masonite, 23 × 18″. Collection the artist and/or family

Woman in Pink Velvet Hat. 1944. Oil on canvas, 18 × 14¼". Collection Arthur M. Bullowa, New York City

One Sunday in 1943 I took my sons for a walk. They were little kids, two and four. I saw a woman walking by. So when I came back home and gave the children their nap, I painted her from memory. I finished it up that night when they were again asleep. I love it. It has no technique, none of the shibboleths of studied artistry. It's just pure expression. Arthur Bullowa loved it and bought it in the late 1940s.

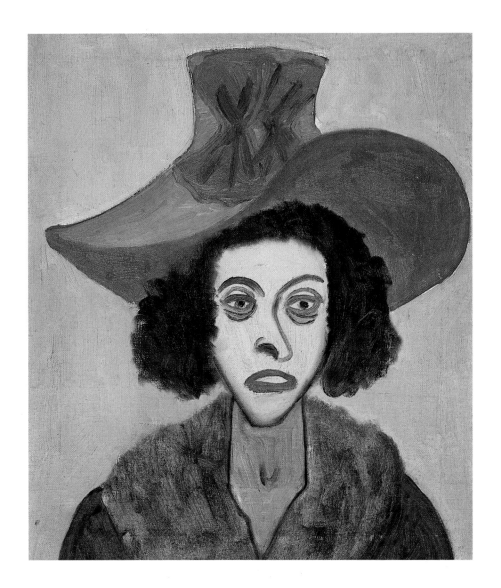

[In 1942, Neel was included in a big exhibition of artists on the Project held at Macy's Department Store, organized by Sam Kootz.

From March 6 to 22, 1944, Neel had a solo exhibition at Rose Fried's Gallery, the Pinacotheca Gallery at 20 West 58th Street. There she showed twenty-four paintings, including: *Symbols, Sam, Nadya and the Wolf, John* (then called *Harvard '21*). Some of the paintings shown were ones Neel had bought back from a man who had bought WPA paintings as scrap canvas. *Life* magazine, in their April 17, 1944, issue reproduced Neel's painting *New York Factory Buildings* in connection with an article, "End of WPA Art."[6]]

Selling the WPA paintings as scrap canvas for 4¢ a pound was disgraceful. The Project had been a way of keeping our economy from falling apart completely. But to the artist his art was always important. The government didn't look at it that way. They just sold them as spoiled canvas to wrap pipes with. I always rooted for another WPA. Holland subsidizes young artists, enough for them to eat and pay their rent. England subsidizes ballet dancers.

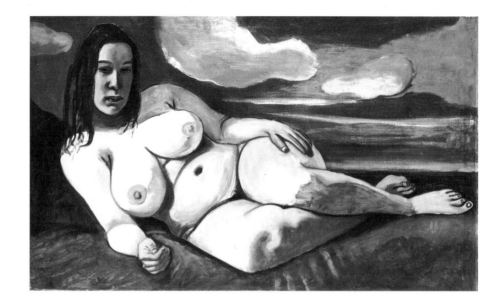

Sue Seely. 1943. Oil on canvas, 30 × 48″. Collection the artist and/or family

[In 1945, Neel left the Pinacotheca Gallery because Rose Fried had turned her attention to the rising Abstract Expressionist movement. Neel went over to the ACA Gallery, run by Herman Baron, a staunch supporter of the American paintings of social concern and social protest. She was well known to Baron, for she had previously been included in his 1938 exhibition, *The New York Group.*]

Abstract Expressionism was becoming very attractive then. I'm not against abstraction. Do you know what I'm against? Saying that man himself has no importance. I'm grateful to trees and things that still put out their leaves. And skies that still operate for us. The Van Allen Belt has not collapsed yet. I think those things are very tolerant with human beings. What I can't stand is that the abstractionists pushed all the other pushcarts off the street. But I think when Bill de Kooning did those women it was great. You know why? I think he had something the matter with him sexually and he was scared of women. He probably saw teeth in vaginas.

Ortega y Gasset was prophetic. He predicted in The Dehumanization of Art *a whole era of art. I think he states there that Juan Gris said Cézanne's arm goes into a cylinder; whereas I paint a cylinder that perhaps becomes an arm.*

There is room for different kinds of art. You know what the Bible says: "In my father's house, there are many mansions." And of course Robert Rauschenberg is good today because he shows the world falling to pieces, and he shows the bombardment of the brain with all those things.

I was in Spring Lake in the summer of 1945 when my father brought in the newspaper which said that Truman had dropped the

bomb. I thought it was frightful. I thought it was a crime. After all, all this talk now about dropping the bomb, we were the only ones that ever did it. It was horrible, awful. I later read to Richard and Hartley the report of John Hersey, published in The New Yorker. *Now we're under a greater threat than we ever were.*

[During the 1940s, Neel took the children each summer to a small cottage at Spring Lake, on the Jersey shore. Her mother and father stayed with her there, helping out with expenses. Neel's time was occupied with chores, running the household, and entertaining two active children. Over the years, several paintings, including *The Sea,* 1947, and *Cutglass Sea,* 1947, have come from the Spring Lake time. Today she continues to spend much of the summer at Spring Lake.]

My father died in May, 1946, when he was eighty-two. He was buried near Philadelphia, and I went to his funeral in the little town of Colwyn, where I had grown up. I realized that I would never see him again. He was a good and kind man, and his head still looked noble. I didn't set out to memorize him because I was too affected. But the image printed itself. So I did him in his coffin the next day, after I returned to New York. Of all my pictures this was the favorite of Harold Rosenberg.

I also did a portrait of my mother in mourning, out in Spring Lake, the summer following my father's death. She had a tortured

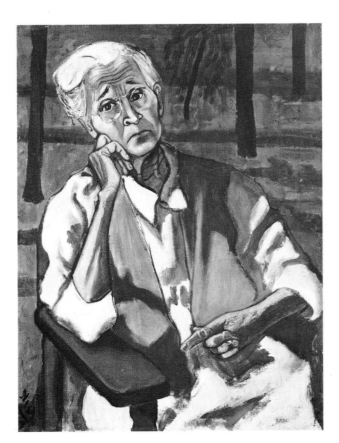

My Mother. 1946. Oil on canvas, 28 × 21″. Private collection, London

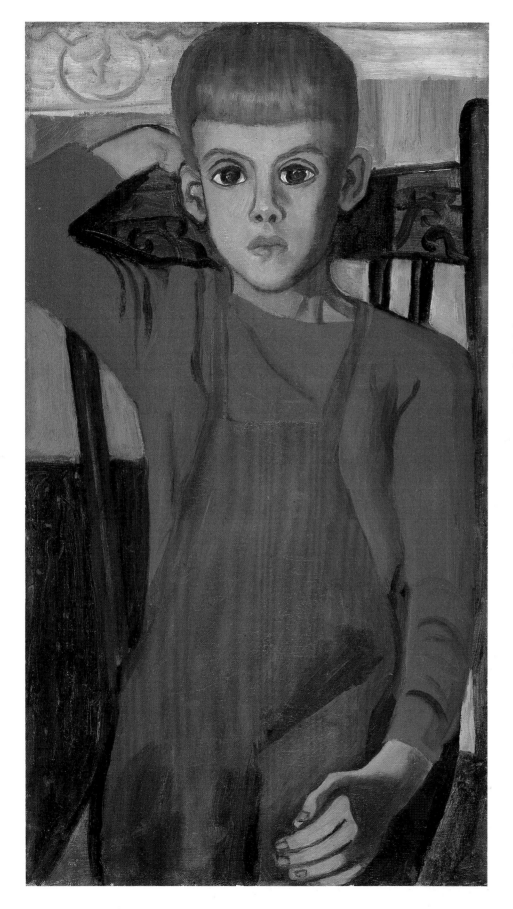

Richard at Age Five. 1944.
Oil on canvas, 26 × 14″.
Collection the artist and/
or family

consciousness and was over *aware. I realized later that the willow tree, which I had included in the painting, was also in the early American mourning pictures. My mother's life was just a shambles after my father was dead.*

Spring Lake represented to me escape. You see, I lived in Harlem. I loved it. I was part of it, but just the same. Just like John and Sam. I really much preferred Sam. But John, pursuing me all the time, with his rather nice manners and good restaurants, and everything, was also essential. Sam used to make big fusses, and scream and yell when I went out with John. But since he did as he pleased, I did as I pleased.

John never gave me up, never. Even though he married a couple of times. He married a woman twenty-five years younger in the early 1940s. Yet he still went out with me. He'd invite me to dinner, and we'd go to Longchamps. It was a nice change from my difficult life. And another thing, John, for all his defects, was civilized, he had manners. He also saw art. He didn't think I should ever get paid for it, because I had the fun of painting.

Dead Father. 1946. Oil on canvas, 19½ × 28″. Collection the artist and/or family

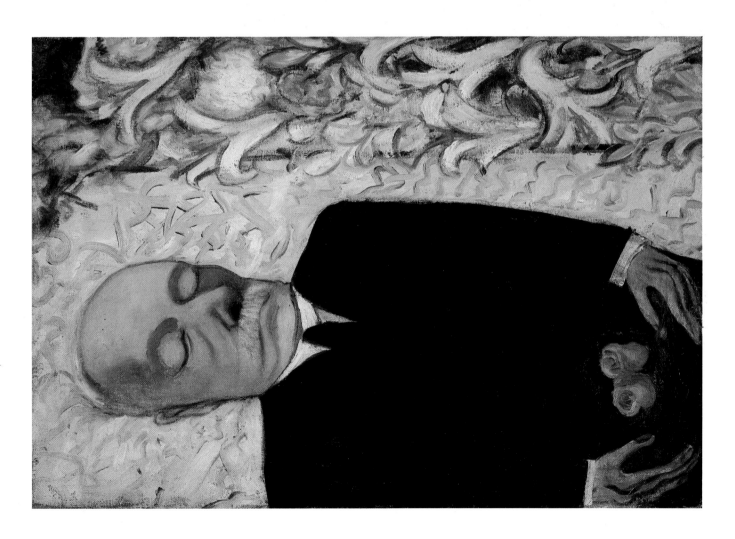

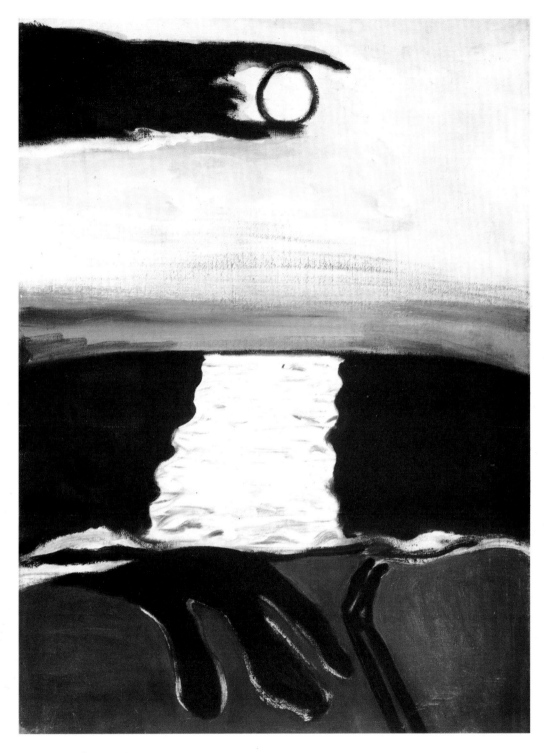

Cutglass Sea. 1947. Oil on canvas, 28 × 20″. Collection the artist and/or family

My father had died and my mother was with me in Spring Lake in a small house. I walked all the way down to the ocean by myself at night, looked at this scene and memorized it, then came home and painted The Sea.

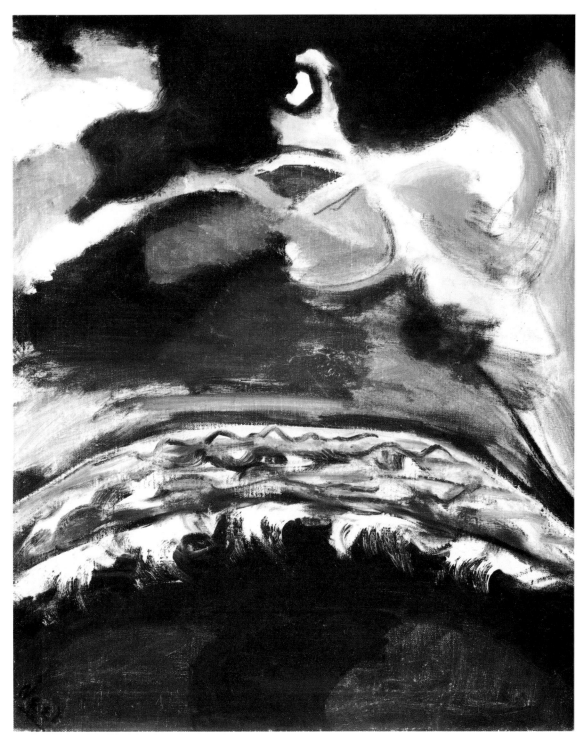

The Sea. 1947. Oil on canvas, 30 × 24″. Collection the artist and/or family

But you know why I made it curved instead of that straight horizon of Courbet? Because I thought you saw more this way, in depth. Although I love that perfectly flat horizon, still, I thought this way you were in it, part of it.

[In 1949, as part of the wave of Cold War anti-Communism, members of the leadership of the Communist Party were brought to trial under the Smith Act. Neel went once to the trial and sketched Judge Harold R. Medina and a witness, Angela Calomaris. Neel had not been in the Communist Party since the 1930s, but she was friendly with some of its members. She went to classes at the Jefferson School given in philosophy by Howard Selsam, in literature by V. J. Jerome, and in art by Sidney Finkelstein. She also read the newspaper *The Daily Worker,* now called *The Daily World.*]

George Bernard Shaw said of the trial that if Christ would come back with the twelve disciples, the Americans would undoubtedly put them in jail. Twelve were tried at the Smith Act trial. It wasn't for doing anything. It was just for thought. The head of the Party, Eugene Dennis, was given five years and he went in with brown hair and came out with white hair. Alexander Trachtenberg, the man who brought all the

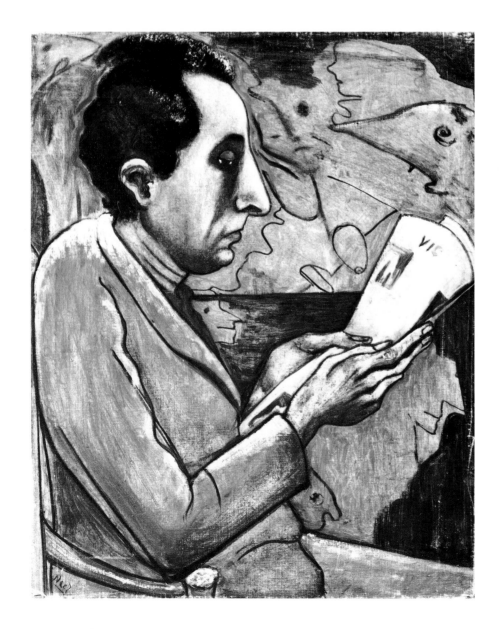

Sam (Snow). 1945. Oil on canvas, 30 × 24″. Collection the artist and/or family

(above left) *Judge Medina.* 1949. Ink on paper, 13¼ × 10¼″. Collection the artist and/or family

(above right) *Angela Calomaris.* 1949. Ink on paper, 13 × 10″. Collection the artist and/or family

Communist literature to this country, had five years in jail too. A lot of them were convicted. Medina was the judge. During the Depression, Medina owned a lot of slum houses. When they evicted the poor people and put their effects on the sidewalk, the Communists would carry them back in. So Medina just hated Communists. He was bored like all judges. The outstanding quality of all judges is infinite boredom.

I did this wonderful drawing of Angela Calomaris, who gave anti-Communist lectures on the radio. She was the stool pigeon. Medina treated her with kid gloves. At the trial they brought out the fact that Calomaris had been arrested for something in New England, but it wasn't anything like speeding. It was moral turpitude, I think. She looked just like a man, an Italian man with a hat with a little feather in it. The drawing is a marvelous satire. The drawing I did of Medina was reproduced in Masses and Mainstream in 1949.

After V. J. Jerome came out of the Lewisburg Federal Penitentiary I went to his home. He told the story of how he went into Lewisburg, and they gave him the mattress of Remington who was murdered by other prisoners because he was a Communist. They said to him: "Here, take this bloody mattress where Remington was murdered and mind your P's and Q's."

(opposite) *Fire Escape.* 1946. Oil on canvas, 36 × 24″. Collection Peggy Brooks, New York City

[From December 26, 1950, to January 13, 1951, Neel had a major solo exhibition at the ACA Gallery. Included were *The Spanish Family, Fire Escape, Sam, The Sea, Edward Pinckney Greene,* and *Dead Father.*[7] Joe Solman, a fellow artist, wrote in pencil in the catalogue: "I can say, without any doubt, Alice Neel is the best portrait painter in America."

Later in the spring, from April 23 to May 23, 1951, Neel had another solo exhibition at the New Playwrights Theatre, at 347 East 72nd Street. The twenty-four paintings included *The Spanish Family, Magistrate's Court, Investigation of Poverty at the Russell Sage Foundation, Hubert Satterfield, The Uneeda Biscuit Strike,* and *T. B., Harlem.* The cover of the catalogue reproduced *T. B., Harlem,* and the writer Mike Gold wrote the foreword:]

Alice Neel has never allowed them to dehumanize her. This is heroic in American painting, where for the past fifteen years Humanity has been rejected, its place given to the mechanical perversions, patent-leather nightmares and other sick symbols of a dying social order.

Alice has for years lived with her children in a Harlem tenement. Her studio is the kitchen and her models the neighbors and the streets. She comes from an old Philadelphia family dating back to the Revolution. But her paintings reveal that here is her true family. In solitude and poverty, Alice has developed like a blade of grass between two city stones. She has become a superb craftsman, and the first

Central Park in the Afternoon. 1946. Oil on canvas, 24 × 26″. Collection Faith Bonosky, New York City

Ballet. c. 1947. Gouache, 24 × 30″. Collection Fred Mueller, Bernhardt Arts, New York City

clear and beautiful voice of Spanish Harlem. She reveals not only its desperate poverty, but its rich and generous soul.

Some of the melancholy of the region hangs over her work. This is as inevitable as the sadness in the work of Gorky or Chekhov. But there is also their truth and their unquenchable faith. ALICE NEEL is a pioneer of socialist realism in American painting. For this reason, the New Playwrights Theatre, dedicated to the same cause, presents her paintings to its audiences, who will know how to understand, appreciate and encourage one of their own.

[Scheduled for the preview of the exhibition at the New Playwrights Theatre was a discussion by writers and artists on the question "Realism vs. Abstraction." Neel recalls that Mike Gold was going to be there, but he could not make it. Her own thoughts on the question today are as follows:]

All my favorite painters are abstractionists: Morris Louis and Clyfford Still. I don't do realism. I do a combination of realism and expressionism. It's never just realism. I hate the New Realism. I hate equating a person and a room and a chair. Compositionally, a room, a chair, a table, and a person are all the same for me, but a person is human and psychological. The work of the New Realists is boring to me because of no psychological acumen. They don't show a soul out in the world doing things.

You know, for a while, when I gave my slide lectures, I had to apologize for being psychological. That was ten years ago. They don't

Last Sickness. 1952. Oil on canvas, 30 × 22″. Collection the artist and/or family

My mother died March 1, 1954, the day the Desegregation Bill was passed. This is in the fall of 1953 and she is already ill. I had this in the Whitney retrospective in 1974 and hesitated to show it, feeling it was too personal. But then I reflected she would much prefer to be on a museum wall than on a shelf. Jack Baur, who was the director at the time of my Whitney show, thought this was one of my best paintings.

Harlem Nocturne. 1952. Oil on canvas, 24 × 21″. Collection the artist and/or family

care anymore. Because now that they're going to blow up the world, they realize that there is psychology.

My mother came in 1953 to live with me, and she died in 1954. She never was happy. She just saw too much and knew too much. But still, that shouldn't make you unhappy. She was often around my house, my big apartment in Harlem, for visits of a couple of months.

Once, when I was at a left-wing literary meeting I used to go to at Annette Rubenstein's, they were discussing American authors. And I suddenly realized how much more my mother knew about the subject than these people, these left-wing intellectuals.

[Throughout the 1950s, as in the 1940s, Neel frequently painted the children of Spanish Harlem: *Georgie Arce,* 1955, *Two Puerto Rican Boys,* 1956, *Dominican Boys on 108th Street,* 1955, and *Two Black Girls,* 1959. She also painted a number of views from her window and other cityscapes, including *Harlem Nocturne,* 1952, *Sunset, Riverside Drive,* 1957, and *Rag in Window,* 1959.]

When I lived at 21 East 108th Street I had a boxer. One day I was walking along with him. A little Puerto Rican boy, nine or ten, asked me if he could come up and play with him, which was the beginning of a long friendship. His name was Georgie Arce and I painted him in a number of pictures.

My apartment was a big railroad flat, but wider than most, and very light with many windows. I always had a big place because of the painting. Two little Puerto Rican girls, Antonia and Carmen Encarnaçion, lived with their family on one of the higher floors. Their grandmother, a wonderful old woman, took care of all the children because the mothers and fathers worked. The children were nice and well behaved when they posed for me for Two Black Girls.

[During the 1950s, Richard and Hartley went to the Rudolf Steiner School on scholarships. They had their high-school education at High Mowing, a boarding school in New Hampshire run along Rudolf Steiner principles by Mrs. Emmett. Later, Richard went to Columbia College and then Columbia Law School; Hartley studied chemistry at Columbia College and Dartmouth, and then went to Tufts Medical School in Boston. Periodically, Neel painted them, as well as their friends, such as *Moose*, 1956.

Dominican Boys on 108th Street. 1955. Oil on canvas, 41¾ × 48″. Collection the artist and/or family

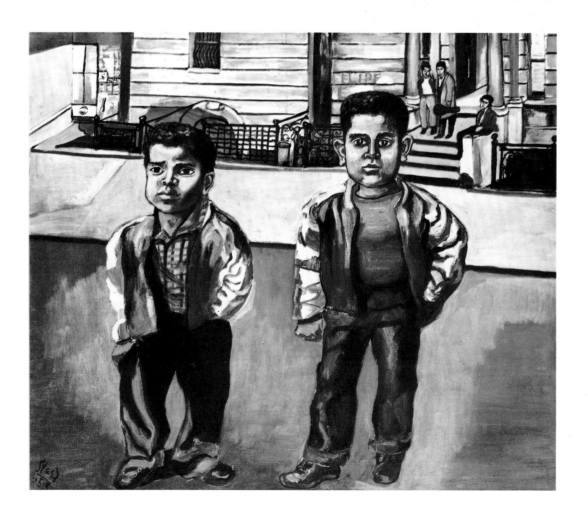

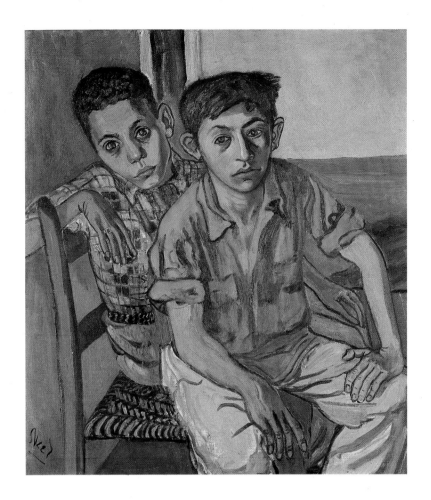

Two Puerto Rican Boys. 1956. Oil on canvas. Private collection, New York City

They came to the door and said: "We hear that you're painting some Spanish children. Would you paint us?" I remember being exhausted but thinking an opportunity like this will never come again, so I did. The one has a perfect Aztec face.

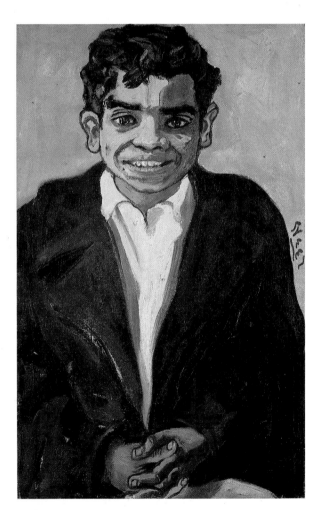

Georgie Arce. 1955. Oil on canvas, 25 × 15″. Collection the artist and/or family

(left) *Two Black Girls.* 1959. Oil on canvas, 30 × 25″. Collection the artist and/or family

(opposite) *Sunset, Riverside Drive.* 1957. Oil on canvas, 50 × 26″. Collection the artist and/or family

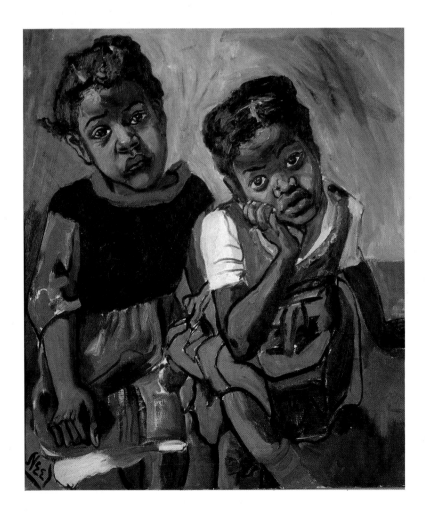

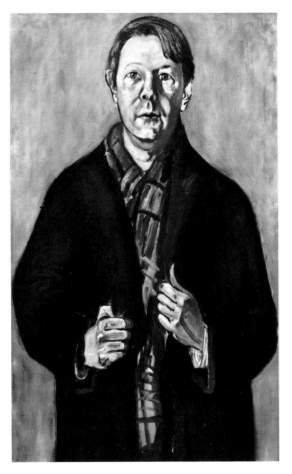

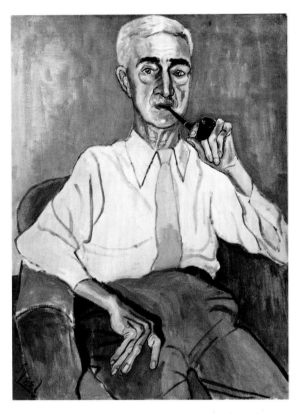

John Lynch. 1959. Oil on canvas. Private
collection, London

Bill McKie. 1953. Oil on canvas, 32 × 23″.
Collection the artist and/or family

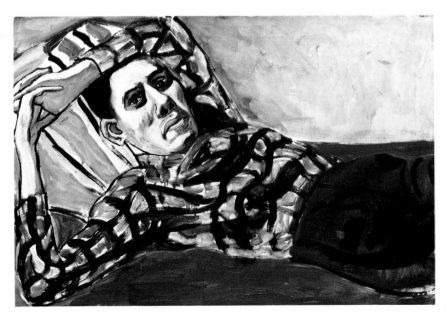

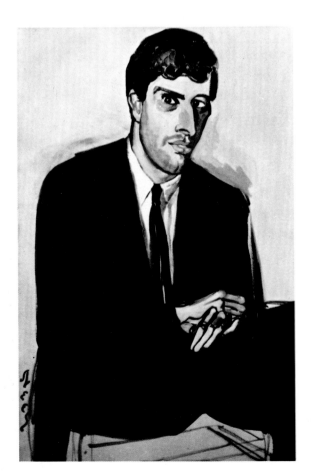

Man Lying Down (with Plaid Shirt). 1957. Oil on canvas, 22 × 32″.
Collection the artist and/or family

Miles Kreuger. 1959. Oil on canvas, 38 × 24″.
Collection Miles Kreuger, Los Angeles

With Richard and Hartley out of the house, and the relationship with Sam coming to an end, Neel could devote all of her time to painting.]

I began going to the downtown Abstract Artists Club, which was stimulating. One night they had Alfred Barr there and other famous people. But they all drank whiskey and got very high, but the audience was cold sober. Milton Resnick and de Kooning would scream four-letter words at each other because they were all quite drunk. It was very funny. I went there to be with other artists from about 1955 to 1965 and to hear what was current. Later, I went to the Figurative Alliance Club.

All my life the Classic and Egyptian collections of the Metropolitan Museum had more influence on me than the painters. Also the African things. Not that I copied them; I admired them. And also Albert Pinkham Ryder—he was a great American artist. He's spiritual, he's a dreamer, and I think his vision of the sea is marvelous. I also liked the street scenes of John Sloan before he was ruined by Renoir. I liked Edward Hopper's Early Sunday Morning, *especially those buildings, but I thought his figures very wooden. I hated Thomas Hart Benton, and I hated those artists who did girls in straw hats out on a hill.*

Falling Tree. 1958. Oil on canvas, 29 × 40″. Collection Steven Kyle, New York City

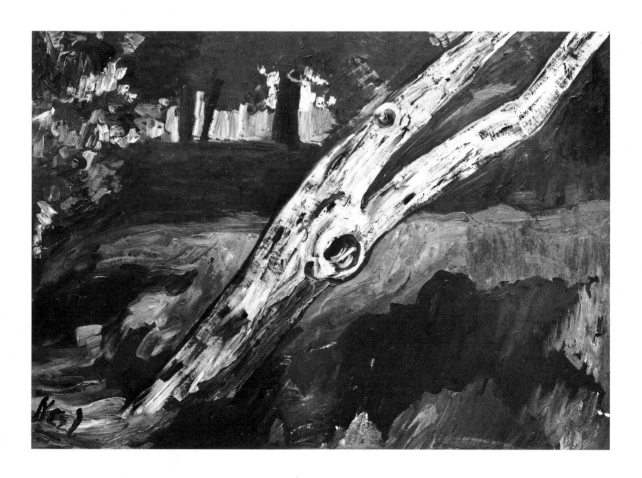

Julian Brody. 1955. Oil on canvas, 32 × 18″. Collection the artist and/or family

(opposite) *Rag in Window.* 1959. Oil on panel, 33 × 24″. Collection Arthur M. Bullowa, New York City

This is a view from my apartment in Harlem. It is done on heavy cardboard, not even masonite, and my collector Arthur Bullowa bought it right after I did it.

I always thought it should have been on a huge canvas, the sort you feel you walk into because the divisions were so interesting. Also, that rag blowing about year after year I called "the twentieth century."

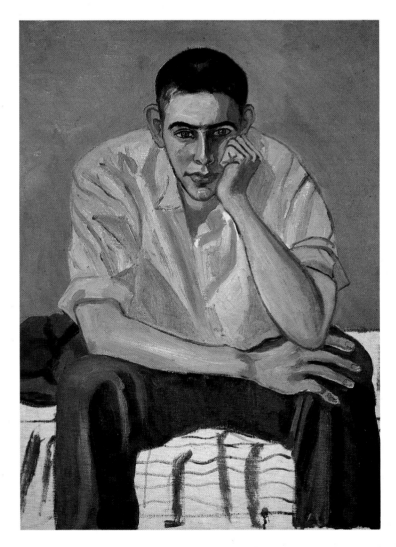

Moose. 1956. Oil on canvas, 36 × 26″. Collection the artist and/or family

Self-Portrait, Skull. 1958. Ink on paper, 11½ × 8½". Collection the artist and/ or family

I went to see a big show of Cézanne's, at least twenty-five or thirty years ago at the Metropolitan. He had a lot of portraits there, and I was amazed at his psychological depth. I didn't think he had it. And guess what he said: "I love to paint people who have grown old naturally in the country." But you know what I can say? "I love to paint people torn by all the things that they are torn by today in the rat race in New York." And maybe one reason I love that so much is because as a child I had to sit on the steps in that dreary small town. But I also think I have an awful lot of psychological acumen. I think that if I had not been an artist, I could have been a psychiatrist. Only I wouldn't have known what to tell them to do, but they don't know either.

In 1958, I was already getting rid of Sam. People would come up and Sam would make a big fight. He drove some people out with a butcher knife once. They came to buy a picture and because they said

Sam. 1958. Ink on paper, 29½ × 22″.
Collection the artist and/or family

Head. 1955. Ceramic. Collection the
artist and/or family, courtesy Robert
Miller Gallery, New York City

*to him, "You have more the attitude of an illustrator," he almost went
crazy. He grabbed a knife and chased them out of the house. People
don't come to see you under those circumstances.*

*Sam was going around with this woman, and finally they had a
son, and then several years later they were married. He went to
California with her in 1959, but came back, any number of times. I
began to regard him as a nuisance. But I got stronger as time went on.
I just concentrated on art.*

*I was analyzed in 1958, not by a psychiatrist but by a
psychologist. Going to the analyst was suggested by doctors at
Columbia Presbyterian Hospital where I had gone for nervous
disturbances. What none of them knew is that it really was a heart
arrest. I got a pacemaker in 1980.*

Frank O'Hara, No. 2. 1960. Oil on canvas, 38 × 24″. Collection the artist and/or family

If it hadn't been for the psychologist my work would never have gotten before the world. I must give him credit. If I hadn't gone to him, I never would be known at all today. He would say: "Well, why don't you send to these shows? It's because you're not as good as they are?" I'd say: "Oh no, I'm much better." But he'd say: "Why don't you send?"

I had a block, I still have it, against publicity, against the outside world. There's something of the pack rat about me. I reached the conclusion that if I painted a good picture, it was enough to paint a good picture, because I couldn't fight the world. I was never a go-getter. I didn't know how to go-get, so I just put it on the shelf. But when the Whitney came here, they took at least fifteen pictures off the shelf—that was a great justification.

I had about seven or eight pictures up at John's for which he never paid one cent. The analyst said to me: "Many men in history have had mistresses, but I don't think any of them got pictures thrown in as an extra bonus." So I gradually reclaimed those pictures and brought them back to my apartment.

John had some bad luck financially and I feel his indomitable will shows in the painting I did in 1958. Perhaps the striped shirt was a harbinger of a prison suit. He felt that I insulted him, but I thought he looked more forceful than in any of the other paintings I did of him.

I went to the psychologist for at least two years. He was practical with me and that was the right thing. He inspired me to call up Frank O'Hara, because I wanted to paint him.

I met Frank O'Hara in the fifties at the Abstract Artists Club. He came to see me in Spanish Harlem, where I lived, and said he would pose for me. He had just been to Spain where, as curator for the Museum of Modern Art, he had picked a show of Spanish painters. When I saw the show it was rather shocking as the artists had all cut and slashed large canvases. This seemed to me like a very poor country spitting in the face of a very rich one.

In 1959, I called Frank O'Hara and asked him to pose for me. First I did a romantic falconlike profile with a bunch of lilacs in the painting. When he came for the fifth time I really had finished the profile; so I asked him if I could do another one quickly, and I did the second "beat" one in a day. I started with the mouth. His teeth looked like tombstones; the lilacs had withered. When he saw the picture he said: "My God! Those freckles! But the Fauves went that far." The reason I wanted to do the second one was because when he came to the door he looked beat. I feel that it expressed his troubled life more than the first. The second Frank O'Hara *was my first reproduction in* Art News, *in 1960.*

After I did those two pictures of Frank O'Hara I met Hub Crehan at an artists' party, and he brought me home. I showed him the portraits of Miles Kreuger and he said: "Well, this is great art." He didn't expect it. They all expected I would paint flowers and plates.

Hub gave me a show at Reed College in Portland, Oregon, early in 1962. He was teaching there. Joe Gould, the nude one, went out there, but it had to be in the closet because of the townies. I could have had a show in Pasadena, but like a fool I refused it.

In 1959, Al Leslie and Robert Frank telephoned me and asked me if I would come down to work on the lot, for $25 a day, and be in the movie Pull My Daisy. They saw me at the Abstract Club. They picked me because I looked like a conventional American type. I had a hat then, and orange gloves, and an orange scarf. I went and there was Allen Ginsberg. So I said: "Oh, you're taking the part of Allen Ginsberg?" And he said: "No, I am Allen Ginsberg." Gregory Corso was there, looking just like a gargoyle that had jumped off a building in France. Dick Bellamy was supposed to be my son. Walter Gutman financed it—G String Enterprises.

In the movie I played the organ, an old-fashioned organ that you

(above left) *Hubert Crehan.* 1961. Oil on canvas, 39 × 31¼". Collection the artist and/or family

(above right) *Milton Resnick and Pat Pasloff.* 1960. Oil on canvas, 46¼ × 28". Collection the artist and/or family

had to pump to make it play. I played Martin Luther's A Mighty
Fortress is Our God, *and this stimulated Larry Rivers to get out his
saxophone. The film was largely improvised. After that, Al Leslie and
Robert Frank wrote* The Hasty Papers: A One Shot Review, *which
included "A Statement" of mine:*

Being born I looked around and the world and its people terrified and fascinated
me. I was attracted by the morbid and excessive and everything connected with
death had a dark power over me. I was early taken to Sunday School where the tale
of Christ nailed to the cross would send me into violent weeping and I'd have to be
taken home. Also I remember a film they showed at the church of the horrors of
delirium tremens that quite unnerved me and prevented my sleeping for many
nights.

I decided to paint a human comedy—such as Balzac had done in literature. In
the 30's I painted the beat of those days—Joe Gould, Sam Putnam, Ken Fearing,
etc. I have painted "El Barrio" in Puerto Rican Harlem. I painted the neurotic, the
mad and the miserable. Also, I painted the others, including some squares. I once,
many light-years ago, married a Cuban and lived in Havana where I had my first
show. Then that all dissolved and in the thirties I was on the W.P.A. turning in a
painting every six weeks. I had a show at the Pinacotheca Gallery during the war
and later two shows at the A.C.A. Gallery. I never knew how to push myself and
still don't know how. Like Chichikov I am a collector of souls. Now some of my
subjects are beginning to die and they have an historic nostalgia, everyone seems
better and more important when they are dead. If I could I would make the world
happy, the wretched faces in the subway, sad and full of troubles, worry me. I also
hate the conformity of today—everything put into its box.—

When I go to a show today of modern work I feel that my world has been swept
away—and yet I do not think it can be so that the human creature will be forever
verboten. Thou shalt make no graven images.

*About 1963, some woman bought four or five pictures. She liked
my work very much, and a couple of years later, realizing what a
struggle it was for me, she began to help me financially for a while. So
this was the first time I really had security. She's a wonderful person.
She had money in her family and all she ever used the money for was
to help people. She and her husband were in Germany during the war.
They worked with the underground. They saved thousands of Jews
from the ovens.*

[Years later Neel told Cindy Nemser:]

I never want to work for hire because I don't want to do what will please a subject.
The persons themselves dictate to a certain extent the way they are done—if they
are very liberated people, I in turn feel very liberated and can paint them in a more
liberated way.[8]

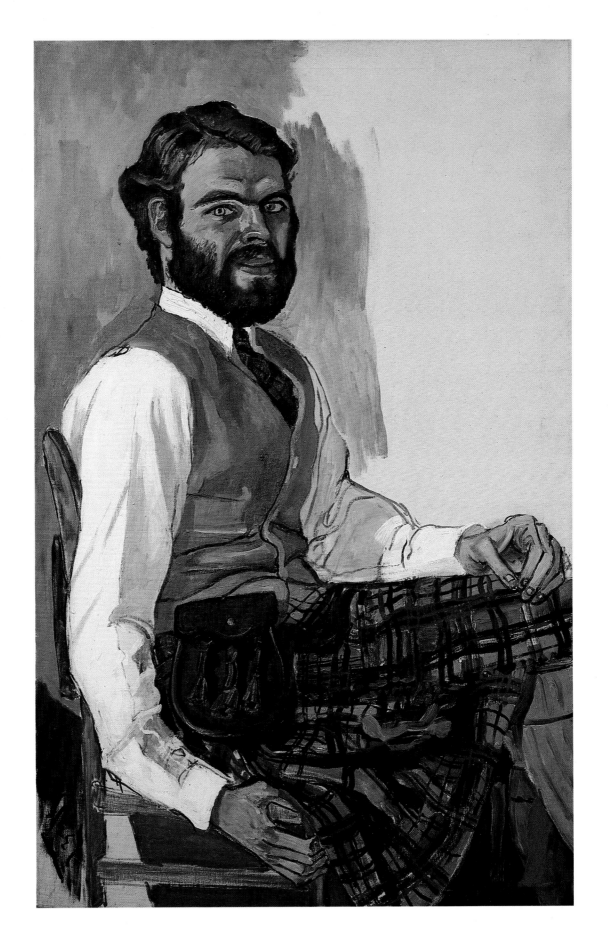

I once painted the portrait of the son of an old acquaintance of mine, who was now an actor but wants to be an artist. She didn't like it because of the nose. But you know I never change a nose because somebody doesn't like it. I just say, "Well, you don't like it, so that's it." And I put it on the shelf.

[The 1960s were years of increased productivity for Neel. In September, 1960, she had a solo exhibition at the Old Mill Gallery in Tinton Falls, New Jersey, organized by Geza De Vegh. She was included in an ACA group exhibition later in the fall. *Frank O'Hara* was reproduced in *Art News* in December, 1960. Besides the Reed College exhibition in Portland, Oregon, three Neel paintings were included in the exhibition *Figures*, held at the Kornblee Gallery from May 21 to June 15, 1962, and organized by Rael Gleitsman. The exhibition was responding to the Museum of Modern Art's exhibition *Recent Painting U.S.A.: The Figure*. The Kornblee show included many figure painters ignored by the Modern: Milton Avery, Nell Baline, Robert Beauchamp, John Button, Charles Cajori, Elaine de Kooning, Robert de Niro, Sherman Drexler, Paul Georges, Robert Goodnough, Ben Johnson, Lester Johnson, Alex Katz, Earl Kerkam, Fay Lansner, Marcia Marcus, Nicholas Marsicano, Philip Pearlstein, Fairfield Porter, Larry Rivers, and George Segal. Neel's entries were *Avedesian, Frank O'Hara*, and *Milton Resnick and Pat Pasloff*. Tom Hess reproduced *Avedesian* in *Art News*.]

Stewart Mott. 1961. Oil on canvas, 44 × 27". Collection the artist and/or family

Milton Resnick and Pat Pasloff was shown in the Kornblee Gallery. Pat Pasloff was so anti-figure that, although they told me she had been there, when I asked her: "Did you see yourself and Milton?" she said, "No, I hate figurative work and I would never go look at it." To me, middle America, Pat Pasloff was exotic. She looked like a Kabuki dancer. I would love to have looked like that. And Milton Resnick in his best clothes, going to Lee Krasner's show at the Pace Gallery. He's holding his overcoat like that Whistler fellow who's holding his wife's red cloak.

[Other important notices came to Neel in 1962. In the spring, Neel received the Longview Foundation Purchase Award from Dillard University in New Orleans. Tom Hess and Harold Rosenberg came to the apartment and told her they had chosen one of the portraits of Stewart Mott, which became part of the collection of the Dalhousie Institute in New Orleans. In June, 1962, Neel was included in the exhibition *Portraits*, held at the Zabriskie Gallery. In October, 1962, Hubert Crehan's article, "Introducing the Portraits of Alice Neel," was published in *Art News*. Crehan began the article:]

Anyone who would make a dogmatic claim that modern portrait painting is dead is in danger of having to seal his lips on this subject after seeing the paintings of Alice Neel.

There are revelations to be made in painting people today, and she makes them. There are risks to be taken in doing portraits, and she takes them. . . .

She paints portraits that come alive and that have style and meaning. She is

master of a technique which can reach high and convincing levels of expressiveness. She is a painter whose work has individual character. There is a place for this work. It is an achievement of portraiture in our time and I have no doubt that it will come to be recognized for its rightful value.

[Other changes occurred to Neel in these early years of the 1960s. In September, 1962, she moved to 300 West 107th Street, where she still lives. In October, 1963, she had the first of many exhibitions at the Graham Gallery on Madison Avenue. Many others followed there.

The portraits of writers, artists, and collectors connected with the New York art world and done in the 1960s include *Max White, 1961, Robert Smithson, 1962, Ellie Poindexter, 1962, David Rosenberg, 1962, Bill Seitz, 1963, Jerry Sokol, 1964, Walter Gutman, 1965, Lida Moser, 1966, Red Grooms and Mimi Gross, 1967, Charlotte Willard, 1967, Henry Geldzahler, 1967, Arthur Bullowa, 1967, Eddie Johnson, 1968,* and *Jerry Malanga, 1969.*

An important review was Jack Kroll's article, "A Curator of Souls," published in *Newsweek,* January 31, 1966:]

The good painter must depict two principal things," said Leonardo da Vinci, "man, and the concept of his mind." Modern artists are exhaustively depicting the latter while largely ignoring the former. Outside of professional portraitists, who provide a service rather than create art, the portrait has almost disappeared among serious contemporary painters. Instead, the camera and photojournalism provide those quick-frozen images which tell moderns what they look like in the spasmodic rhythms of their lives.

Arthur Bullowa. 1967. Oil on canvas, 50 × 33″. Collection Arthur M. Bullowa, New York City

In this situation, portraitist Alice Neel is like an old pagan priestess somehow overlooked in the triumph of a new religion. Indeed, with her shrewdly cherubic face, her witty and wizard eyes, she has the mischievous look of a maternal witch whose only harm lies in her compulsion to tell the truth. . . . Neel's painted truths have made her magnificently unfashionable in the art marts, and the most powerfully original portrait painter of her time.

Neel's new show at New York's Graham Gallery makes an extraordinary impression. The walls are alive with people—not "real people," but art-people, humans caught in the torrid, temperate and frigid zones of their passage through the human span. "It smells of mortality," says Shakespeare's Lear of his own flesh, and Alice Neel's portraits strike all the senses with the superbly scary impact of mortality. She is uncanny at bodying forth the history of compromise, surrender and curdled victory that is written in the flesh of human beings.

Her "Human Comedy," as she calls it, is thus a symphony of victimizations—except for children, whom she paints masterfully in their wary sweetness. Here are bitter kids from Spanish Harlem, slightly hysterical, cozily shrill ladies, millionaire art collectors wearing luck like cologne. She is wonderful with Negroes, capturing the condensed rainbow of color hidden in their flesh—here is Abdul [Rahman], a cabdriver and Black Muslim, amused by his own charade of kingliness in fez and robe; and former CORE director James Farmer, tight, controlled, efficient, with the thoughtful anger of the professional problem solver.

Neel is the heir of the European expressionist painters who saw modern man distorted by unnamable demons. But the weather in her world is not depressing; it shows deep affection for the hard work the ego must do to find reasons for comfort and self-love.

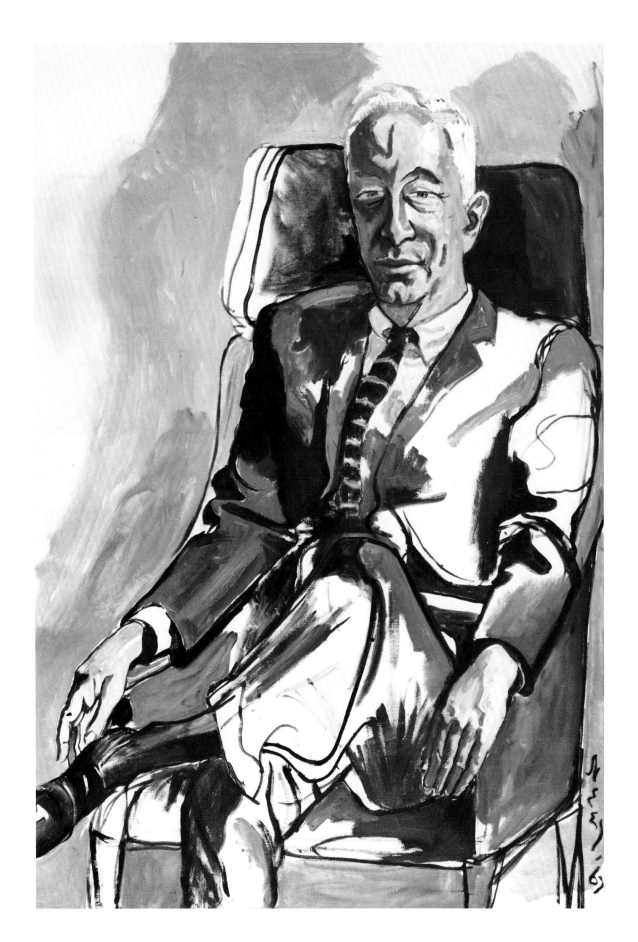

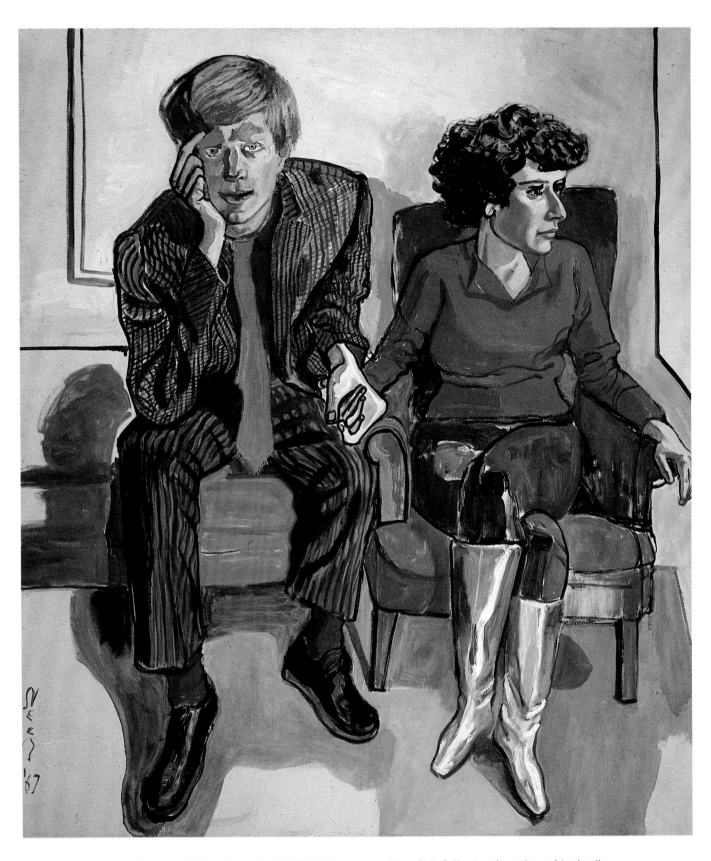

Red Grooms and Mimi Gross, No. 2. 1967. Oil on canvas, 60 × 50″. Collection the artist and/or family

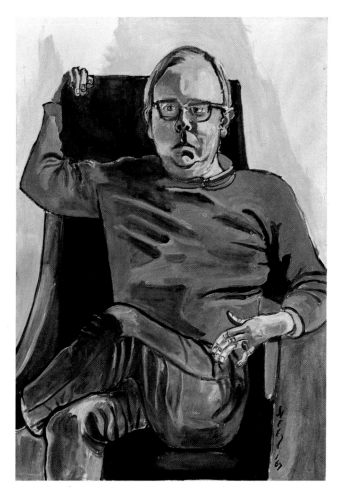

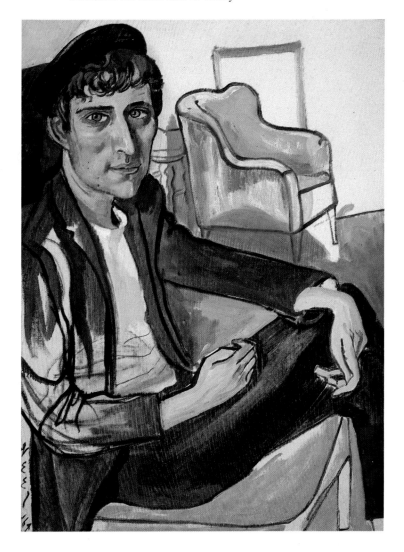

Jerry Sokol, No. 1. 1964. Oil on canvas, 40 × 30″.
Collection the artist and/or family

Henry Geldzahler. 1967. Oil on canvas, 50 × 34″.
The Metropolitan Museum of Art, New York City

I used to go to avant-garde openings and I would always see two artists there: Robert Smithson, "the wolf boy," and Edward Avedesian, "angel face." I remember when Sidney Janis had a place on the ground floor on 57th Street, and when you opened a refrigerator door a siren would scream out.

Robert Smithson in 1962 was completely unknown and he used to come to shows I would have. Then he posed for me. He had acne, which for me was just an interesting surface, but he was very angry when he saw the painting, and made me take some of the blood off his cheek. Another day I went to see him in his studio where he was making papier-mâché Christs all covered with blood. "Why Robert," I said, "you wouldn't let me have even a little blood and look how much blood these Christs have."

Then I didn't see him for several years and when I did, he was much fatter. I said: "Oh, Robert, you're so fat." "Success, dear, success!" he replied.

When Hartley came at Christmas I was just finishing the painting of Walter Gutman. I had seen him coming into the Martha Jackson Gallery two years before, so when he finally posed in 1965 I knew exactly how I would paint him. He was "the bulls and bears market." He brought his family to look at the painting, but it was too much for them. It is really a museum piece. When I give my slide lecture, I show Madison-Avenue money in the painting I did of Timothy Collins, who looks like a warrior, but a warrior who only operates in the money market, and then Walter Gutman, the old-fashioned money market.

In the 1960s, Robert Lowell came into the Graham Gallery one day and saw the painting of Kenneth Fearing reproduced on the cover of Masses and Mainstream, *a little left-wing magazine. Robert Lowell said to me: "If you'll paint me, I'll give you a manuscript for it." I said that would be fine. He was in an excited state and went downstairs where James Graham had a floor with quite a few statues, and he bought Tecumseh, a classical head of an American Indian done in Rome. The only interesting thing about it was the necklace of bear's teeth.*

The Gallery delivered it to them. His wife, Elizabeth Hardwick, called several days later and said Robert Lowell had gone to the mental hospital for a month or so and that they could not afford the Tecumseh bust. The Gallery took it back and only charged them for delivering it. She also told them that ever so often Lowell got upset, pursued other women, and then would go to the hospital for several months. She called me and said he couldn't pose for several months, but she wanted to come to see me.

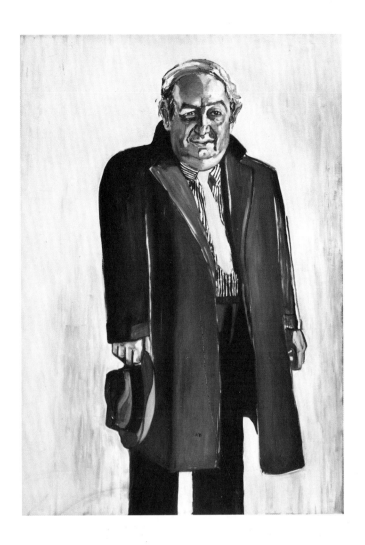

Walter Gutman. 1965. Oil on canvas, 60 × 40″. Collection the artist and/or family

When Gutman came, I remembered exactly the composition I wanted: holding his hat that looks as if he sat on it at night. He was very fond of lady wrestlers, and to amuse him while he posed I stood up a painting of a girl named Marion— an Irish girl, very free, with fat legs and boots, looking arrogant, and with bad teeth in front; he never tired of looking at it.

At my studio she saw the painting of Sam Putnam and wanted to buy it, but then said she could not afford that much, although I made it very cheap. Could she rent it? I rented it to her for $50 for three months. After about six weeks, she brought it back and said: "We don't think any man who was such a great translator could look like that." And I said: "But you never saw him, but I did." I knew him very well; he was always drunk and looked exactly like that. I never received any of the rent.

Needless to say, I never painted Robert Lowell. Hardwick got into the Academy and Institute of Arts and Letters about three or four years after I did, and I saw her there after Lowell had died. She said she was sorry I hadn't painted him.

[Another group of figures that Neel painted in the 1960s were blacks active in the Civil Rights movement, such as James Farmer and Abdul Rahman.]

James Farmer was born with a neat ankle and he was well dressed as the head of CORE, but my picture is more true because he was marching in Mississippi and he almost was killed one day. My picture is full of anger.

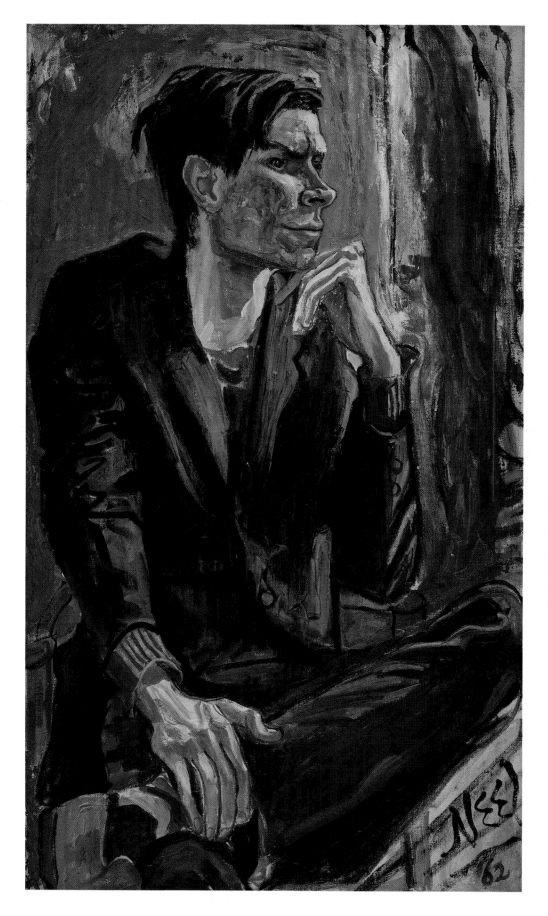

Robert Smithson. 1962. Oil on canvas, 40 × 24½″. Collection the artist and/or family

(opposite) *Ellie Poindexter.* 1962. Oil on canvas, 30 × 24″. Collection the artist and/or family

Ellie Poindexter came to see me. I had just moved into my new apartment on West 107th Street, and those black things are cars out the window. Ellie looks like a snake and her fur also looks like a snake. I did this from memory after she had left.

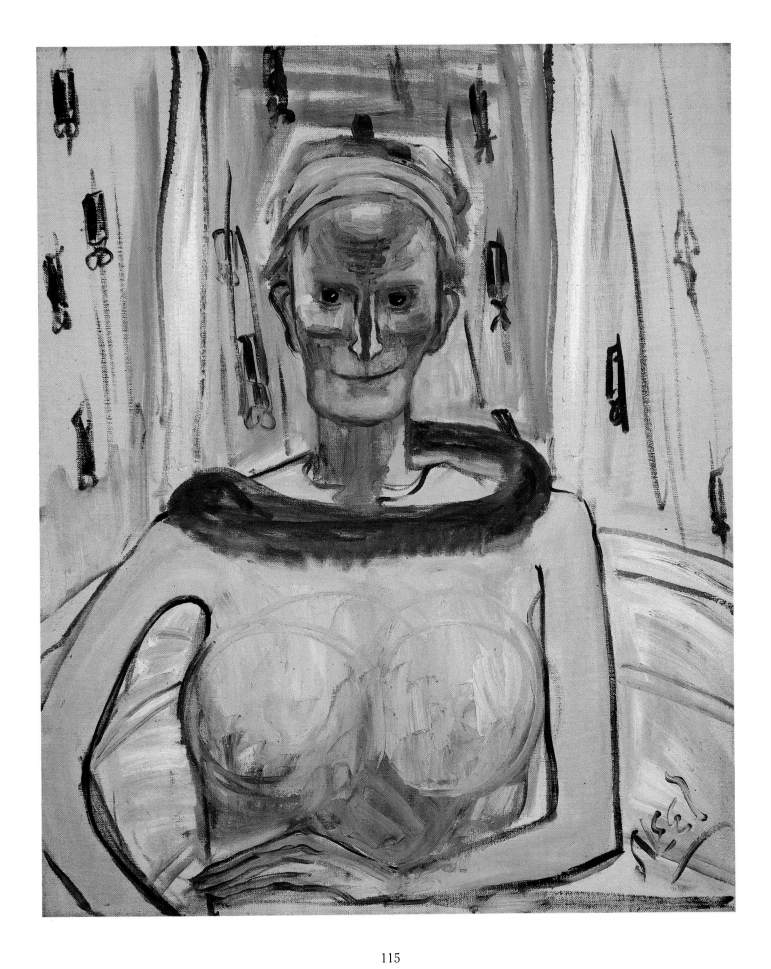

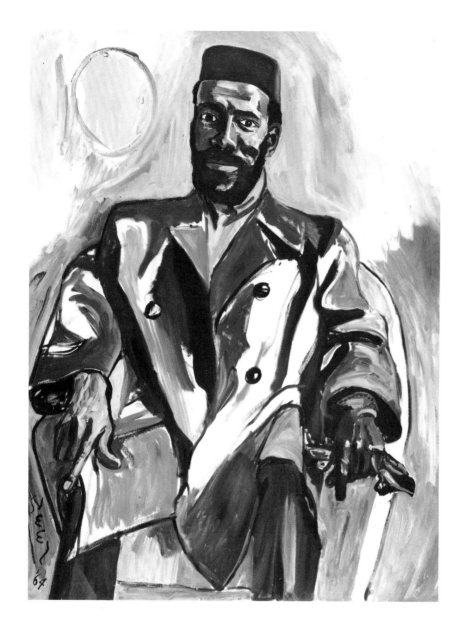

Abdul Rahman. 1964. Oil on canvas, 46 × 34″. Collection the artist and/or family

(opposite) *Linus Pauling.* 1969. Oil on canvas, 50 × 36″. Collection the artist and/or family

Abdul Rahman was a taxi driver who came and posed for me. The American Federation of Arts sent my painting of him around the country in 1964–65. It was called Cab Driver. *He is a different Negro. I have studies of the Negro people, like those little girls, being overpowered. This man is not frightened. He is a nationalist, a black nationalist, even though there's a certain hysteria about him. Do you see that gauntlet that's like what royalty had? The circle next to his head was really the rising sun of Africa, but it looks like the number ten. I just liked it there.*

[Neel's gallery includes scientists, such as Linus Pauling, as well as her two sons and their friends, Julie Hall, Sol Alkaitis, Priscilla Johnson, the "Wellesley girls," and Nancy Greene, who married Richard in December, 1963,

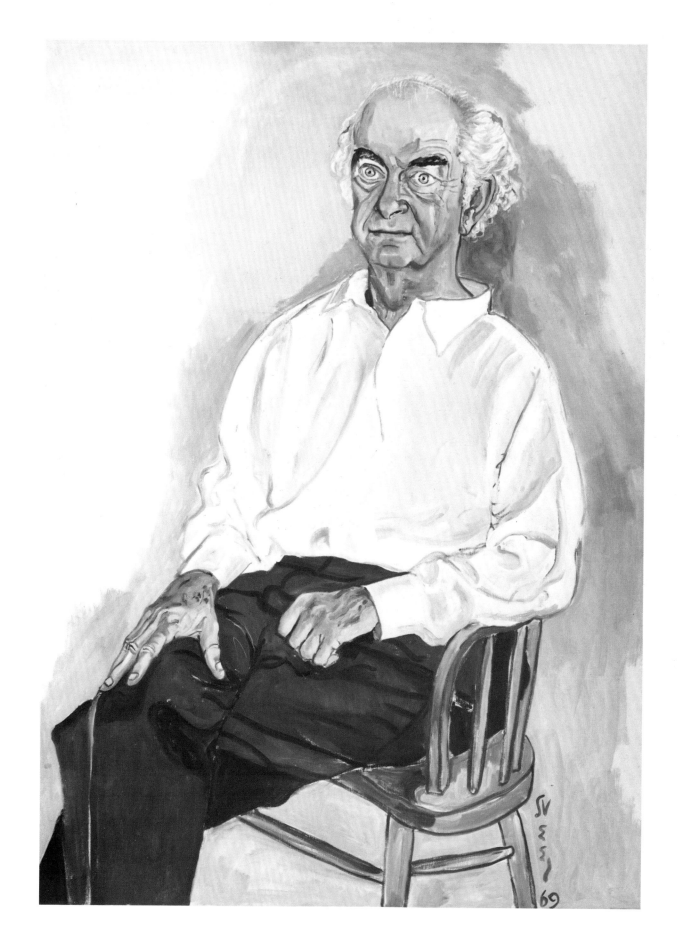

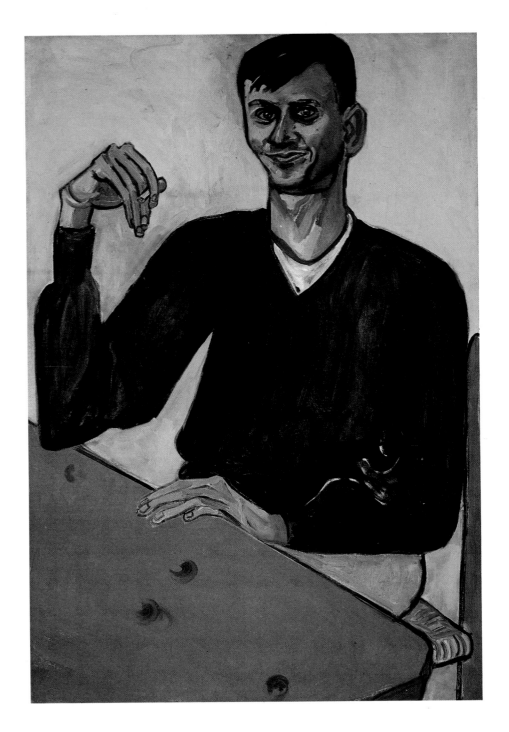

Sol Alkaitis. 1965. Oil on canvas, 40 × 27". Collection the artist and/or family

while he was still in law school. Yet Neel also found room for a West Side personality, the Fuller Brush man.]

He was Jewish and he had been in Dachau. Those things in his pocket are prizes for buying some of his brushes. He was a wonderful salesman on the Upper West Side. I went to Europe once, and then my conscience bothered me when I got to Austria. So I thought all these museums and everything . . . I'll go to Dachau. So I went to Dachau— frightful, you know, frightful. And the smoke from flesh that's burning

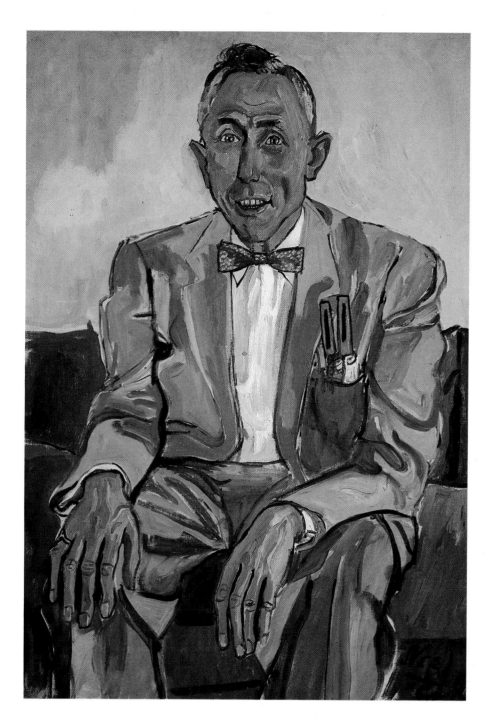

Fuller Brush Man. 1965. Oil on canvas, 40 × 27″. Collection the artist and/or family

is always yellowish, different from other smoke. Everybody must have known. But there were guards sitting up there, and if anybody escaped, they just shot them. And I showed the Fuller Brush man a photograph of the sculpture there of a prisoner with an old tattered overcoat. He said: "What nonsense! We never had overcoats; we never had anything but those thin striped suits." And then he couldn't talk anymore about it. He said he had to make twenty-five sales a day for Fuller Brush or lose his job. But he was so happy to be in America.

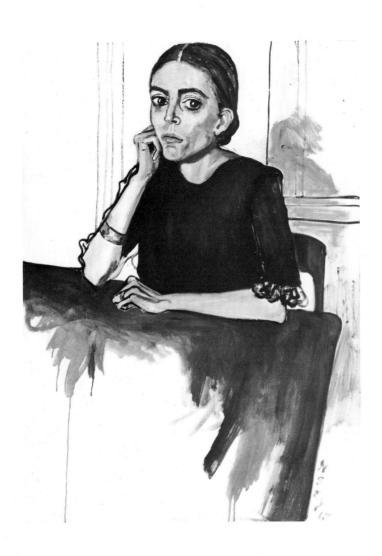

Portrait of Julie. 1967. Oil on canvas, 42 × 29½″. Collection the artist and/or family

Pregnant Maria. 1964. Oil on canvas, 32 × 47″. Collection the artist and/or family, courtesy Robert Miller Gallery, New York City

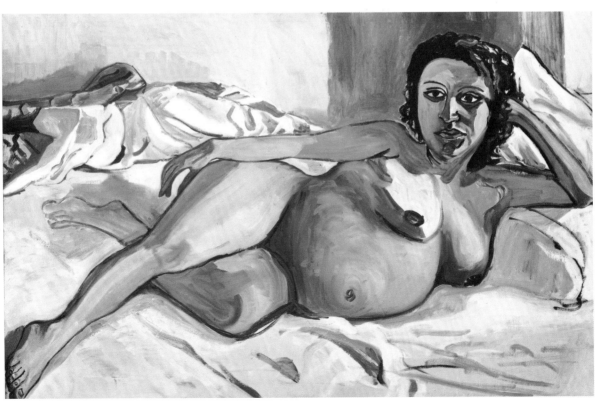

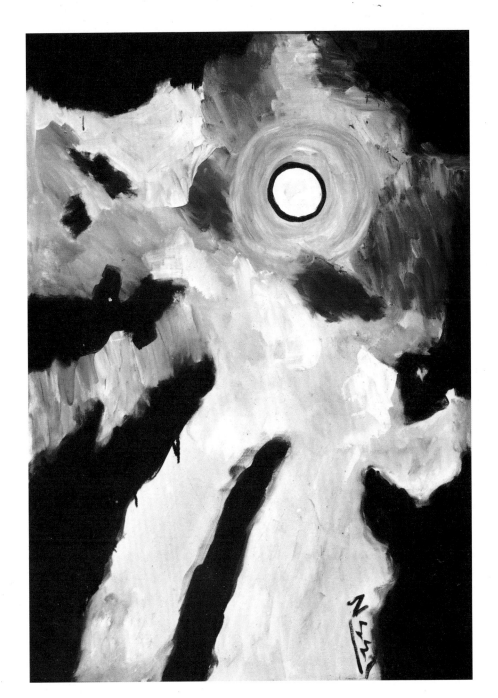

Eclipse. 1964. Oil on canvas, 46 × 31″. Collection the artist and/or family, courtesy Robert Miller Gallery, New York City

I took a trip to Europe with Hartley in 1965. I remember Van Gogh and the man who painted flowers and groups of people—Fantin-Latour—at the Orangerie. I also saw the Prado with Velázquez and Goya, and El Greco's home in Toledo. I wish I could have painted that landscape in Toledo.

Before I left for Europe I saw a show of Giacometti in New York, and in London another show. When I reached Florence, I saw the great David of Michelangelo, and wondered what had happened to humanity that in four hundred years man had become an alienated and lost wretch.

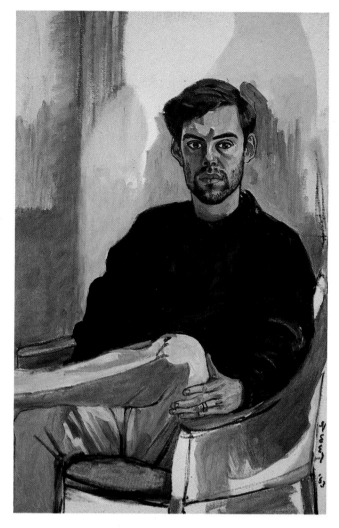

Richard. 1963. Oil on canvas, 50 × 34″. Collection the artist and/or family

Richard was in Law School at Columbia and taking finals. They never shaved because they were studying so hard. This painting hung in the Penthouse of the Museum of Modern Art in 1963, and a lady coming out of the elevator said: "Well, Richard, you need a shave."

Hartley. 1965. Oil on canvas, 50 × 36″. Collection the artist and/or family

Hartley was studying medicine at Tufts in Boston, and he visited me at Christmas, 1965. He told me he could not bear dissecting a corpse and that he would have to leave. He was already a chemist, but wanted to be a doctor. There is death in this painting. Also, his forehead had never looked like this, and the woman at whose home he had a small apartment said he looked gray when he came back.

This was also the time of the Vietnam war and many American boys were dying, plus the horror of the napalmed Vietnamese. He told me he couldn't see a corpse as a thing, as some of the other students could. He was twenty-five and was in a trap, but finally decided to go back to Tufts.

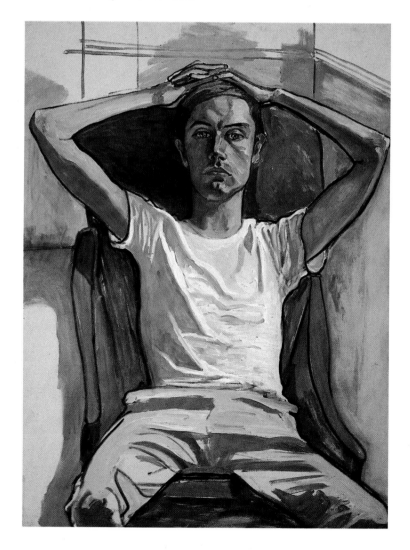

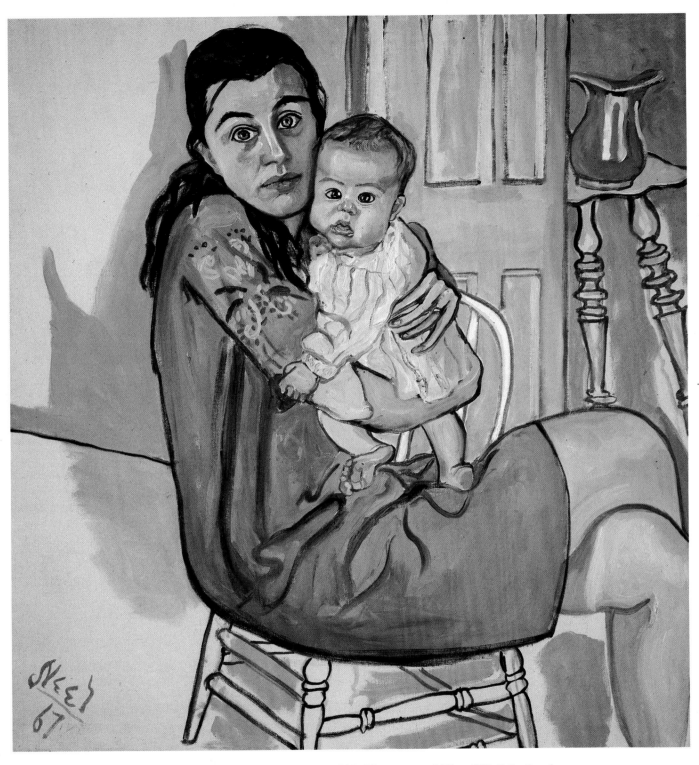

Mother and Child (Nancy and Olivia). 1967. Oil on canvas, 39¼ × 36″. Collection the artist and/or family

Olivia was three months old and Nancy looks afraid because this was her first child. Olivia was very active. I painted this in the country on a rainy day in 1967.

In the mid-1960s I did have a class that I taught in someone's studio twice a week, at night. I made a couple of men into artists. I painted Frank Gentile, 1965, in that class. In the early 1970s, they offered me the job of Artist in Residence at Amherst, which I turned down. I hate to teach. About 1977, Sarah Lawrence offered me a job teaching. I still didn't want to do it. Teaching changes the focus. You begin by thinking what to say to your students. You have to be a psychologist. I don't want to have to think about that. I want to think what I am going to paint, what importance it has to life, what the days are.

I hate to bring up details in times like these, because times like these, with their nuclear threat, make it all seem so trivial.

[During the late 1960s and early 1970s, Neel contributed art to exhibitions in support of the anti-Vietnam war movement. And she picketed the Museum of Modern Art at the time of the Attica Prison riots, carrying a placard that read: "Rockefeller calls the shots at Attica and at the Museum of Modern Art."]

I did a poster for an anti-war exhibition. It was a brand-new canvas, 40 by 30 inches, using collage. McNamara used to put it in

(above left) *Olivia, One Year.* 1968. Pencil on paper, 13 × 9″. Collection the artist and/or family

(above right) *David.* 1962. Ink on canvas, 17½ × 14½″. Collection the artist and/or family

(opposite) *Plant in Window.* 1964. Oil on canvas, 60 × 36″. Collection the artist and/or family

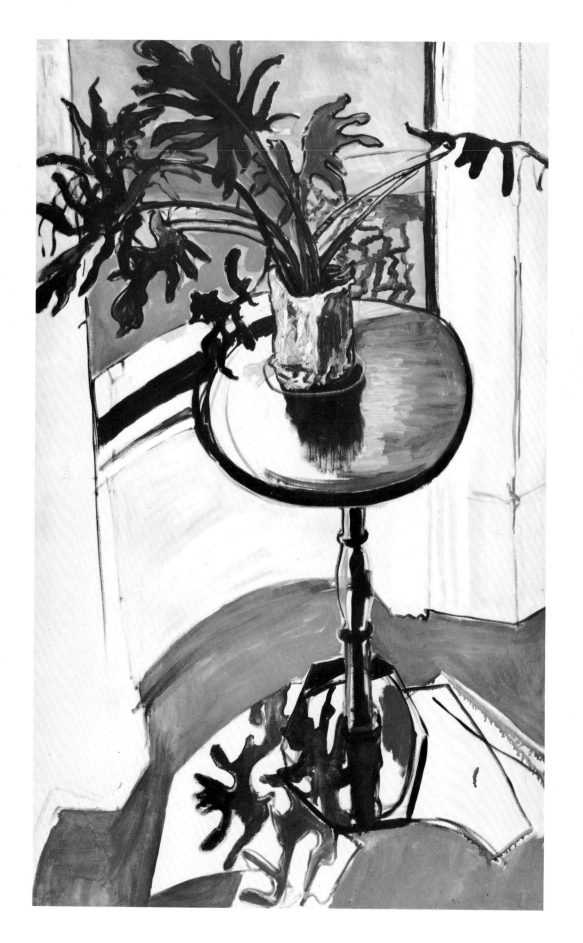

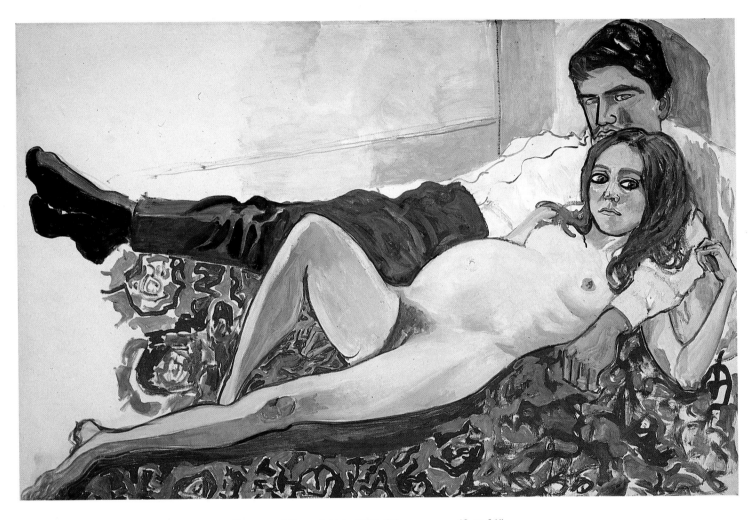

Pregnant Julie and Algis. 1967. Oil on canvas, 42 × 64".
Collection Arthur M. Bullowa, New York City

I had a show at the Maxwell Gallery in San Francisco in June, 1967. It lasted a month and Hartley, who had come with me, and I stayed at friends of his in Berkeley where this painting was done. Late in the afternoons, from four until seven, the light in Berkeley is just marvelous. And that's when I did this. It was the fashion to have the mattress on the floor. Julie was pregnant, and one of the things I liked about the composition was the heads above each other and also the scissor-shape legs. In 1968, it was reproduced on the front page of The Village Voice.

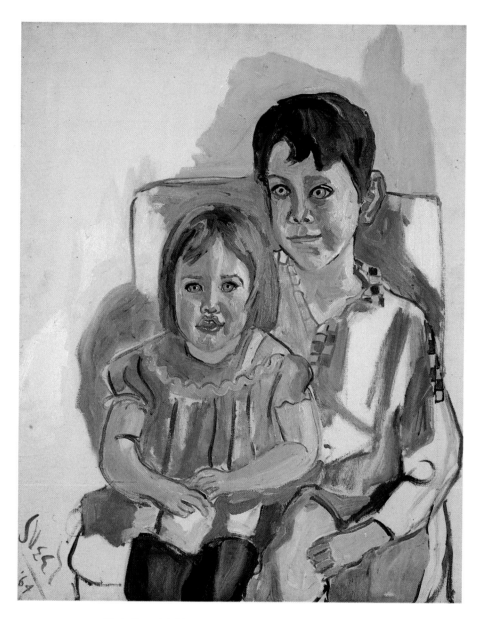

Abe's Grandchildren. 1964. Oil on canvas, 32 × 25″.
Collection the artist and/or family

*After the Depression, Abe became a taxi driver. He
was a Communist and, on the WPA project, was always
making trouble. His daughter was a doctor and had
several husbands—these were children of two of them.
Abe wanted to give his daughter a picture of the
children, but didn't like this painting. I loved it. The little
girl is less than two and the boy is four. I did another
more ordinary one of them, and Abe bought it. He had
been a Wobbly, and then a fur worker, and when he
was a fur worker he gave one day's pay a week to the
Communist Party. He used to sing a song: "There's not
a hair on the bald head of Jesus."*

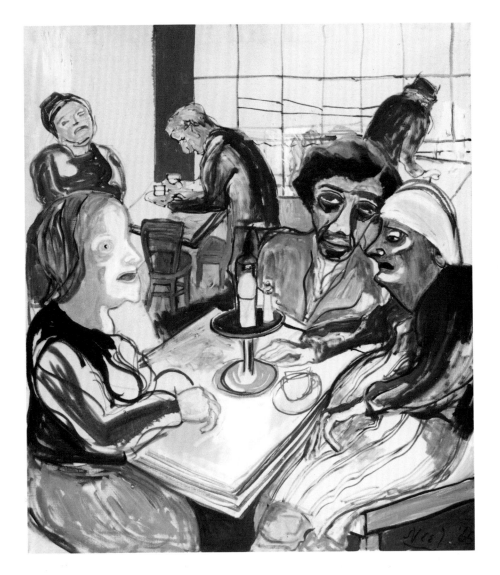

*dollars and cents how much it cost to kill the Vietnamese. It became a
purely financial, economic thing.*

I also did a drawing of Che Guevara. Ramparts *magazine did that
terrific article on Che. The Green Berets murdered him. They
discovered something that could tell human presence apart from
animal presence, so they found out where he was in Bolivia. And when
the interrogator questioned him, he said something insulting to Che.
Che slapped his face, so the interrogator just took out his revolver and
killed him. You don't do that to a prisoner of war, but they wanted him
dead. They cut his hand off and sent it to his family to prove that they
had killed him.*

*You know what's amazing? The Republican Convention or the
Democratic Convention. To think of Allen Ginsberg, William
Burroughs, and Jean Genet as being the healthy people. Like Goya bats*

flying over the city, yet they are the healthy ones. They are the heroes. You know, Mayor Daley was the monster, beating up people. People won't accept the revolutionary quality of people unless those people are perfect. But that's nonsense. It's not perfect people that make a revolution. It's just people that see the necessity for it. Mike Gold used to say so.

You know why I love Genet, that filthy character? Because everything that happened he turned into literature. It couldn't be too base for him to make great literature out of it. He was a genius, no matter what happened. For instance, he said the shame that he felt when the judge had the jar of vaseline on the desk in front of him—he really loved that shame. You see, this is what he used in his homosexual peregrinations.

I don't know Genet, but I read a little bit of him, so I do know him in a way. In the book Our Lady of the Flowers, there is a beautiful young man. When he raves about a man, it's just like a woman raving about a man she loves, about his arms on a motorcycle bar and everything. They take him to court because he has killed an old man. And Genet sits in the court just adoring him, talking about how handsome and beautiful he is. And then, finally, after all the evidence, the judge says to him: "Now it's your turn to testify." Our Lady of the Flowers said: "Your honor, he couldn't get a hard-on." That to me is pure genius, to have Genet worship him. Because it shows a realistic crude character. He admires shoplifters, thieves, and traitors. I hate to tell you—in Africa I loved hyenas. They appealed to me more than lions. They're very weak and slinky and horrible, and their backs slope down.

Ginny. 1969. Oil on canvas, 60 × 40″. Collection the artist and/or family

[In 1969 Neel traveled with John Rothschild to Russia as guests of Intourist. Several American travel agents, who had arranged trips to Russia in the 1930s, before Russia was formally recognized by the United States, were invited with all expenses paid.]

John's travel bureau was a pioneering travel bureau. But all he wanted really was acclaim for it. When I met him in the 1930s, we used to go to dinners at the Russian Consulate. I remember seeing Margaret Bourke-White's photography there. He was then sending trips to Russia through Intourist.

John was a perfect travel agent. He had seven secretaries and he had a magnificent office with cork floors. And he did good things in his travel bureau. But I told him before he died: "I don't give a damn whether the middle class sees Africa." However, I did a great portrait of Kanuthia, who was one of his business associates.

130

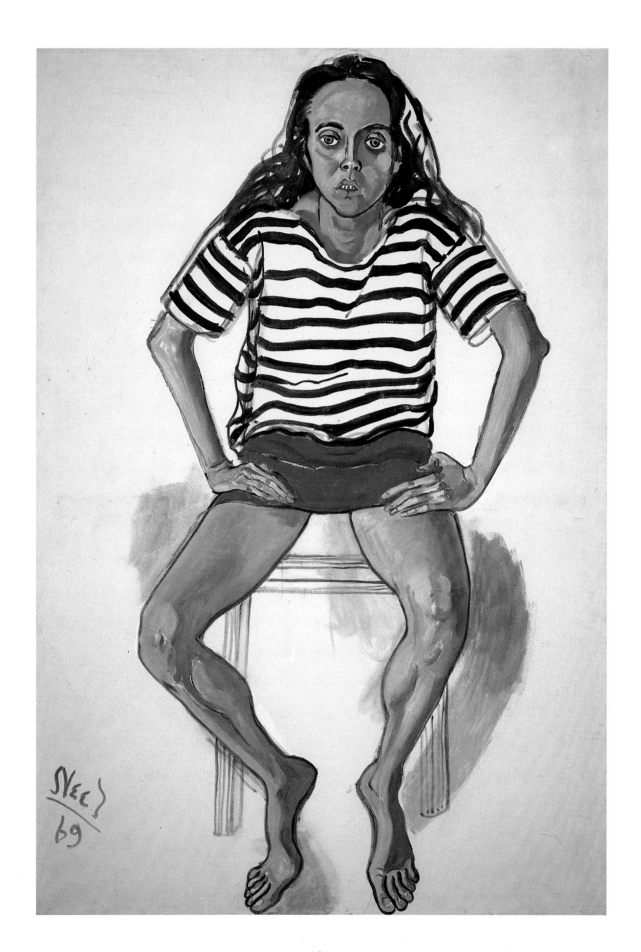

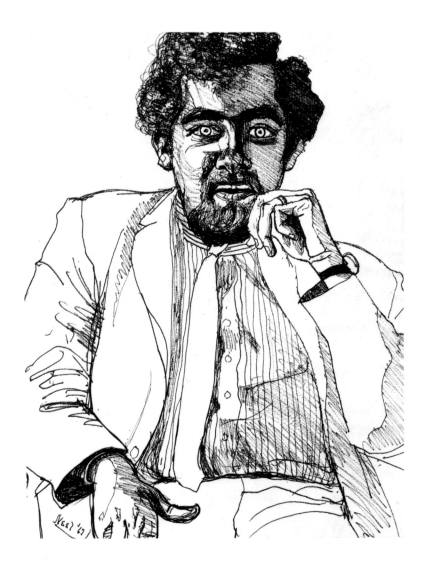

Peter Homitzky. 1967. Ink on paper, 30 × 22½". Private collection

(opposite) *Pregnant Betty Homitzky.* 1968. Oil on canvas, 60 × 36". Collection the artist and/or family

In 1970 or 1971, John took a room in my apartment. I wouldn't let him take over my apartment because it was really my studio. He just wanted to bring in little tables and bourgeois it. He died in April, 1975.

[In 1971 Neel's alma mater, Moore College of Art, formerly the Philadelphia School of Design for Women, gave her a retrospective exhibition and, in the spring, awarded her an Honorary Doctorate of Fine Arts. Neel's doctoral address ranged over many topics, but the state of art in the world and the situation of women artists dominated. Here are some excerpts from it:]

This is a great era of change and it is very exciting to be an artist—even with the terrible things that are going on, such as the war in Vietnam and the fact that society is almost in a state of chaos. In reviewing the International Show in New Delhi, a critic refers to the American Section which was devoted to examples of the currently moribund minimal-conceptual esthetic debacle, and tells how many Indian artists found the American exhibit insulting and withdrew their work. Things move so fast today that before a movement dies the next movement is already felt. . . .

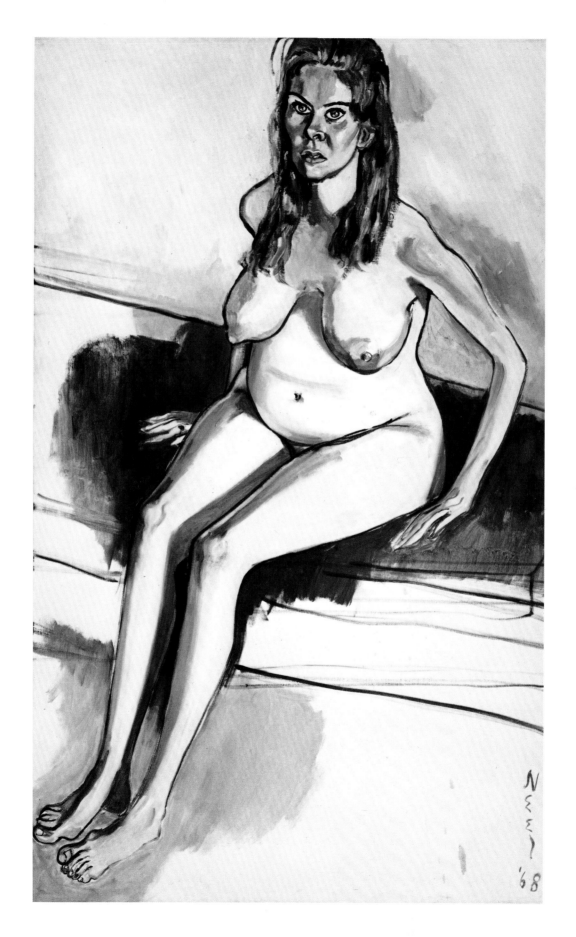

Destruction and bitter criticism are a reflection of the overall picture. However, great attention is being paid to art and the artist is being lifted out of his idiosyncratic alienation (witness me) and all society is taking an interest in him. Giacometti is a tale of what was and the great Picasso reviewing all art and presenting it with a destructive virtuosity is perhaps the end of an era.

The women's lib movement is giving the women the right to openly practice what I had to do in an underground way. I have always believed that women should resent and refuse to accept all the gratuitous insults that men impose upon them. The woman artist is especially vulnerable and could be robbed of her confidence.

There is a great play by Athol Fugard, an African, called *Boesman and Lena*. The hero is played by James Earl Jones and Lena by Ruby Dee. After James Earl Jones starred in *The Great White Hope* on Broadway he deliberately chose to play this story of life in South Africa at an off-Broadway theater. In this play he is the voice of the most oppressed and crushed. Boesman completely deprived by the white man, with all his worldly goods on his back and the back of his wife Lena, takes it out on her. It is a great play of today. An interesting footnote: Athol Fugard was not permitted by his government to come to America for the opening of his play.

I have only become really known in the sixties because before I could not defend myself. I read a quote from Simone de Beauvoir saying that no woman had ever had a world view because she had always lived in a man's world. For me this was not true. I do not think the world up to now should be given to the men only. No matter what the rules are, when one is painting one creates one's own world. Injustice has no sex and one of the primary motives of my work was to reveal the inequalities and pressures as shown in the psychology of the people I painted. It is not for nothing that Samuel Beckett won the Nobel Prize. His world view, encapsulated capitalism, carries the theory of dog eat dog to its ultimate outpost.

Kanuthia. 1973. Oil on canvas, 40 × 30″. Collection the artist and/or family

When El Greco and Raphael painted, religion was powerful and the great art was done in relation to faith and the church. A Campbell's soup can has supplanted Christ on the cross. Money is king and advertising and technology religion for the arts, and now complete destruction and anti-art. In *The Village Voice* an artist offered as his work the fact that he thought blue all day. This destruction also relates to a desire to destroy the market place and the art combines—nothing to buy or sell is the slogan.

My choices perhaps were not always conscious, but I have felt that people's images reflect the era in a way that nothing else could. When portraits are good art they reflect the culture, the time and many other things. I once saw a print of a portrait of Commodore Perry who commanded the fleet that brought about "the Open Door Policy" in Japan in 1854, done by a Japanese artist. It resembles Perry but was seen and executed in an entirely Japanese manner. (By the way, Perry received $20,000 as a reward for intimidating Japan.) The great portrait by Goya of the Duke of Wellington is a super Englishman and hero seen through the eyes of a Spaniard who admired him as the conqueror of Napoleon who had committed so many crimes in Spain. Crimes that Goya did great etchings of in his series, "The Disasters of War." This by the way is evidence that the artist can be socially committed without lowering his level.

Never has prejudice of all sorts come under attack as it has today. There is a new freedom for women to be themselves, to find out what they really are. Freud's

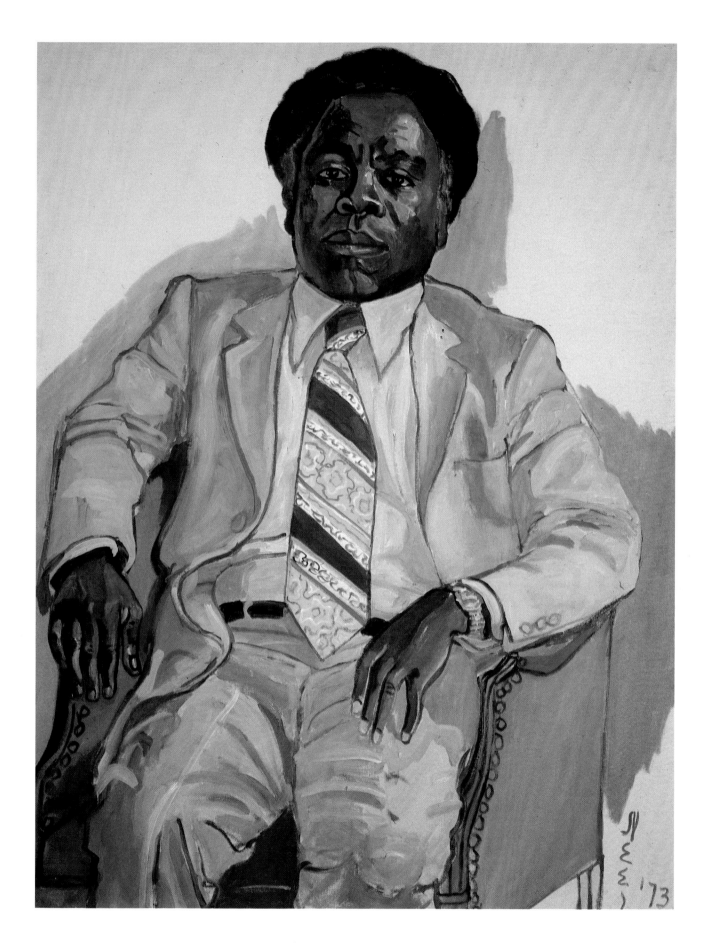

"What do they want?" is easy to answer. They know what they do not want, but just as the slave can only dream of what he will have after freedom, which he knows he wants, women must first be free and live and discover what they want. The March edition of *Harper's* has a great article on women's lib by Norman Mailer, seen from the male point of view, and then there is the book *Sexual Politics* by Kate Millet presenting the case for women.

As to the role of the museum. Nothing could be more important than that one's work be shown. In 1963 I painted Bill Seitz when he was still curator of The Museum of Modern Art. He would disclaim any influence on the art world by saying "we just reach out there"—I told him that what he hung on his walls in turn had a great influence and became sanctified. In the portrait there is an arm resting on its elbow with a completely non-committed hand doing nothing which was my way of presenting his attitude. I'll admit this is rather subtle, and picketing is much more effective. The human image for many years was not considered important. In 1962 when the Museum of Modern Art had its *Recent Painting U.S.A.: The Figure* show I went to a symposium there (all men, by the way) and none of the speakers really connected with the kernel of the subject.

[Invited to exhibit in the Whitney Museum of American Art Annual in 1972, Neel showed *The Family (John Gruen, Jane Wilson and Julia)*. Artists had for years been suggesting to the Whitney Museum's curatorial staff that Neel be given an exhibition. In 1973, John I. H. Baur, by then Director of the Whitney, and I, then Associate Curator for 18th- and 19th-Century Art at the Whitney, went to Neel's studio and discussed the idea of a show of her work. The following year, from February 7 to March 17, 1974, she had her first major museum retrospective of fifty-eight paintings covering the second floor of the Whitney, organized by Elke Morger Solomon.]

I was delighted to have the Whitney show. It covered five decades of figure work. Jack Baur wanted to give me the credit for having preserved the figure when the whole world was against it.

[Another retrospective, with a major catalogue, *Alice Neel: The Woman and Her Work*, was organized by William D. Paul, Jr. for the Georgia Museum of Art in Athens, Georgia, from September 7 to October 19, 1975. He showed not only figural works but also the whole range of Neel's painting, including still life and landscape. Besides Paul's preface, Cindy Nemser, Dorothy Pearlstein, and Raphael Soyer contributed essays and statements, and John I. H. Baur submitted a witty poem. Neel's Moore College of Art doctoral address was published in full.

During the decade, she had solo exhibitions across the country at museums, galleries, and colleges, where she often gave slide lectures. She continued to have exhibitions at the Graham Gallery in 1970, 1974, 1976, 1977, 1978, 1979, 1980, and 1981. In 1982, the Robert Miller Gallery had an exhibition of her still-life and landscape paintings.]

I gave a lecture at Harvard in 1979, and the President of Harvard, Derek Bok, sent me a gold star for giving the best lecture on art. He also showed the film by Nancy Baer.

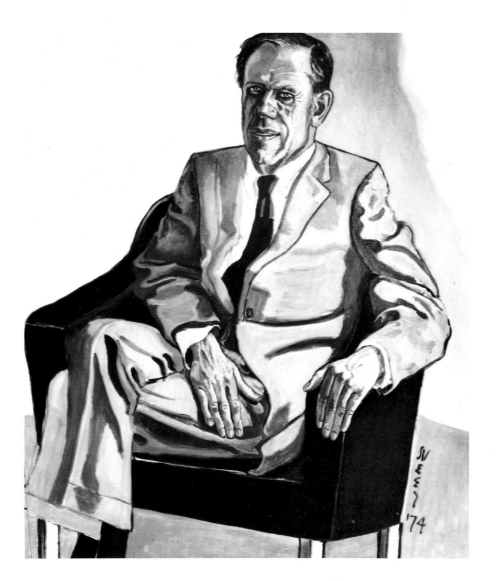

Jack Baur. 1974. Oil on canvas, 45½ × 38″. Collection the artist and/or family

[During the 1970s and continuing into the 1980s, Neel's paintings of art-world people are her largest category of portraits, including: *Andy Warhol*, 1970, *Benny and Mary Ellen Andrews*, 1972, *Duane Hanson*, 1972, *June Blum*, 1972, *Vera Beckerhoff*, 1972, *Marxist Girl, Irene Peslikis*, 1972, *Stephen Brown*, 1973, *The Soyer Brothers*, 1973, *Isabel Bishop*, 1974, *Dorothy Gillespie*, 1975, *Aryomni*, 1976, *Sari Dienes*, 1976, *Faith Ringgold*, 1977, *Geoffrey Hendricks and Brian*, 1978, *Michel Auder*, 1980, and *Marisol*, 1981.

Others in or on the periphery of the art world include art historians, critics, dealers, collectors and their families, including: *Jackie Curtis and Rita Red*, 1970, *David Bourdon and Gregory Battcock*, 1970, *The Family (John Gruen, Jane Wilson and Julia)*, 1970, *Timothy Collins*, 1971, *Jackie as a Boy*, 1972, *John Perreault*, 1972, *Linda Nochlin and Daisy*, 1973, *Dorothy Pearlstein*, 1973, *Jack Baur*, 1974, *The De Vegh Twins*, 1975, *Mary Beebe*, 1975, *Cindy Nemser and Chuck*, 1975, *Ellen Johnson*, 1976, *Ann Sutherland Harris and Neil*, 1976, *Henry and Sally Hope*, 1977, *Tom Freudenheim*, 1979, *Florio*, 1978, *Betsy Miller*, 1978, and *Richard Lang*. Music-world people include: *Virgil Thomson*, 1971, *David Soyer*, 1979, and *Jack Beeson*, 1980.]

137

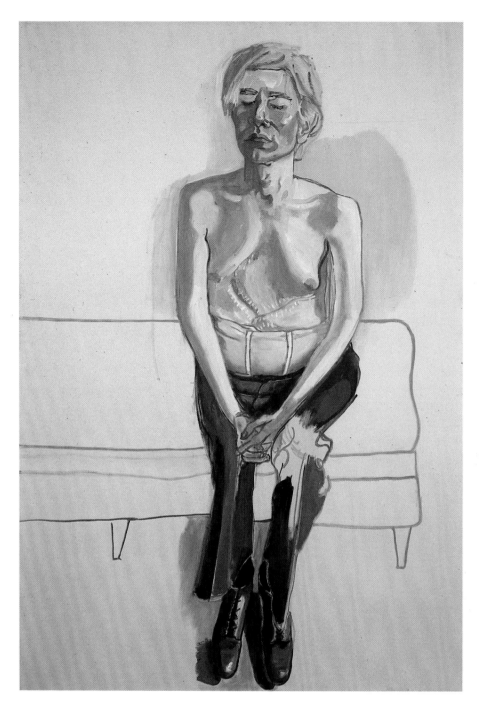

(opposite) *Duane Hanson.* 1972. Oil on canvas, 66 × 40″. Collection the artist and/or family

Andy Warhol. 1970. Oil on canvas, 60 × 40″. Collection Whitney Museum of American Art, New York City. Gift of Timothy Collins

He took that shirt off. Now the reason he wears that corset is when the doctors took the bullets out that Valerie Solanis shot him with, they had to cut his stomach muscles. The Africans wouldn't let me show it for my slide lecture on TV that I gave in Nairobi, Africa. They said: "Oh no, half man, half woman, it would ruin our children." As a person, Andy is very nice. Considerate and rather quiet. But as an art-world personality, he represents a certain pollution of this era. I think he's the greatest advertiser living, not a great portrait painter. From Brillo to portraits, you know. But I think his tomato cans are a great contribution.

138

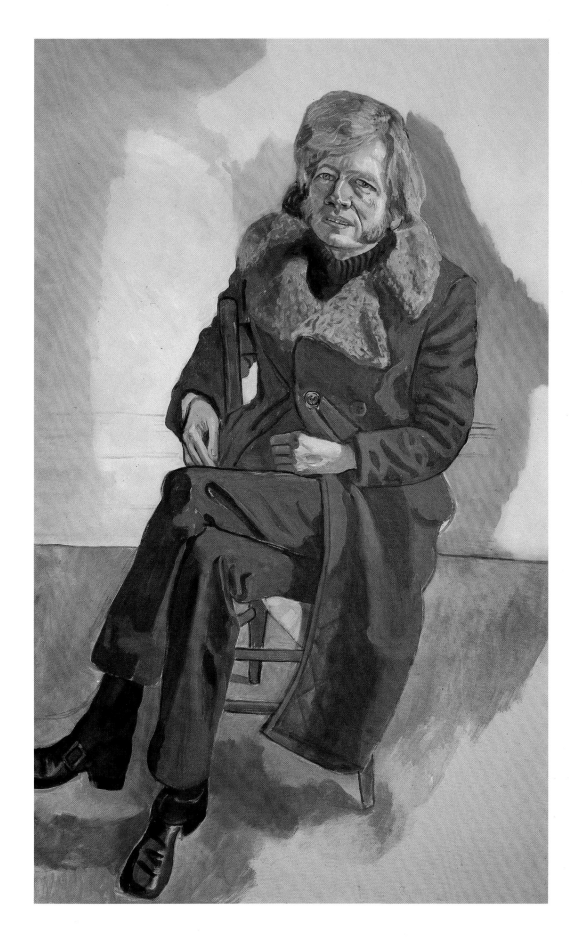

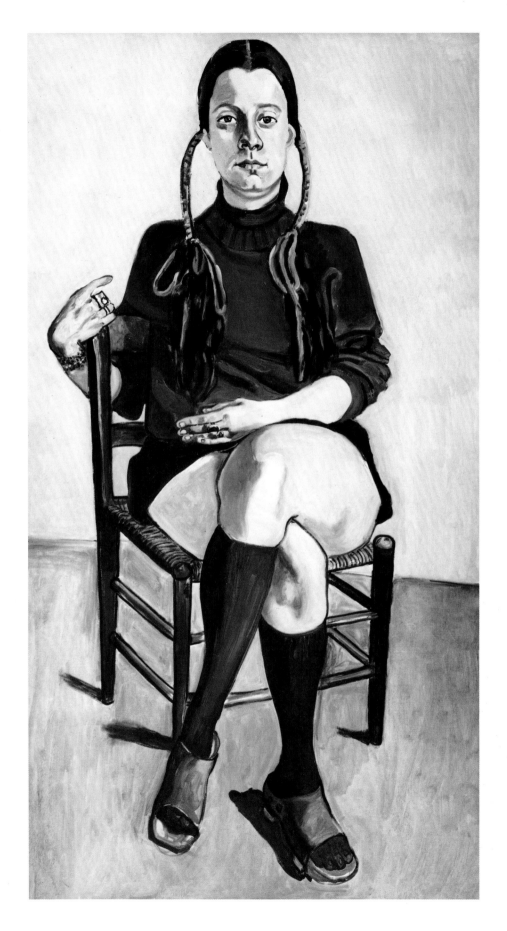

Vera Beckerhoff. 1972. Oil on canvas, 60 × 32″. Collection the artist and/or family

I do not pose my sitters. I never put things anywhere. I do not deliberate and then concoct. I usually have people get into something that's comfortable for them. Before painting, when I talk to the person, they unconsciously assume their most characteristic pose, which in a way involves all their character and social standing—what the world has done to them and their retaliation. And then I compose something around that. It's much better that way. I hate art that's like a measuring wire from one thing to the next, where the artist goes from bone to muscle to bone, and often leaves the head out. I won't mention who does that.

When I paint it's not just that it's intuitive, it's that I deliberately cross out everything I've read and just react, because I want that spontaneity and concentration on that person to come across. I hate pictures that make you think of all the work that was done to create

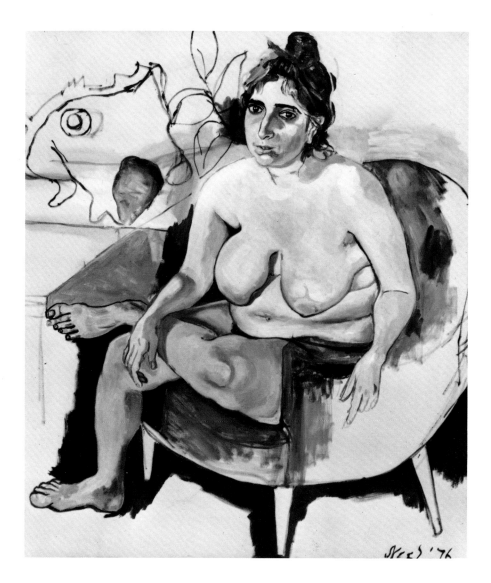

Aryomni. 1976. Oil on canvas, 46 × 38″. Collection the artist and/or family

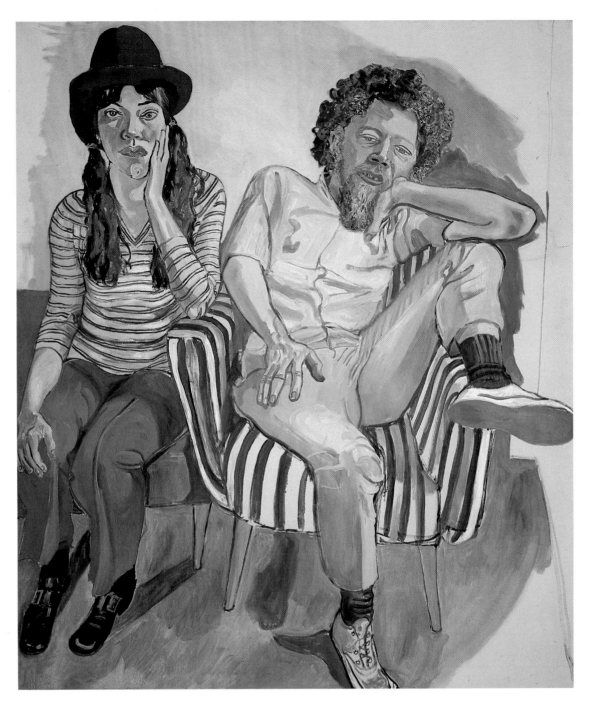

Benny and Mary Ellen Andrews. 1972. Oil on canvas, 60 × 50″. Collection the artist and/
or family

them. When Tom Hess reviewed Cindy Nemser and Chuck, *he gave me
credit for seeming spontaneous.*[9]

*In the winter of 1973, the Soyer brothers, Raphael and Moses,
came to pose for me. Moses said to me: "If you intend to paint us you
should, because none of us will live forever."*

They sat on the couch and since they rarely had a chance to speak

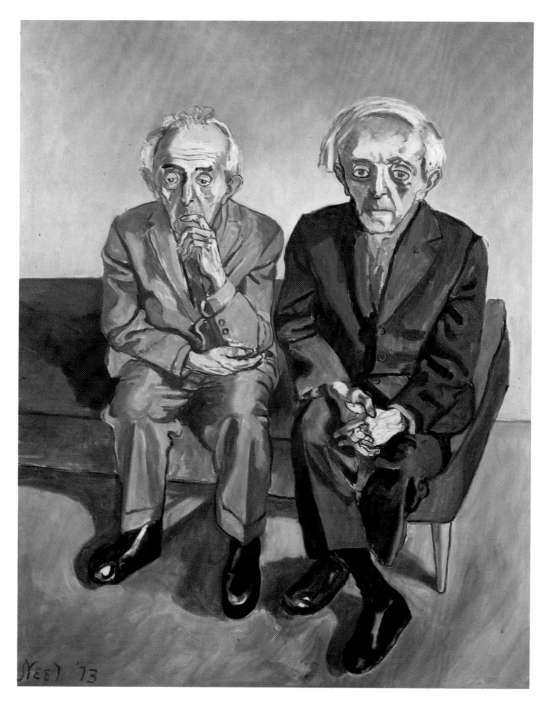

The Soyer Brothers. 1973. Oil on canvas, 60 × 46″. Collection Whitney Museum of American Art, New York City. Gift of Arthur M. Bullowa, Sydney Duffy, Stewart R. Mott, Edward Rosenthal, and Purchase

Russian, they spoke to each other in Russian. They were talking of art and in time I began to feel like the super, just working when I was dying to know what they were saying to each other. I was just recovering from the flu and did not feel well, so in the rest periods I would put my head down to keep from feeling dizzy.

The canvas, a large one, 60 by 46 inches, was on the easel, and I

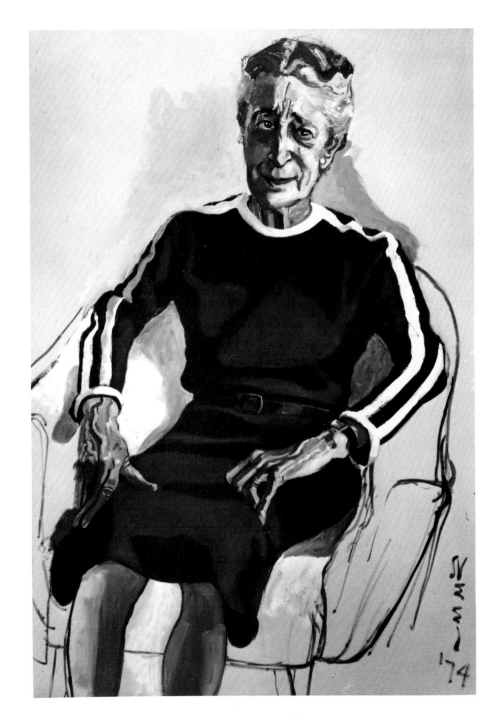

Isabel Bishop. 1974. Oil on canvas, 44 × 30″. Montclair Art Museum, Montclair, New Jersey

(opposite) *Sari Dienes.* 1976. Oil on canvas, 59¾ × 38″. Collection Hirshhorn Museum and Sculpture Garden, Smithsonian Institution, Washington, D.C.

began drawing, which is the way I work. Moses told me I was very brave to just start doing that. I made a wonderful drawing, which I should have photographed, but I didn't have the equipment, so I had to destroy it to a certain extent by painting over it.

Old age even by itself is poignant. But the struggle. Look at Raphael's face. See how he struggles. Both of them. When Moses died, in the fall of 1974, the picture was hung in the lobby of the Whitney Museum for several months. The Whitney owns the painting.

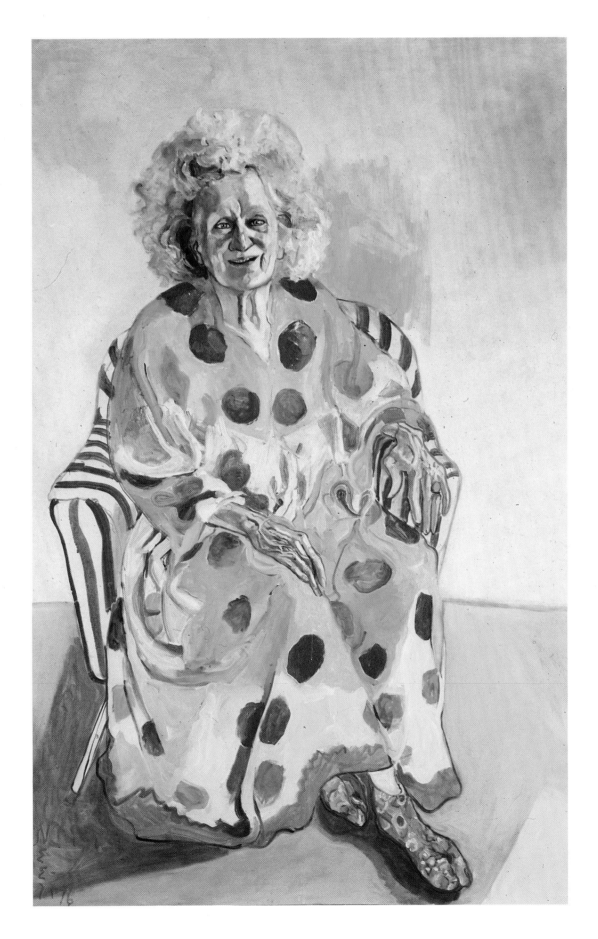

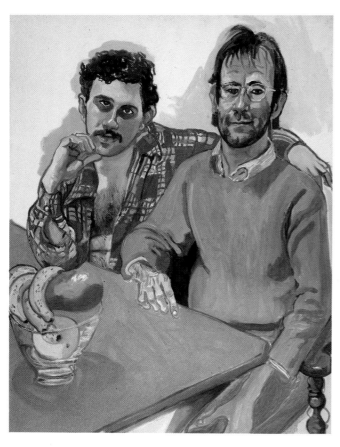

Geoffrey Hendricks and Brian. 1978. Oil on canvas, 44 × 34″. Collection the artist and/or family

(opposite) *Marisol.* 1981. Oil on canvas, 42 × 25″. Collection the artist and/or family

Michel Auder. 1980. Oil on canvas, 50 × 40″. Collection the artist and/or family

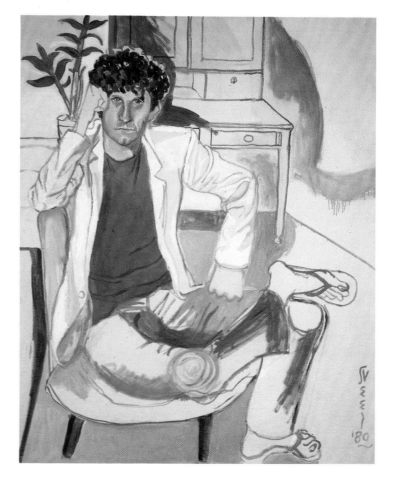

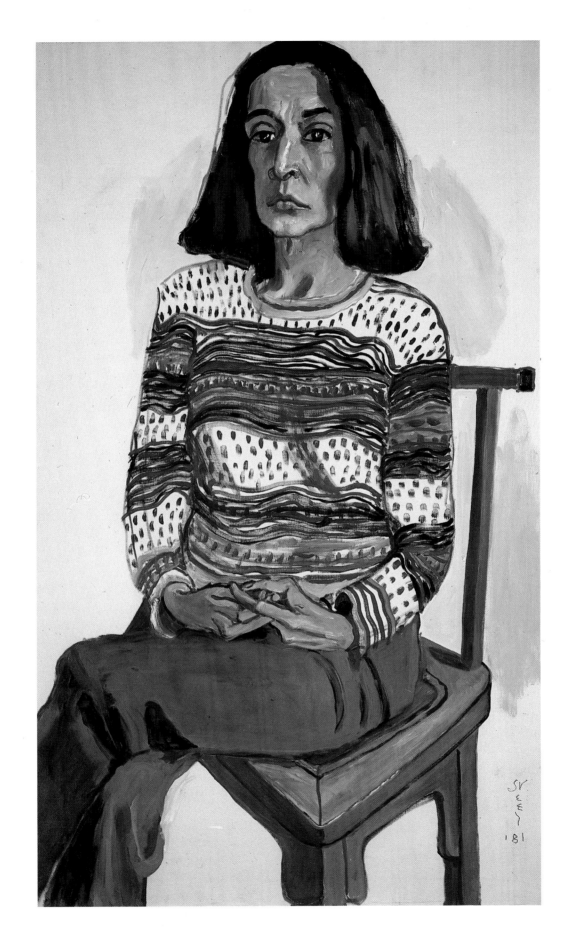

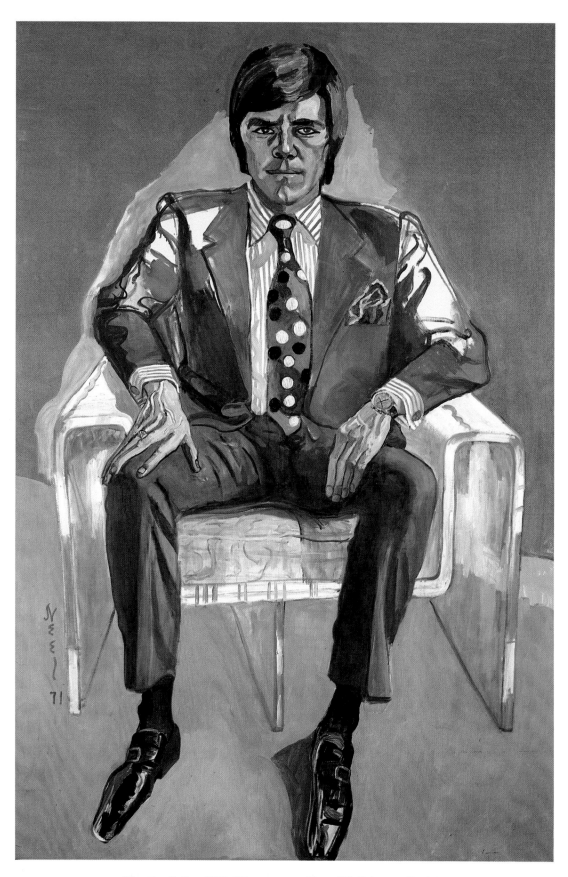

Timothy Collins. 1971. Oil on canvas, 62 × 40″. Private collection

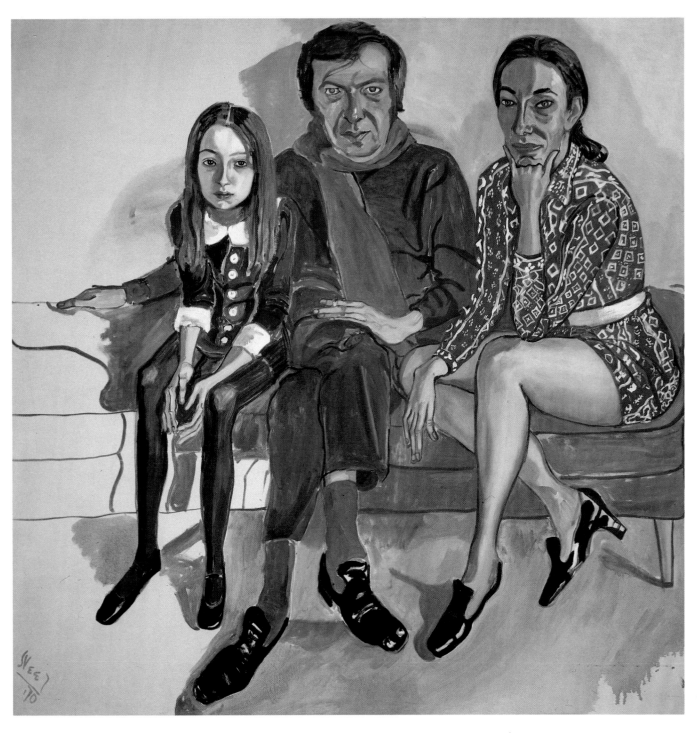

The Family (John Gruen, Jane Wilson and Julia). 1970. Oil on canvas, 58 × 60″. Collection the artist and/or family

John Gruen, critic, Jane Wilson, artist, and their daughter Julia, ballet student. John Gruen reminded me of a gypsy father and Jane Wilson looked so much like a fashion model that I was amazed later to find out that she had been a fashion model before she was an artist. This was shown at the Whitney Annual in 1972.

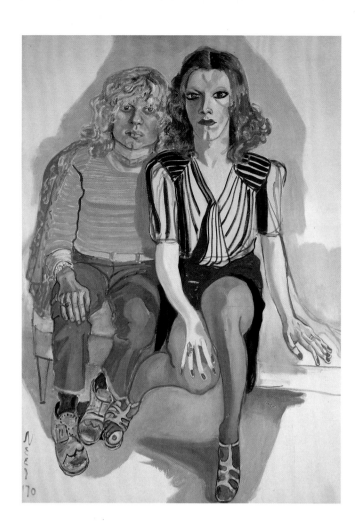

Jackie Curtis and Rita Red. 1970. Oil on canvas, 60 × 42″.
Private collection

(opposite) *Jackie as a Boy.* 1972. Oil on canvas, 44 × 30″.
Private collection, New York City

David Bourdon and Gregory Battcock.
1970. Oil on canvas, 60 × 56″.
Courtesy University of Texas at Austin

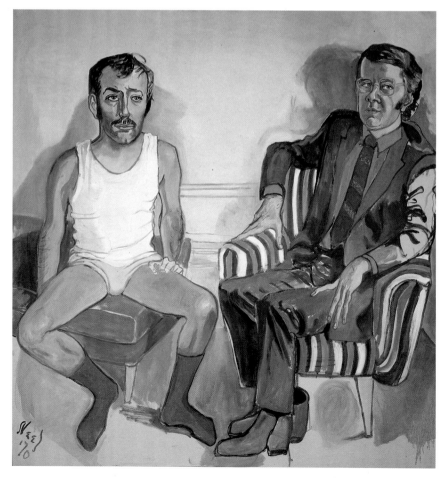

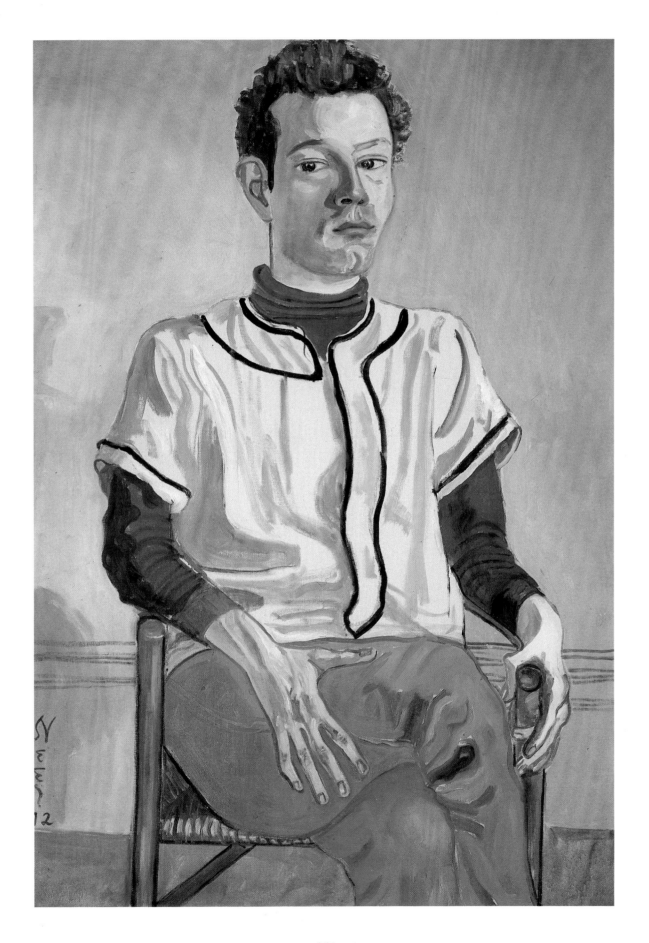

Linda Nochlin and Daisy. 1973. Oil on canvas, 55½ × 44″. Collection the artist and/or family

John Perreault. 1972. Oil on canvas, 38 × 63½″. Collection Whitney Museum of American Art, New York City. Gift of Anonymous Donor

John Perreault came to see me in 1972. He was organizing a show at the School of Visual Arts and wanted my nude *Joe Gould, painted in 1933. I said: "Isn't it a shame that I'm going to show something I painted forty years ago, but I don't have a male nude now, because, you know, both my sons are married and working." I didn't tell him they wouldn't have posed nude. He said: "Well, you can always paint me." So I immediately got a canvas out.*

He was a great model, John Perreault. He never complained, he never offered advice, he never said: "This should be this, or that should be that." And these two, Joe Gould *and* John Perreault, *hung in Visual Arts.*

Cindy Nemser and Chuck. 1975. Oil on canvas, 41½ × 59¾".
Collection the artist and/or family

Dennis Florio. 1978. Oil on canvas, 48 × 38″. Collection the artist and/or family

The De Vegh Twins. 1975. Oil on canvas, 38 × 32″. Private collection

Nancy and the Rubber Plant. 1975. Oil on canvas, 80 × 36″. Collection the artist and/or family

Olivia with Blue Hat. 1973. Oil on canvas, 46¾ × 26½″. Private collection, London

Olivia. 1975. Oil on canvas, 54 × 34″. Collection Arthur M. Bullowa, New York City

Olivia. 1976. Oil on canvas, 58 × 48″. Collection the artist and/or family

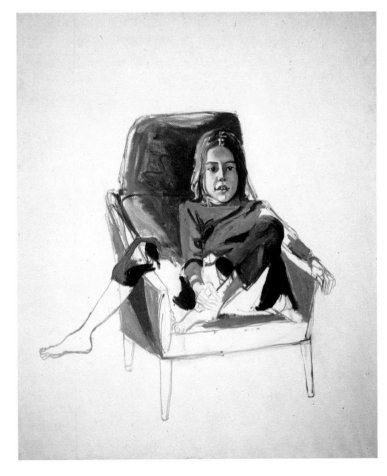

[Neel continues to paint her family, increasing in number. Nancy and Richard's daughter, Olivia, was born in 1967, their twins, Alexandra and Antonia, in 1971, and Victoria in 1974. Ginny and Hartley had Elizabeth in 1975 and Andrew in 1978. Because Nancy lives only seven blocks from Neel in Manhattan, there are many paintings of her—pregnant, nursing, and holding her children. Many were done at Spring Lake where Nancy, Richard, and their children spend much of each summer with Neel.

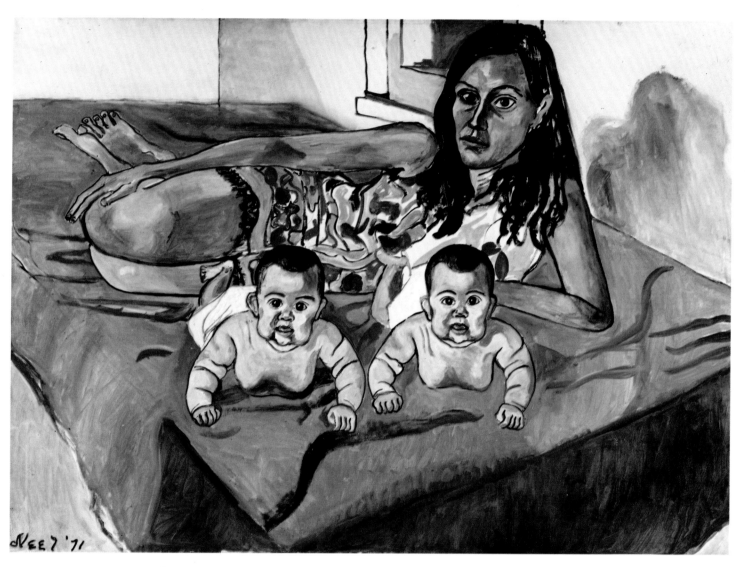

Nancy and the Twins. 1971. Oil on canvas, 44 × 60″. Collection the artist and/or family

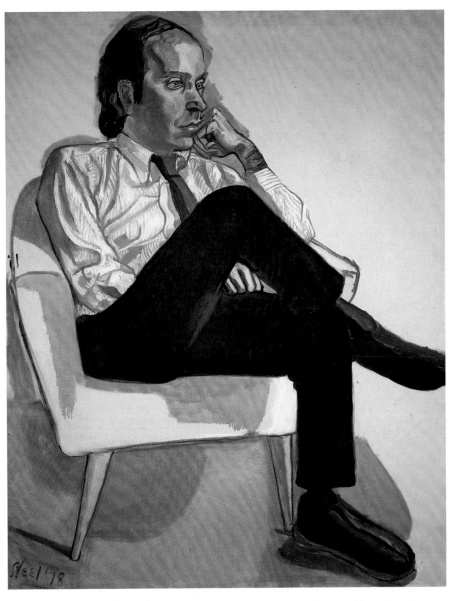

Hartley. 1978. Oil on canvas, 52 × 40". Collection the artist and/or family

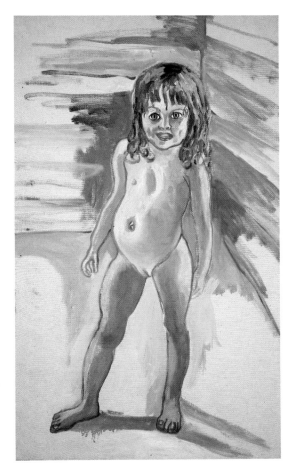

Elizabeth. 1977. Oil on canvas, 40 × 24".
Collection the artist and/or family

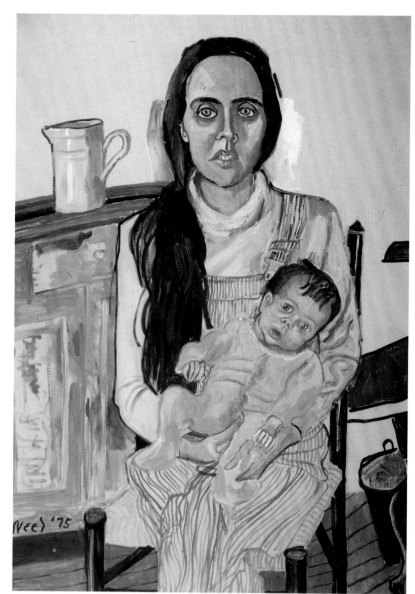

Ginny and the Baby. 1975. Oil on canvas, 42 × 30″. Private collection

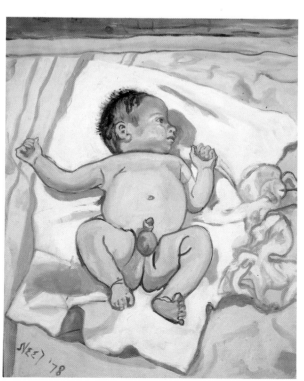

Andrew. 1978. Oil on canvas, 30 × 24″. Collection the artist and/or family

159

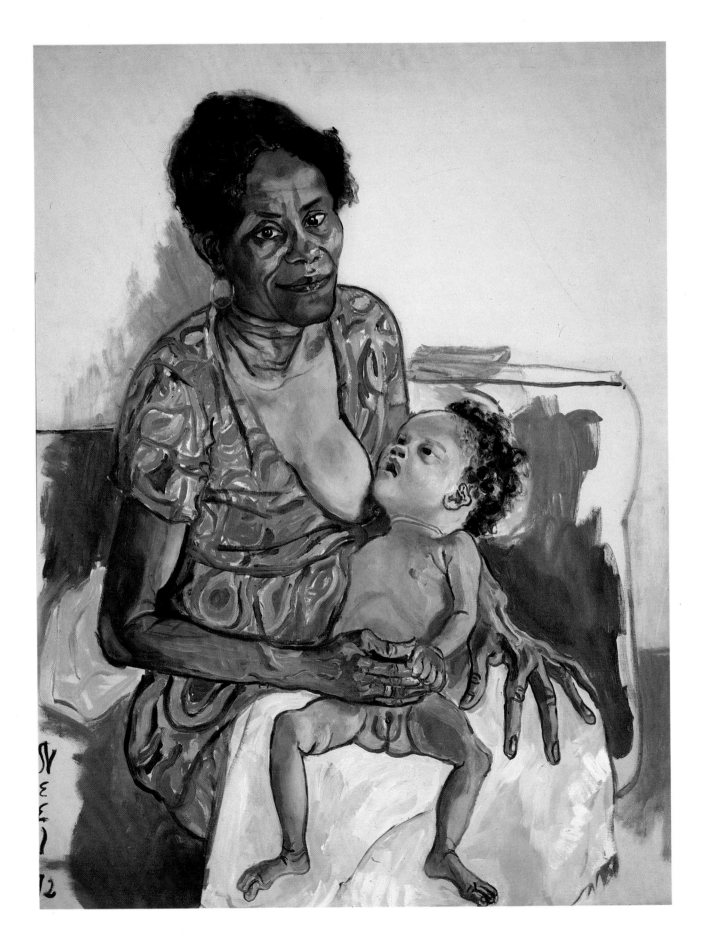

In 1972, she painted *Carmen and Judy,* a portrait of her Haitian house-keeper and her deformed child. In general, far fewer paintings were done of the neighborhood community in the 1970s and 1980s, and still fewer of the radicals and political people of the earlier decades, the exceptions being *Bella Abzug,* 1975, *Gus Hall,* 1980, and *Mayor Koch,* 1981.]

That's a Haitian woman. Look how hard she's worked, look at that hand. That little child is retarded—it was seven and a half months old and never turned over yet. There are ten thousand crib deaths in this country per year. It went to bed with a little cold, and in the night it died. Fortunately, because it was utterly retarded. She was a wonderful mother. Then she had one more baby, and then had her tubes tied. And the baby is just as advanced as this one was backward. She has about four other children in Haiti, too.

(opposite) *Carmen and Judy.* 1972. Oil on canvas, 40 × 30″. Collection the artist and/or family

Ginny with the Yellow Hat. 1971. Oil on canvas, 40 × 29″. Collection the artist and/or family

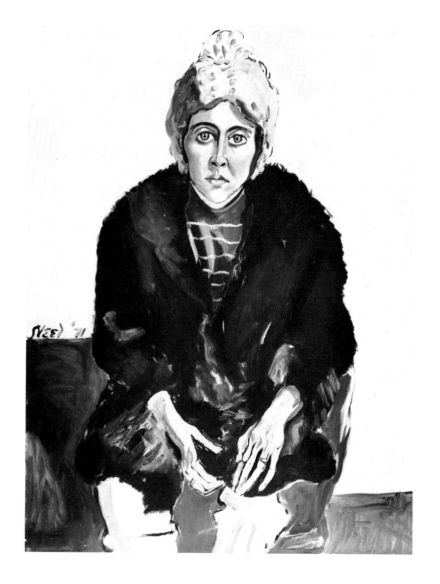

[A major theme with Neel is pregnant women. *Couple on a Train*, done in 1930, was her earliest. In the late 1960s and 1970s she painted: *Pregnant Maria*, 1964, *Pregnant Julie and Algis*, 1967, *Betty Homitzky*, 1968, *Pregnant Woman*, 1971, and *Margaret Evans Pregnant*, 1978. When asked what it was that appealed to her about pregnant women, she replied:]

It isn't what appeals to me, it's just a fact of life. It's a very important part of life and it was neglected. I feel as a subject it's perfectly legitimate, and people out of false modesty, or being sissies, never showed it, but it's a basic fact of life. Also, plastically, it is very exciting. Look at the painting of Nancy pregnant: it's almost tragic the way the top part of her body is pulling the ribs.

(opposite) *Margaret Evans Pregnant.* 1978. Oil on canvas, 57¾ × 38″. Collection the artist and/or family

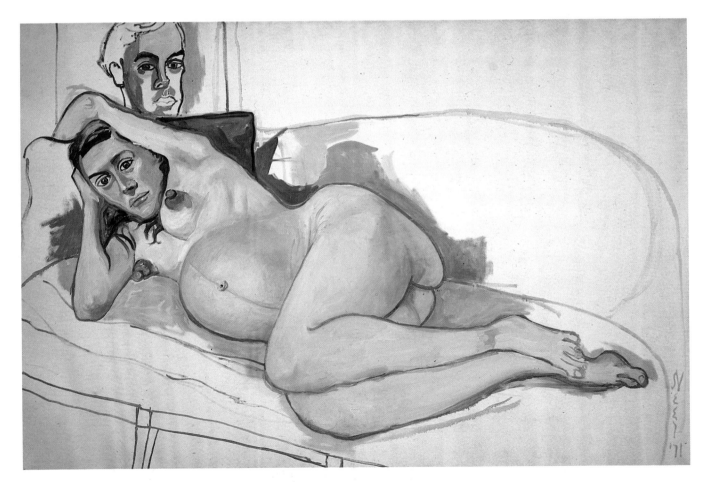

Pregnant Woman. 1971. Oil on canvas, 40 × 60″. Collection the artist and/or family

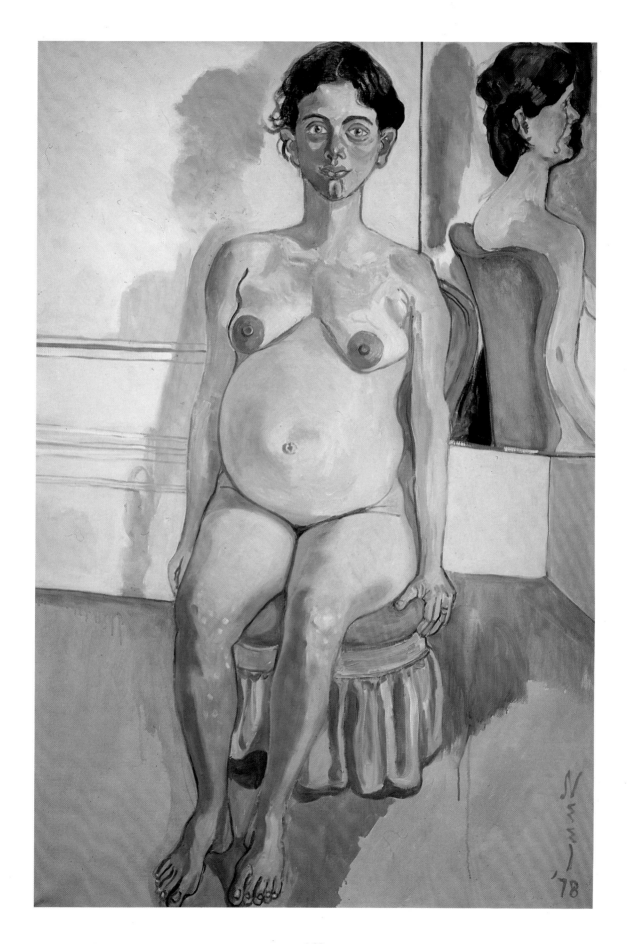

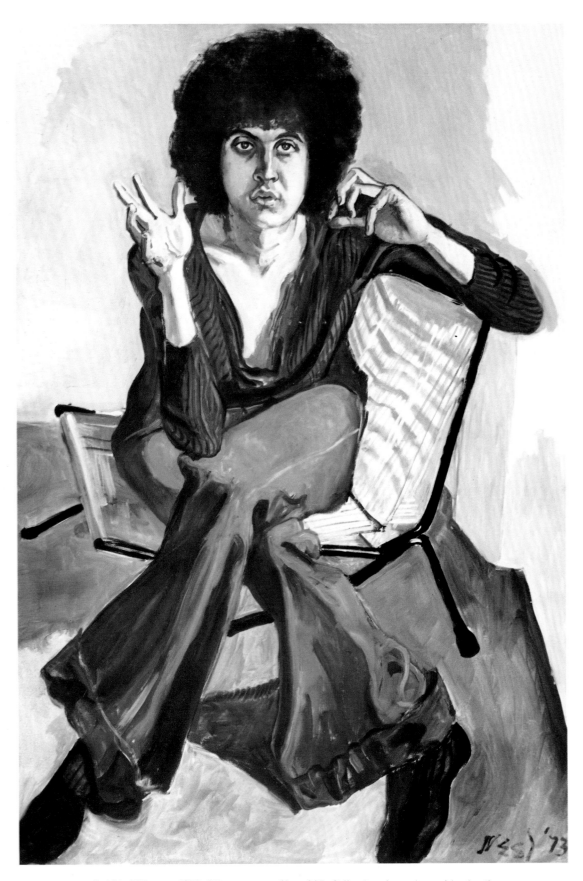

Robbie Tillotson. 1973. Oil on canvas, 58 × 38″. Collection the artist and/or family

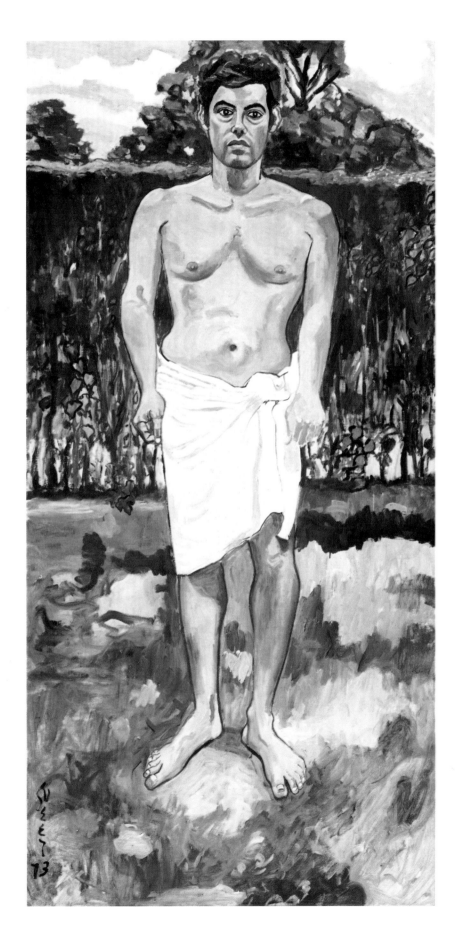

Richard. 1973. Oil on canvas, 80 × 38″. Collection the artist and/or family

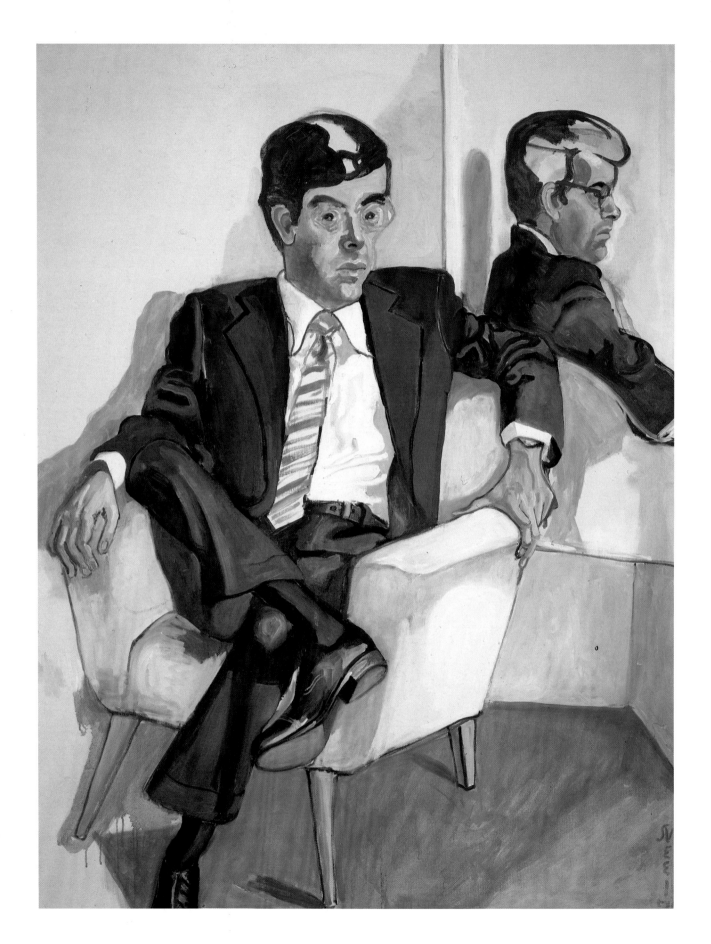

(opposite) *Richard in the Era of the Corporation.* 1979. Oil on canvas, 60 × 45″. Collection the artist and/or family

I want my portraits to be specifically the person and also the Zeitgeist. *So that my things of the 1960s are different from the 1970s, and only at the end, when I did Richard, did I know what the 1970s were about. The 1970s was when corporations took over.*

Art is a form of history. That's only part of its function. But when I paint people, guess what I try for? Two things. One is the complete person. I used to blame myself for that, do you know why? Because Picasso had so many generalities. And mine were all—mostly a specific person. I think it was Shelley who said: "A poem is a moment's monument." Now, a painting is that, plus the fact that it is also the Zeitgeist, *the spirit of the age. You see, I think one of the things I should be given credit for is that at the age of eighty-two I think I still produce definitive pictures with the feel of the era. Like the one of Richard, you know, caught in a block of ice—Richard in the Era of the Corporation. And these other eras are different eras. Like the '60s was the student revolution era. Up until now, I've managed to be able to reflect the* Zeitgeist *of all these different eras.*

I see artists drop in every decade. They drop and they never get beyond there. That was one of the things wrong with the WPA show at Parsons in November, 1977. Hilton Kramer's attitude toward that show was absurd. You can't dismiss the Great Depression as having very little importance. He flattered me. He said at least I didn't join the crowd and do just the same thing they were all doing. He was right, in a way. Those people dropped, back in the '30s, and they never got over it. Many artists developed an attitude and a technique, and they never changed. Even though the world changed drastically, they kept right on doing the same thing.

Cat. 1978. Bronze. Collection the artist and/or family

Bust of Man. 1978. Terracotta. Collection the artist and/or family

(opposite) *Thanksgiving.* 1965. Oil on canvas, 30 × 24″. Collection Jonathan and Monika Brand, Philadelphia

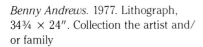

Benny Andrews. 1977. Lithograph, 34¾ × 24″. Collection the artist and/or family

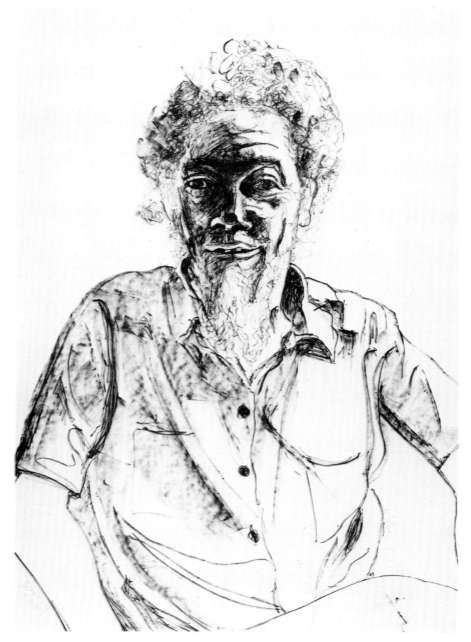

[Neel has done still-life paintings throughout her career. When asked why she does still life, she replies:]

I am an old-fashioned painter. I do country scenes, city scenes, figures, portraits, and still life. Still life is a rest. It's just composing and thinking about lines and colors, and often flowers.

I painted Chicken in the Sink *in 1965 because Hartley was there and I felt happy. It was really a capon. I called it* Thanksgiving. *That's satiric: "Thanksgiving" for everybody but the turkey, or bird, because that bird looks wretched.*

I did Still Life, Black Bottles *in 1977. You know, when you go to art*

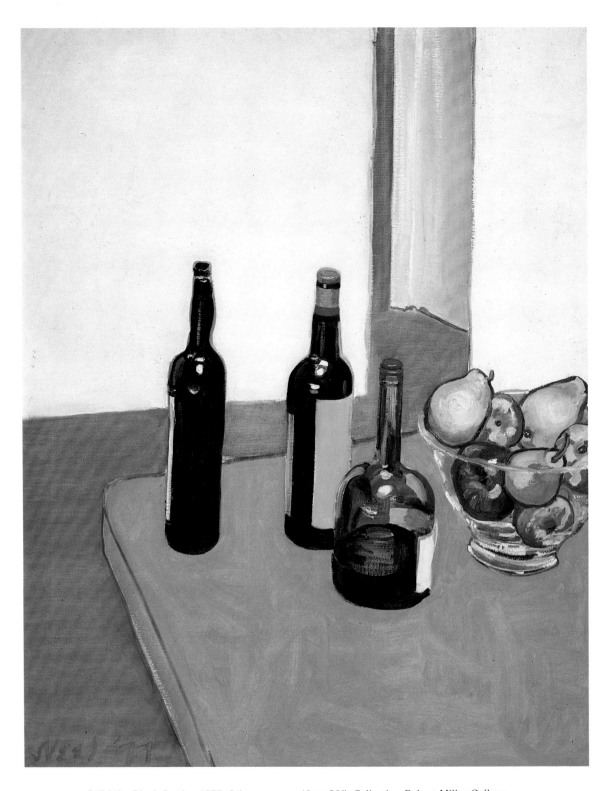

Still Life, Black Bottles. 1977. Oil on canvas, 40 × 30″. Collection Robert Miller Gallery, New York City

school you do bottles. I had these beautiful bottles. It was like doing a thing that you did many years ago and then doing it again. I love the feeling in this, and my back was collapsing at that time, so I did this in the midst of torture.

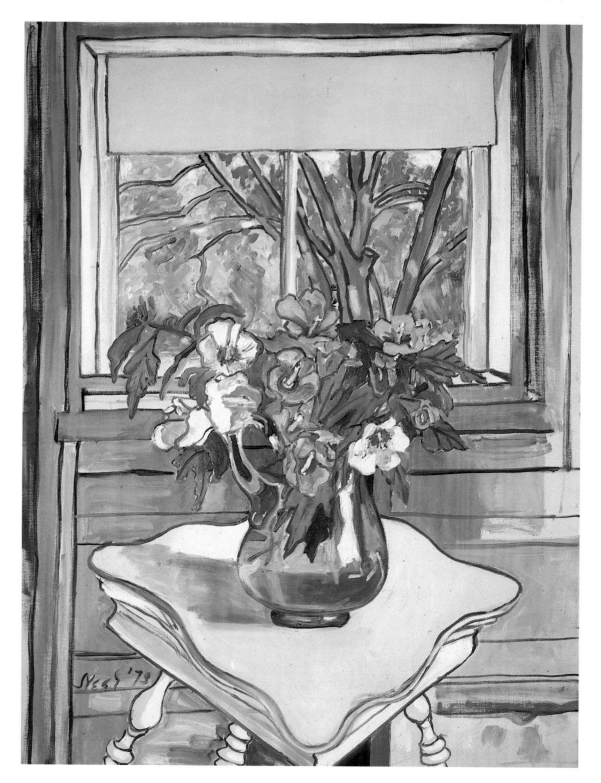

Still Life, Rose of Sharon. 1973. Oil on canvas, 40 × 30″. Collection Arthur M. Bullowa, New York City

Rose of Sharon or Althea, they have two names. We have a hedge of them in Spring Lake. They're a very interesting flower. When I was a girl of about fifteen or sixteen, that was one of the first things I tried to paint. When I made this, I was really back there, when I was fifteen.

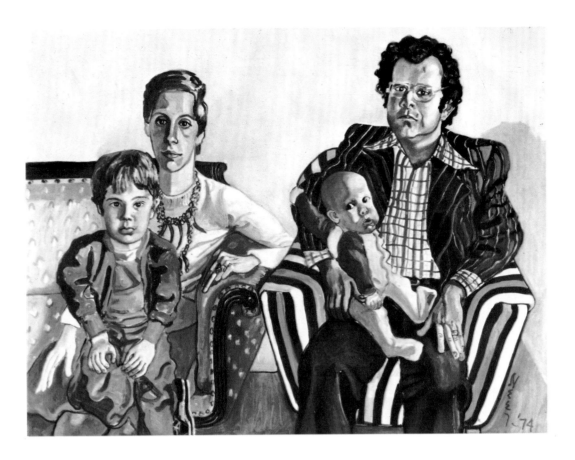

The Robinson Family.
1974. Oil on canvas, 40 ×
52″. Collection Steven D.
Robinson, Miami

Martin Melzer. 1977. Oil
on canvas, 39½ × 45″.
Collection Martin and
Nancy Melzer

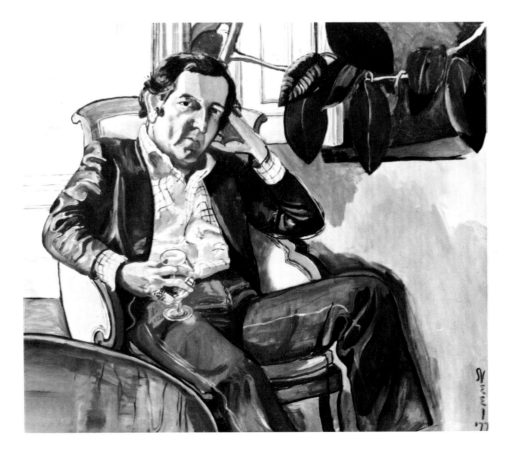

Westreich Family. 1978. Oil on canvas.
Collection Mrs. T. Westreich,
Washington, D.C.

[An unusual opportunity came to Neel in 1976 when she was commissioned by the Archdiocese of Philadelphia to paint the portrait of Archbishop Jean Jadot.]

Victoria Donohoe, an art critic who had given me good reviews in the Philadelphia Inquirer *and who loved my work when I had the show at Moore College, called me up. She was up in the Catholic hierarchy in Philadelphia, and she asked me: "Do you think you'd be well enough to paint the Papal Delegate from Rome, Jean Jadot?" You see, we do not have ambassadorial relations with the Vatican, so they send a papal delegate who's also the representative at the United Nations. I agreed to do it.*

Jean Jadot was very learned, and not only that, he was completely for the working class. He worked fourteen years in Africa. He loved the oppressed. I stayed at the Washington Hilton and went every morning to the Apostolic Delegation. I took my paints with me from New York but got a canvas down there. I had a frightful easel where I had to stand all the time, and Jadot, if I dropped a brush, would get it for me. Guess what he told me? I was the bravest person he'd ever met.

(opposite) *Loneliness.*
1970. Oil on canvas, 80
× 38″. Collection Arthur
M. Bullowa, New York
City

107th and Broadway.
1976. Oil on canvas, 60
× 34″. Private collection,
courtesy Grimaldis
Gallery, Baltimore

Archbishop Jean Jadot. 1976. Oil on canvas, 60 × 40″. Collection Apostolic Delegation, Washington, D.C.

I painted him for one week, and I liked the picture, although the hands are rather odd. He objected a little to them and I said: "Oh well, you'll have to give me artistic license." I made them very nervous, very high-strung. I tried to have it not too academic. You know, right away I got his expression.

While I was in Washington I went to a party with the President of the Academy of Science, Philip Handler, and his wife, for détente with Russia. Dobrynin was there, and, thank God, the Russians supplied the food. There was a whole sturgeon prepared in some wonderful way, the most marvelous Russian caviar, wonderful Russian bread, gorgeous. I told Jean Jadot the next morning I had gone to the party and that the costumes of the women were more elegant than the opening night of the Metropolitan Opera. He said: "The rich care nothing for the poor."

Later, at the 41st Eucharistic Conference in Philadelphia, there was an exhibition held at the Civic Center. The painting of Jean Jadot hung with many others, including Manzu's bust of Pope John XXIII. Afterwards Victoria Donohoe took us to a wonderful dinner at the Barclay Hotel. All the bishops and collectors who had made the exhibition possible were there, and I was the guest of honor. This was one of the attempts of the Catholic Church to get back into the art world.

[In 1976, Neel was elected to the American Academy and Institute of Arts and Letters.]

It is the greatest honor this country can give an artist. One time the discussion centered around the fact that the members in the Institute were too old. So I raised my hand and said: "Blame yourself, not me. I was always in New York. Why didn't you take me in instead of having a cellar full of Speicher paintings. That bad painter! It just took you that long to know that I was good, so don't blame me." Guess who applauded me—Malcolm Cowley.

[In 1979, Neel was selected along with Isabel Bishop, Selma Burke, Louise Nevelson, and Georgia O'Keeffe for the National Women's Caucus for Art awards for outstanding achievement in art. The awards were presented by President Jimmy Carter in the Oval Room of the White House.

Of major importance to Neel was the exhibition held at the Artists' Union in Moscow in the summer of 1981.]

My idea was that anything that stimulates détente makes the danger of nuclear war less. That's why I wanted to go. It was through the Artists' Union in Russia, not through the government. I finally had

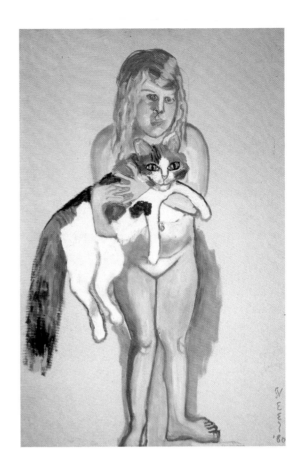

Victoria and the Cat. 1980. Oil on canvas, 25¾ × 39¾".
Collection Fred Mueller, Bernhardt Arts, New York City

Antonia. 1982. Oil on canvas, 50 × 32".
Collection the artist and/or family, courtesy
Robert Miller Gallery, New York City

Alexandra. 1976. Oil on canvas, 46 × 25".
Collection the artist and/or family

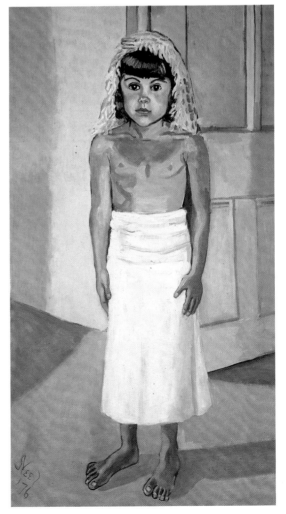

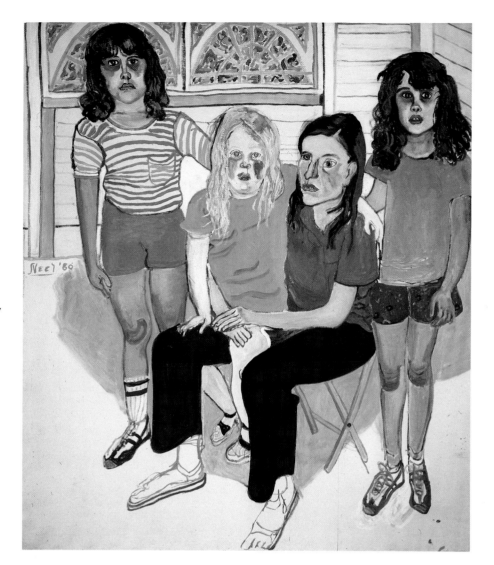

The Family. 1980. Oil on canvas, 58 × 50″. Collection the artist and/or family

to pay for the whole thing, which I did from the money I had gotten from prints. And we all went: Richard, Nancy, Olivia, Hartley, Ginny, and their two children, Elizabeth and Andrew. We stayed for ten days—seven in Moscow and three in Leningrad. I was disappointed that the artists were away, but it was July.

[In the last decade, Neel has kept up a busy schedule of lecturing on her art at art schools, universities, and museums across the country. She weaves into her comments on her individual paintings her views of art and the art world. Her reputation for being both outrageous and wise is well established. In private conversations and interviews she elaborates on these views.]

The thing that always made me happiest in the world was to paint a good picture. It had nothing to do with selling it. Since I was so tied down, I thought it was all right, if you paint a good picture, to just put it on a shelf. I got so discouraged. I'm no good in the commercial world.

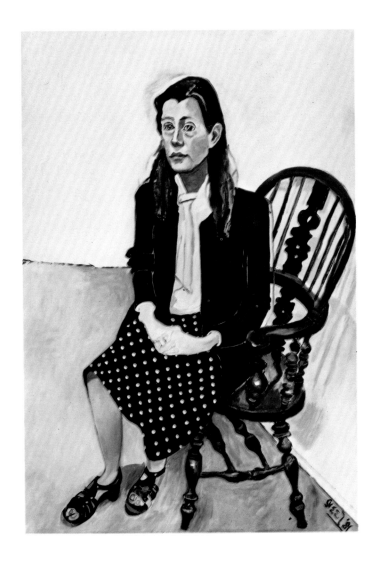

Nancy. 1981. Oil on canvas, 60 × 40″.
Collection the artist and/or family

I never was. But it's not all right. When I give lectures to these young people—for instance in Baltimore I was once on a symposium, and all they wanted to do was "to make it." And I said to them: "Don't you know that before you make it, you have to have something to make it with. I think to go to New York and SoHo right off is absurd; you should shop around yourself, see what it is. See what your art is, and then when you think you've made some discovery, go in and do it. But don't do like me, don't just put it on a shelf."

All experience is great providing you live through it. I would tell these classes of art students, the more experience you get, the better, if it doesn't kill you. But if it kills you, you've gone too far. That's all. You never learn anything like you learn it by experiencing it.

I even identified art with religion—when you just gave up everything for art. You gave up clothes, you gave up comfort, you gave up well-being, you gave up everything for art.

You know what art is? Art is a philosophy, and it's a great

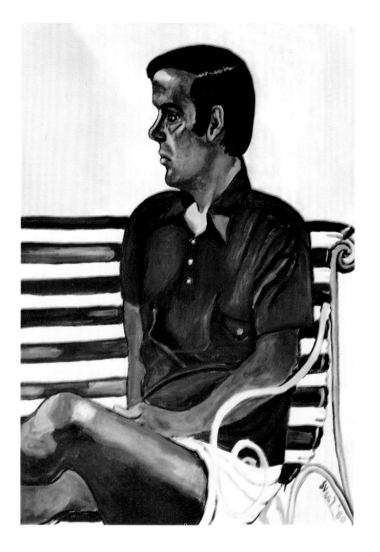

Richard. 1980. Oil on canvas, 44 × 30″.
Collection the artist and/or family

communication. I just saw George Segal lately. He has such a playful attitude toward art. He said he had fun doing something. And I can't remember ever having fun doing anything.

The hardest thing for me to accept is change all the time. The human race wants something they never can get: security. They can get relative security, you know. But everything keeps changing.

The favorite author of Georg Lukács was Thomas Mann, because Mann could see how sick the world was. But the sickness has now been transformed into junkiness. You see, the character of this era is its utter lack of values.

[Do you have any theories about art?]

I have an intellect, so in between painting I know all the theory and I do have theories. But I never think of a theory when I work. You know what I enjoy almost the most of anything? Dividing up the

181

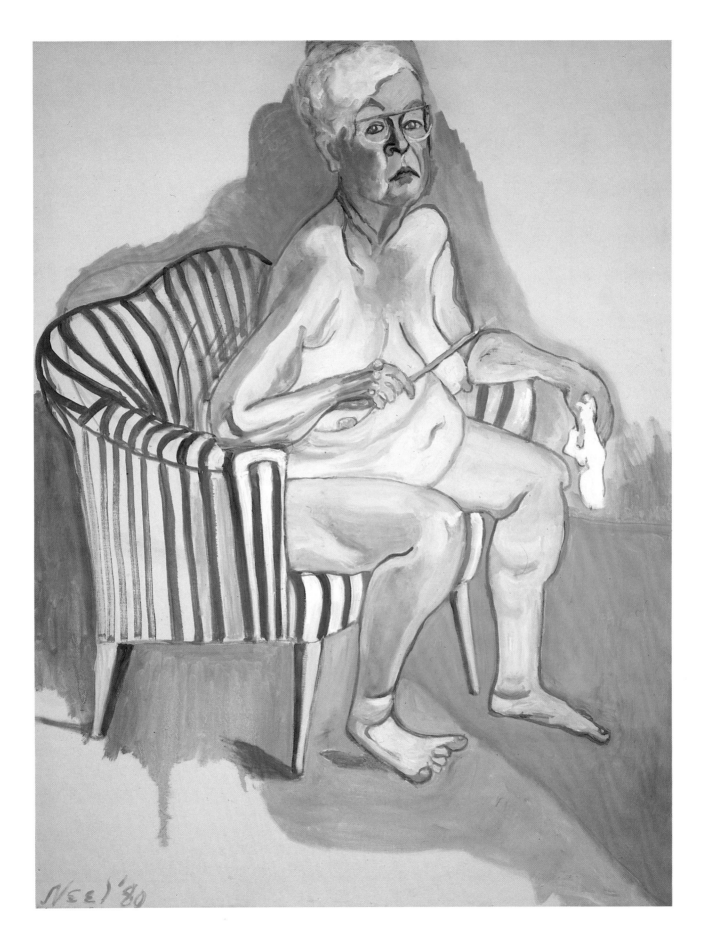

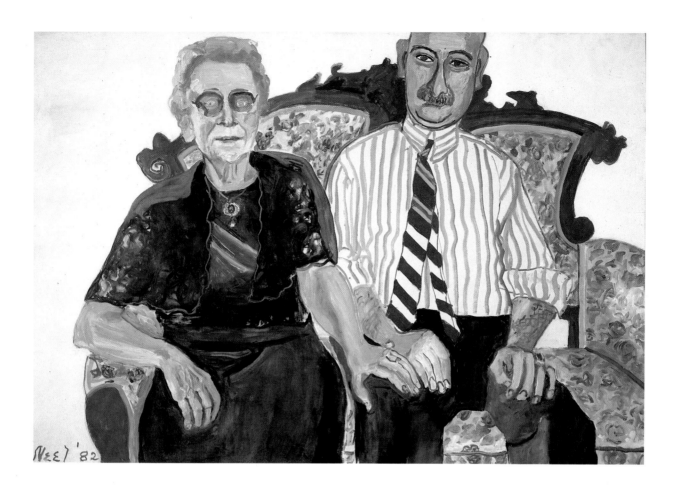

Annemarie and Georgie. 1982. Oil on canvas, 35 × 49¾". Collection the artist and/or family

(opposite) Self-Portrait. 1980. Oil on canvas, 54 × 40". Collection the artist and/or family

canvas. When I was in high school I was very good at mathematics, and I love dividing up canvases. And then I don't want to clutter my mind with theories because I think theories, when you're working, hold you back. Because you try to get it into a Procrustean theory and it doesn't fit there. So you should just let yourself go in direct contact with what you see.

Art is two things: a search for a road and a search for freedom. It's very hard to get freedom. You know all these things in life keep crawling over you all the time, so it's very hard to feel free.

A good portrait of mine has even more than just the accurate features. It has some other thing. If I have any talent in relation to people, apart from planning the whole canvas, it is my identification with them. I get so identified when I paint them, when they go home I feel frightful. I have no self—I've gone into this other person. And by doing that, there's a kind of something I get that other artists don't get. Patricia Bailey said in a review of my exhibition at Graham in 1980: "Her work has been a way of diminishing her personal sense of separation from life."[10] That's right. It is my way of overcoming the alienation. It's my ticket to reality.

I could accept any humiliation myself, but my pure area was art, and there it was the truth. I told the truth the best I was able. I think that the best art is the art that makes the truest statement of when it was existing, both aesthetic, and political, and everything. For when it was existing. Lenin preferred Balzac to any other Western writer because Balzac realized the importance of money and trade in life. Do you know The Human Comedy—*about young men from the provinces who go to Paris to make their fortune? That is really what life is—*The Human Comedy. *And put together, that's what my paintings are.*

Now, it's a dangerous thing that Claes Oldenburg got so famous just doing gadgets. That lipstick in front of Yale. It's the vulgarity of America that can be translated into just gadgets or just technique. It's pragmatism. William James. The fundamental philosophy of America.

We are a gadget-ridden people. But not that much. Not that much, because there are still people with souls. We cannot reduce ourselves to just a gadget. That will have a big fad for a while, because it's something new. And also it falls into that big pot out of which everything comes, and by which everybody is influenced.

It's just my first principle. And somebody said to me: "But that's your subjective truth." And I said to them: "But I wouldn't have gotten so famous for my so-called subjective truth if it hadn't been in some way matched up with what is so, you know."

I think Chaim Soutine is great, but in one way he's an old-fashioned artist. He was so ridden by his own vision that he did not see objective reality. Soutine is a very strange genius. He was doped by his own emotions. He could only do what he could do. He has a landscape where the whole thing is falling down. It's like a mental state. And yet it's a landscape and it's wonderful. Now Goya, though, saw objective reality much more than Soutine.

There is another thing about Soutine I didn't like. He still belonged to the generation who worked inside the frame. My painting always includes the frame as part of the composition. Soutine is just like Rembrandt, inside the frame.

Edvard Munch is a genius, too. They are the people I love: Goya, Soutine, Munch. But Munch I never saw in the beginning. I did a painting, and you'll swear that I was influenced by Munch, but I hadn't even heard of him yet.

I have a touch of Expressionism, but it never crosses out the analytical completely.

When I got psyched, my analyst said to me: "Why is it so important to be so honest in art?" I said: "It's not so important, it's just a privilege."

You know what Tom Paine said: "These are the times that try men's souls." Yes, sure, fair weather and winter soldiers. And you know what Thomas Jefferson said: "Ever so often, the tree of liberty must be watered by the blood of tyrants." That's nice, too, isn't it?

[In the late 1970s, Neel wrote the following statements:]

I do not know if the truth that I have told will benefit the world in any way. I managed to do it at great cost to myself and perhaps to others. It is hard to go against the tide of one's time, milieu, and position. But at least I tried to reflect innocently the twentieth century and my feelings and perceptions as a girl and a woman. Not that I felt they were all that different from men's.

I did this at the expense of untold humiliations, but at least after my fashion I told the truth as I perceived it, and, considering the way one is bombarded by reality, did the best and most honest art of which I was capable.

I always was much more truthful and courageous on canvas.

I felt that profundity in art was the result of suffering and deprivation—but I am not sure that this is so.

Every person is a new universe unique with its own laws emphasizing some belief or phase of life immersed in time and rapidly passing by. Death, the great void of life, hangs over everyone.

I love, fear, and respect people and their struggle, especially in the rat race we live in today, becoming every moment fiercer, attaining epic proportions where murder and annihilation are the end.

I am psychologically involved and believe no matter how much we are overcome by our own advertising and commodities, man himself makes the world.

Notes

1. Theodore Sizer (1892–1967) later wrote on John Trumbull and other eighteenth- and nineteenth-century American artists.

2. Wobbly, a member of the Industrial Workers of the World.

3. For a chronology of the Federal agencies see Marlene Park and Gerald E. Markowitz, *New Deal for Art* (Hamilton, New York: The Gallery Association of New York State, 1977), pp. xii and xiii.

4. There were eight divisions within the Federal Art Project for artists: murals, easel paintings, photographs, sculptures, graphics, posters, motion pictures, and the Index of American Design. There were also divisions directing teaching, exhibitions, and other related activities. See Park and Markowitz, *op. cit.*

5. For a review of *The New York Group* exhibition see *Art News* 36 (June 4–18, 1938), p. 13; the review does not mention Neel by name. An earlier solo exhibition, held at the Contemporary Arts Gallery in May, 1938, was reviewed in *Art News* 36 (May 14–28, 1938).

6. For a review of Neel's Pinacotheca exhibition see "The Passing Shows," *Art News* 43 (March 15–29, 1944), p. 20.

7. For reviews of the ACA exhibition see S[tanton] L. C[atlin], "Reviews and Previews," *Art News* 49 (January, 1951), p. 49, and N. L., "Review of Exhibition at A.C.A.," *The Art Digest* (January 1, 1951), p. 17.

8. Quoted in Cindy Nemser, "Alice Neel—Teller of Truth," in Georgia Museum of Art, *Alice Neel: The Woman and Her Work* (Athens, Georgia: Georgia Museum of Art, 1975), unpaged.

9. See Thomas B. Hess, "Sitting Prettier," *New York* (February 23, 1976), pp. 62–63.

10. See Patricia Bailey, "Alice Neel Portraits," *Art/World* (November 20/December 20, 1980), pp. 1, 6.

Alice Neel:

the Work, the Words, the Woman

Alice Neel is in the forefront of American portrait painters. She has searched the faces of her sitters and investigated their characteristic poses to reveal to them and to us the specifics of their personalities and of their places in the world. But at the same time, she has consciously aimed to record a historical epoch by creating for posterity a gallery of our contemporary artistic, professional, and business people.

In the early 1930s, Philip Rahv, animated by radical zeal, chided her for painting *individual* portraits. Her retort was: "Well, one plus one plus one is a crowd."[1] Indeed, it is the crowd, the accumulation, that becomes for her important. Today she says: "Art is a form of history. . . . I want to get the specific person plus the *Zeitgeist.*" The *Zeitgeist*—the spirit of the age—is captured not only in each individual painting but in the work as a whole.

Like the novelist Honoré de Balzac in his *Human Comedy,* Neel declares the vulnerability of human lives to time, ambition, and money: "I love to paint people torn by all the things that they are torn by today in the rat race in New York."

By painting the individual and by painting our time, Neel has nevertheless not neglected what she sees as the universal issues: pregnancy, motherhood, mourning, death. She has simply put those constants of human activity into the context of contemporary history.

The individual and the age, the specific and the general, are not the only polarities that inform and give shape to her artistic program. In conversation about her life, she continually returns to a whole range of contradictions and contrasts; in fact, she builds the story of her life around her heightened awareness of those contradictions. She refuses to reject any of the polarized possibilities, even when they seem destructive. "All experience is great providing you live through it," she remarks. "The more experience you get, the better—if it doesn't kill you. But if it kills you, you've gone too far."

Brought up in what seemed to her the banality of small-town America, Neel was first aware of an intellectual level opposed to conventionality from the example of her mother, a lonely, unhappy, and often selfish woman, who was well read and intelligent.

In art school, Neel developed her own independence and feeling for subject and refused to submit to mechanical exercises. Lettering, for example, seemed important to Neel for what it said, not for the shape of the letters. Unsympathetic to other female students who acted out gender stereotypes, Neel gravitated to the intellectually daring. She was attracted particularly to a man who represented the opposite of her Philadelphia upbringing. Carlos Enriquez—handsome, dark, aristocratic, bohemian, intense about art and life—was the man who became her husband. The sophisticated, artistic Cuban life into which Carlos introduced her widened her horizons.

Back in bohemian New York in the late 1920s, Neel came to feel a new set of socially

sanctioned contradictions: parenthood and career. Exacerbating these contrasts was a series of events that marked her life: the death of one child, pregnancy and the birth of another, the absence of her husband and child, which allowed her time to paint, and then the realization, in mid-summer 1930, that she had been abandoned. She painted with a vengeance. The sudden intensity of activity erupted into poignant and raw images.

Couples, children, motherhood, and nudes were her themes. In the two memory paintings showing couples—*Coney Island Boat* and *Couple on a Train*—Neel depicted women as passive companions to their men. In the latter, the man, complacently dozing, thrusts his chin and nose like a puzzle piece into the shoulders and cheek of his pathetically ballooning, pregnant companion.

In Neel's moralizing *Degenerate Madonna,* her childless friend Nadya holds the malformed, fetus-like creature she was never to have. The dangling corpse in Neel's minimally stated *Futility of Effort* represents the child born in hope and destroyed by circumstances beyond the control of the mother: Neel's situation in the two instances of losing her children. In these paintings, she seems to be working through fears and fantasies.

The most revealing images of 1930 are *Rhoda Meyers with Blue Hat* and, particularly, *Ethel Ashton.* Neel painted from life the strongly shadowed, brutally candid nude portrait of her friend Ethel. There is no other contemporary American artist at that time who produced such a sharply realized image, born in knowledge of the female situation. The equivalent images that come to mind are those done by the German artists, such as Otto Dix, who were then formulating a "new objectivity" for German art. To Dix and to Neel, sexuality becomes a sociological as well as a psychological and biological function. Then, with her breakdown, Neel was brought in touch with the extreme other side of life's contrasts.

The contrasts kept her going after her recovery, during the early 1930s, when she lived with Kenneth Doolittle. A current of sexuality reemerged in her work. The watercolor *Kenneth Doolittle,* 1931, shows him dressed in his orange underwear, thrusting his parted legs forward, with his heavy fingers crossed in front of him, and slyly eyeing the spectator. In the painting *Nadya Nude,* 1933, done after she moved to Greenwich Village, Neel fashioned an image of stronger sexuality. Nadya's heavy thighs, thick black pubic hair, rounded belly, and large, soft breasts look ready to undulate to mechanical sexual rhythms, much like Nona in Neel's short story. The face is an ashen mask of aging impassivity, thrown back and small against the pillow. In *Nadya and Nona,* 1933, the nude Nadya, again hollow-eyed and inert in facial expression, is joined by the posterior, taut form of Nona, hunching against the bed. With her painted puppet eyelashes, Nona's face displays the haunting poignancy of the doll in Neel's painting *Symbols.* In a history of art that includes the idealized allure of Titian's *Venus of Urbino,* or the sportive coquettishness of Manet's *Olympia,* Neel presents us with the image of two worn-out women "somewhat damaged by their bohemian lives."

Living with Kenneth Doolittle, and socializing with such Village characters as Christopher Lazar and Sam Putnam, was offset by the bourgeois comforts offered by John Rothschild. After she left Doolittle, she did a number of satirically erotic watercolors of herself and John, which indicate her basic ambivalence about the relationship.

In the years following her introduction to the ideas of the Left, after Neel joined the Public Works of Art Project and the Federal Art Project of the WPA, she did a number of social realist paintings. Many of these were turned in to the WPA office as part of her obligation to submit one painting every six weeks. A work such as *Synthesis of New York,* 1933, shows heavily coated figures with skulls for faces trudging along bleak New York City streets on their way to the subway; *The 9th Avenue El,* 1935, has two wretched figures

of the Depression standing on the corner. These paintings are fantasies about the devastating effects of the Depression on urban living. Although the style and the choice of subjects in these paintings continue the Ash-Can realism of Robert Henri, early Stuart Davis, and George Luks, the skeletal figures explicitly declare the symbolic content: New York is a city of dead souls.

By the late 1930s Neel was living with José and she gave birth to Richard in 1939. Then Sam entered her life and another son, Hartley, was born in 1941. Living in Spanish Harlem during the 1940s and 1950s, she never stopped painting; her subjects were often the Puerto Ricans and Dominicans who were her neighbors. At this time she did a series of paintings of her young friend Georgie Arce, a Puerto Rican who grew from innocence to toughness—first hospitably open and finally angrily play-acting with a rubber knife. Georgie eventually wound up in Attica Prison, and Neel still corresponds with him.

During the 1950s she also painted older Communists, labor leaders, and community organizers at a time when it was not merely unfashionable but even professionally dangerous to do so. Her collection includes portraits of Mercedes Aurora, Art Shields, Hubert Satterfield, Bill McKie, Pat Cush, Mike Gold, and more recently David Gordon and Gus Hall.

Through all this period the sharpest contradiction was being a woman in a society that did not understand female, professional singlemindedness and that defined women by the male company they kept. By moving from man to man and from subject to subject she could elude classification and have it all: career, art, sex, and family.

The late 1950s, until about 1961, was a transition period for Neel. Her analysis under the care of a sympathetic psychologist encouraged her to put herself forward in the art world. With her sons grown and Sam gone, she could concentrate on art. The results meant that an increasing number of younger artists and influential critics began to pay attention to her.

The 1960s, 1970s, and early 1980s have been productive years for Neel. Her gallery of *Zeitgeist* notables has grown to include many artists, art dealers, picture framers, art critics, art historians, museum directors and curators, collectors, art groupies, and tastemakers as well as scientists, medical doctors, musicians, and even a mayor and an archbishop. Often these figures share the canvas with equally interesting looking children and spouses. Moreover, her landscapes and still-life paintings are commanding fresh attention. She was elected a member of the American Academy and Institute of Arts and Letters; President Jimmy Carter gave her a citation; the Roman Catholic Church has honored her; and the Artists' Union of Moscow gave her a major exhibition. She reads art magazines, poetry, *The New York Times*, and *The Daily World*. The contrasts still remain in her life.

In the last two decades Neel has settled into a routine for approaching her subjects and a method of working. The mere chronology of the passing years has not given evidence of style change; style is dependent only on the expressive possibilities of the subject and their importance to Neel. Typically, she begins by choosing a canvas that seems appropriate to the size and nature of the subject. Her sitters come to her studio wearing what they want to wear, but sometimes she has previously seen them in a certain outfit which she requests. In the case of Walter Gutman, Neel knew exactly how she wanted to paint him two years before she commenced the picture. Then her subjects seek out their chairs, taking their time to arrange their limbs and turn their heads. All during this settling-in process Neel talks with them and studies their faces and their body language: "Before painting, when I talk to the person, they unconsciously assume their most char-

acteristic pose, which in a way involves all their character and social standing—what the world has done to them and their retaliation."

Cindy Nemser has described the unexpected discoveries that came to her when she and her husband posed in the nude for Neel:

> My image disclosed an unexpected sensuosity, coupled with sadness and vulnerability, while my husband's portrait underscored his healthy sensuality and basic generosity of spirit. These traits were not only delineated by the rendering of our facial expressions, but were also to be read in the pose we had chosen for ourselves which Alice then transferred to her canvas. We sat close together, holding hands in an attitude of mutual support. My body concealed Chuck's sexual parts while his hand rested on my waist in a gesture of affectionate protectiveness. In this double portrait, Alice had psyched us out as individuals and had also arrived at the essence of our relationship.[2]

Once Neel has seized on the sitter's characteristic pose and gestures, she begins what is her favorite part of the process: dividing up the canvas. This means drawing with thinned ultramarine paint the outlines and features of her subjects and the outlines of the furniture, when relevant. There is no other preliminary drawing. She then proceeds by filling in the color, working all over the canvas. She may finish in three days or a week.

Her palette in the last twenty years contains the same colors as before, but she emphasizes the lighter and brighter hues and tints. She leaves parts of the canvas unpainted, allowing the image "to breathe, to escape." There is no strong direct light from outside of the canvas to throw the side of a face into dramatic chiaroscuro. Thus drawing, light, and color merge in a Neel work, and paint is applied with virtuoso gusto.

Probing further into an analysis of Neel's style, we become aware that there are two tendencies in her work. She often differentiates the characters in her "gallery" from her family by the way she handles space. For her gallery—examples being *Henry Geldzahler,* 1967, *Jackie Curtis and Rita Red,* 1970, and *Linda Nochlin and Daisy,* 1973—Neel pulls the figures forward, giving them little depth, no cast shadows, no sculpturally felt chiaroscuro, and hardly any environment other than the sitter's chair. Everything about them is seen; nothing is hidden or mysterious.[3] In this way she fully conforms to the modernist credo of our times, for if one single word designates modernism in painting, it is "surface."

An example of a portrait of a uniformly illuminated figure pushed toward the foreground is *Walter Gutman,* 1965, depicting the financier and artist with his bulky overcoated torso resting on two columnar legs. There is no background, no floor, and no shadow by which the figure's place in space is apprehended. Gutman seems a mythic icon, sprung fully dressed to wheel and deal in the financial marketplace and the art world. In *Timothy Collins,* 1971, a portrait of another money-maker, the figure sits in a modern, molded lucite chair, anchored to the floor by one slim shadow but catapulted forward by the orange-red background.

In such a foreground of immediately apprehended men and women, space definers, such as furniture and floor lines, are unnecessary. And, indeed, these environmental clues are sketched in just enough to make the sitter's pose comprehensible.

The exceptions occur in those paintings in which the furniture acts as an important design foil for the shapes of the sitters. In the painting *Linda Nochlin and Daisy,* 1973, the dark, lime-green satin fabric covering the couch contrasts beautifully with Daisy's strawberry blond hair and Nochlin's purple blouse. Moreover, the straight and curving forms of the wooden trim give structure to and echo the rhythmic arrangement of the

figural forms. Similarly, in *Cindy Nemser and Chuck,* 1975, the couch acts as the frame for the two nudes, but, presented as a whole, it isolates the anxious nestling of Cindy, who wants simultaneously to put herself forward and retreat into the protective arms of her husband. Chuck's shoulders fit comfortably into the corner edge of the backrest. Both their feet rest on the floor in rhythm with the three visible legs of the couch.

In what we have been calling her gallery, Neel is unconcerned with linear perspective and ignores the correctness of continuity in the floor and wall lines. In *Margaret Evans Pregnant,* 1978, the floor lines make no perspective sense, but as a design on a flat surface they work well. This is Neel's inheritance from Cézanne and the Cubists. Old Master space, with orthogonals mathematically measured and converging at the vanishing point, became a convention coordinated with the need of the Renaissance oligarchs to bring scientific, verifiable, and, ultimately, hierarchical order to life. The more democratic twentieth century, however, needs to account for the subjective and psychological ways that we perceive the world—ways not necessarily rational but right. Picasso's table edge loses its straight line continuity when interrupted by a dish or a napkin, and the resulting irrational rightness forces our attention. Cubism, and Neel's work as well, demands the active participation of the twentieth-century viewer in the way mathematically determined, Old Master space no longer does.

While the modernist sensibility encourages our involvement on the one hand, there are also limitations created by its conventions. In Neel's paintings, the figures posture and gesture in immediate reaction to their situation as sitters. Linda Nochlin, in her art historical studies, has elucidated how the nineteenth-century realists celebrated "contemporaneity," a word synonymous with "being of one's time."[4] This also meant being in a milieu with other people. In Neel's work, subjects are in the immediate shadowless foreground of the studio; the very lack of milieu suggests an isolation from all but the most narrow aspects of our era.

Some of the couples and families portrayed in Neel's paintings suggest an estrangement not only from the outside world, but from each other. In the era of Rembrandt—at the time of the rising bourgeoisie and the consolidation of the family—families and couples were shown gesturing tenderly toward each other, with the wife accepting a subservient and more passive role.[5] With Neel's families and couples, such as *The Family (John Gruen, Jane Wilson and Julia),* 1970, and *Benny and Mary Ellen Andrews,* 1972, such tenderness is generally absent. In *Red Grooms and Mimi Gross,* 1967, they hold hands, but Mimi looks off the canvas, away from her more assertive husband. Few of the couples gain strength and warmth from each other. In this regard, the most tender is *Geoffrey Hendricks and Brian,* 1978, an unconventional couple.

The faces of Neel's gallery subjects express a range of attitudes from cavalier disdain to resignation. Seldom do the individual faces hint at an internal life in contradiction with their public persona, and that is why her people function so well as types.[6] Rarely, in fact, does Neel paint just faces; she needs the whole body to express her perception of the person. Clues, when they exist, are revealed more often in the body language; the faces mostly wear a mask of self-assurance. The transvestite Jackie Curtis, in *Jackie Curtis and Rita Red,* 1970, dressed in a soft striped blouse and miniskirt, has no problems with his adopted identity. He brassily looks straight at the viewer; with unblinking mascaraed eyes and red Hollywood lips, he might easily step right out into our space. The only clue in this masquerade—that he (or Neel) might not really give a damn—is the large man's toe coming through the end of his sandaled stocking.

Other examples of her gallery figures betrayed by their gestures include *Archbishop Jean Jadot,* 1976, and *Bill Seitz,* 1963. Neel wanted to give the archbishop an intellectually

alive presence, so she emphasized the nervous quality of his hands. Regarding Bill Seitz, she tells of a conversation with him in 1963 when he was Curator of Exhibitions at the Museum of Modern Art:

> Bill would disclaim any influence on the art world by saying, "We just reach out there." I told him that what he hung on his walls in turn had a great influence and became sanctified. In his portrait, there is an arm resting on its elbow with a completely noncommitted hand doing nothing, which was my way of presenting his attitude.

The effects of that conversation on Neel led to her choice of the "characteristic" pose. The artist, not the sitter, makes the final decisions.

Neel has another tendency that we see most clearly in the pictures of her family and of the artists about whom she has special feelings. For these, she deepens the space and introduces cast shadows. At times she uses poses of reverie or symbolic poses. The meaning of these works invariably involves time, sometimes the future, and often death as the final consequence of human time. A look at several of Neel's paintings, the ones she considers particularly dear, bear out this other tendency.

In *Hartley on the Rocking Horse*, 1943, Neel painted her younger son astride the wooden horse—a blond, pale-eyed toddler in a spacious darkened interior. The curtain, the rush-covered chair, and the window articulate the receding space at the right. At the left, our eye travels back to the dresser, above which a mirror reflects the image of Neel herself in the process of painting an image of childhood.

Neel painted *My Mother*, 1946, at Spring Lake, New Jersey, shortly after her father's death. Neel's mother is mourning that death. Behind her, stretching into the background, is a line of trees, one of which is a willow, the neoclassical symbol of mourning.

The Sea, done at Spring Lake the following year, 1947, has a curved horizon line. Neel very consciously warped the horizon because "this way you were in it, part of it." In her early *Requiem*, the mourning figure is lying on the shore of a sea, almost embraced by the watery depths of the sea. Willows, of course, grow by waterways. In 1947, her own lingering sorrow for her father may have impelled her to paint a picture of the sea in which she was *in* the sea.

Neel effectively uses both deep space and shadow to give weight to her autobiographical interior scene *Loneliness*, 1970. For a long time Neel referred to *Loneliness* as the closest she ever came to a self-portrait because it gave concrete substance and image to the desolation she felt when Hartley left home to marry Ginny. Neel focuses on the empty, old, Indian-red leather chair, washed by sunlight pouring in through a window, with two windows visible across the street. The space in the painting from picture plane to shadowed floor, to empty chair, to window, to the windows of the building several dozen yards across the street, heightens the mood of lonely emptiness. When asked why she likes the painting, Neel responds: "That's after Hartley got married and left, but I really like the divisions in the painting. In its formal aspects, it approaches abstraction." Earlier, her concentration on control and on the canvas's divisions in *Still Life*, 1940, kept her emotionally steady at a time of deep worry over the consequences of her son Richard's eye ailments.

Nancy and the Rubber Plant, painted in 1975, is one of Neel's rare portraits that includes both shadow and a degree of depth unusual in her oeuvre. Moreover the work is far more complicated spatially and in terms of light than usual. She admits that it "had one peculiarity—I worked on it longer without getting tired of it." To the left is the refer-

ence to space: a window with its shade raised revealing the West-Side skyline. On the right rear wall is a reference to time: the 1940 memory portrait *Audrey McMahon*, head of the New York WPA project, whose gesture echoes that of her daughter-in-law, Nancy. Shapes of sunlight play across Nancy's arm, legs, the chair, and the floor, creating a counter pattern to the rubber plant's leaves.

In her cityscape *107th and Broadway*, 1976, depicting the same windows as in *Loneliness*, she explicitly refers to the hulking cast shadow of her own building against the windowed facade as "the shadow of death."

Another work, *Duane Hanson*, 1972, one of her best, most sympathetic, full-length single portraits of an artist friend, merits analysis in this regard.[7] The sculptor sits looking at Neel. The face appearing under a shock of blond hair reveals two sides of Hanson—a handsome, youthful one somewhat in shadow, and the one illuminated by the light in Neel's studio, the side alive with facial lines, tense lips, and mature careworn eyes. His hands match the sides of his face; one is relaxed and somewhat hidden, while the other is tightened. A heavy red coat with fur collar encases his body, forming a protective shell. The figure seems unstable on the small chair, tipping toward the back and about to slip into the blue-violet shadow which surrounds him. The unfinished passages of the painting serve to emphasize the shadow pressing down upon him from the upper left.

Neel has spoken at length about Hanson and about the conversations they had about sickness and death. She has said of her art that "everything you think and feel goes into a painting." Indeed, her knowledge of Hanson, her empathy for what she feels are his concerns and apprehensions, influence her rendering of the sculptor. The result is an intense and unstable figure of Hanson, a feeling of urgency, as there is to Neel herself when she hastens to leave this painting once she has set down the essentials—the tensions and contradictions mirrored in his particular face.

The portrait of *The Soyer Brothers*, 1973, also projects a feeling of tenseness and urgency. In Neel's own words: "Old age even by itself is poignant. But the struggle. Look at Raphael's face. See how he struggles. Both of them."

Several family portraits are pensive images, such as *Hartley*, 1965, *Hartley*, 1978, and *Nancy*, 1981. One might well ask: Why does the image of the contemplative person have such nobility? Perhaps it comes to us as a relief from the images in our minds of the aggressive actions of the everyday hustle. In any event, thought, that tenuous state of being, implies time and space.

The painting *Richard*, 1973, operates on a symbolic level. Her son stands in a shadowless garden setting—frontal, rigid, iconic, loins draped with a white towel, fists clenched, and eyes staring past the viewer with strange highlights on the pupils suggesting an inward light—almost a Christ-like image. Neel has often said of her works that she does not need to paint self-portraits because she herself becomes absorbed into the portraits she creates. "I come under the spell of a person—out of myself into that other person."

Nancy pregnant is the subject of one of her great works, *Pregnant Woman*, 1971, brought from the level of the specific and time-bound to the symbolic and timeless. Her earliest representation of a pregnant woman was in *Couple on a Train*, 1930. In 1964, she did *Pregnant Maria;* in 1967, *Pregnant Julie and Algis;* in 1968, *Betty Homitzky;* and in 1978, *Margaret Evans Pregnant,* and others. Neel's feeling is that pregnancy is "a very important part of life and it was neglected" in the work of past artists. Indeed, there is great variety in these images of pregnant women.

Parents with children is another category: *Hubert Crehan and Sasha*, 1962, and *Kevin and Andy*, 1980, both show fathers with children. The Haitian housekeeper, in *Carmen and Judy*, 1972, is burdened with the tragedy of having a mentally retarded

child; Neel admires the strong hands and patient face continuing to care for the child.

Neel's daughter-in-law, Nancy, is the most frequent subject of the parent/child paintings. The earliest is *Mother and Child (Nancy and Olivia)*, 1967, showing the young mother, Nancy, anxiously hugging her first daughter who is squirming in her arms. A more self-assured Nancy, in *Nancy and the Twins*, 1971, benignly observes the two five-month-old "gladiators" (Neel's term), moving turtlelike toward the viewer. In *Nancy and Victoria*, 1974, Nancy sports her fourth daughter on her lap with utter self-confidence. In *The Family*, 1980, Nancy's three younger daughters seem to tower over her figure. The painting is set in the garage studio at Spring Lake. Even the seemingly universal theme of "the family" is affected by the sociology of our times and our mores. Nancy's face has become a mask hiding the internal tensions of self-denial. However universalized the theme may be and whatever the results, Neel is never unaware of the specifics of the human situation.

The nature of Neel's realism is to intensify and make more immediate our encounters with our own era. If we are in or on the fringes of the art world in New York City, we are likely to meet the characters whom she has painted—if not them specifically, then the type: the thoughtful artist, the shrewd, penny-pinching collector, the unctuous art dealer, the empty-headed art groupie, the earnest art student, the self-assured art historian, and the clever artist's wife. She does not make judgments on these people; she presents them as the essence of their experience. Other figures—scientists, doctors, and her two sons—are also caught up in Neel's analysis and observation of the *Zeitgeist*. But by being farther away from the art world, they are as a group rendered more sympathetically.

As her own words strikingly confirm, Neel today embodies contrasts. In appearance, as has often been remarked, she looks like the grandmotherly type. She accepts her age and that role—concerning herself with the comings and goings of her grandchildren, visiting Hartley, Ginny, and their children in Vermont, and taking Olivia to an avant-garde play. But that is only one aspect of herself. She is still very much the painter: starting new portraits, talking about other artists, going to openings, agonizing over sales and dealers, planning exhibitions, giving lectures, and pronouncing on what is important in art.

But the art world and her family in no way consume her full attention. More than any other artist I know, she is well-read and alive to what is going on in the world: to what is the latest biography of Freud, to what are the advances in medicine, to what the Secretary of State is doing about the arms race, to what turns the civil wars in Central America and the Middle East are taking. She worries about what seems to be the inevitability of a nuclear holocaust.

Neel's words are very much in the spirit of the Homeric epic style. She tells her life as an episodic serial of accumulated descriptive detail punctuated with recalled conversations. She makes no moral judgments about the individuals who hindered or helped her. But she knows her enemies; when misfortune befalls them, she feels revenged by fate. Rarely are regrets expressed, causes analyzed, or rationales explained. She tells her life as if it happened from moment to moment as a sensuously textured surface of experience. And yet this existential retelling of individual actions does not preclude her firm belief in the continuity of the generations or her continued protest against the inhumanity of institutions and systems.

Goya, Van Gogh, Munch, Kokoshka, Soutine, and Dix were all realists who stretched, twisted, and punctured the skin of conventional verisimilitude for expressive ends. Alice

Neel has inherited their calculating intensity, but she has also absorbed the legacies of Freud and Marx, and she is always conscious of our twentieth-century political and intellectual revolution. For Neel, a painting achieves its true importance when it blends art and history, offering the viewer an engaging sensuous surface and at the same time capturing the essences of people, like herself, who have come to accept contradictions and to be themselves.

Notes

1. All quotations are from Neel's text published here or from additional conversations held with the artist during September and October, 1982.

2. Cindy Nemser, "Alice Neel—Teller of Truth," in Georgia Museum of Art, *Alice Neel: The Woman and Her Work* (Athens, Georgia: Georgia Museum of Art, 1975), unpaged. For another sitter's experiences, see Henry R. Hope, "Alice Neel: Portraits of an Era," *Art Journal* 38 (Summer, 1979), pp. 273–81.

3. This is similar to what Erich Auerbach in another context refers to as the Homeric epic style. See his *Mimesis: The Representation of Reality in Western Literature*. Translated by Willard R. Trask (Princeton, New Jersey: Princeton University Press, 1953), pp. 6–7.

4. See Linda Nochlin, *Realism* (Baltimore, Maryland: Penguin Books Inc., 1971), pp. 103 ff. For a more recent discussion of this issue, see Donald Kuspit, "What's Real in Realism?" *Art in America* 69 (September, 1981), pp. 84–94.

5. See particularly David R. Smith, "Rembrandt's Early Double Portraits and the Dutch Conversation Piece," *The Art Bulletin* 64 (June, 1982), pp. 259–88.

6. For a discussion of the representation of facial expression see the chapter "The Experiment of Caricature," in E. H. Gombrich, *Art and Illusion: A Study in the Psychology of Pictorial Representation* (Princeton, New Jersey: Princeton University Press, 1960).

7. I have previously discussed the paintings *Duane Hanson* and *Pregnant Woman* in Boston University Art Gallery, *Alice Neel: Paintings of Two Decades* (Boston: Boston University Art Gallery, 1980), pp. 6 and 7.

Biography

1900
January 28. Born in Merion Square, Pennsylvania. Moved to Colwyn when she was about three months old.

1918
Graduated from high school.

1921
Enrolled in the Philadelphia School of Design for Women (now Moore College of Art).

1924
Summer, attended the Chester Springs summer school of the Pennsylvania Academy of the Fine Arts. Met Carlos Enriquez.

1925
Graduated from the Philadelphia School of Design for Women. Married Carlos Enriquez and traveled with him to Havana, Cuba.

1926
December 26, daughter Santillana Enriquez born in Cuba.

1927
Summer, returned to the United States with Santillana. First visited her family in Colwyn; in the fall, moved with Carlos and Santillana to New York. December, Santillana died of diphtheria.

1928
November 24, daughter Isabella, called Isabetta, born.

1930
May 1, Carlos left with Isabetta to visit Cuba. Productive summer of painting followed by a nervous breakdown on August 15. Hospitalized at the Orthopedic Hospital, Philadelphia.

1931
Winter, attempted suicide and sent to the Wilmington Hospital. Briefly returned to the Orthopedic Hospital and then to the suicidal ward of the Philadelphia General Hospital. Summer, spent at Dr. Ludlum's Sanatorium, where she recovered sufficiently to be sent home. September, home to Colwyn, then visited Nadya Olyanova in Stockton, New Jersey. Met Kenneth Doolittle.

1932
Moved with Kenneth Doolittle to Greenwich Village, New York City. Participated in Washington Square Outdoor Art Show where she met John Rothschild.

1933
December, enrolled on the Public Works of Art Project (PWAP). Included in exhibition at the Boyer Gallery in Philadelphia.

1934
Winter, Kenneth Doolittle destroyed many of Neel's paintings.

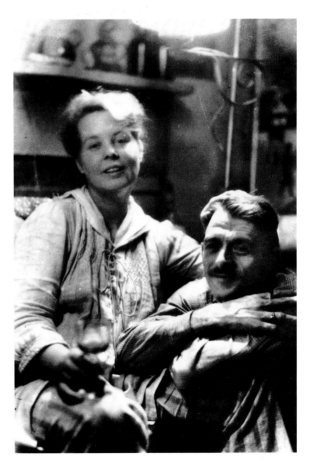

Alice Neel with Kenneth Doolittle, 1933

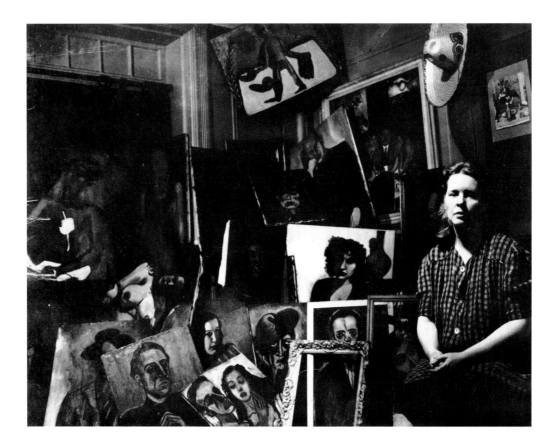

Alice Neel in her Harlem studio, 1948

1935
Joined the rolls of the WPA/Federal Art Project, Easel Division. Moved to West 17th Street, New York. Met José Santiago.

1938
Moved to Spanish Harlem. Included in exhibition *The New York Group*, held at ACA Gallery, New York.

1939
September 14, Richard Neel born. José left.

1940
January, met Sam.

1941
September 3, Hartley Stockton Neel born.

1944
March, solo exhibition at Pinacotheca Gallery, New York.

1946
Father died.

1950
December, solo exhibition at ACA Gallery, New York.

1951
Solo exhibition at New Playwrights Theater, New York.

1954
Mother died. Second exhibition at ACA Gallery.

1959
Appeared in Alfred Leslie and Robert Frank's film, *Pull My Daisy*.

1960
Neel's paintings first reproduced in *Art News*.

1961
Richard Neel graduated from Columbia College.

1962
Included in group exhibition *Figures* held at Kornblee Gallery, New York. September, moved to 300 West 107th Street.

1963
Spring, Hartley Neel graduated from Columbia College. October, first Graham Gallery exhibition. Richard Neel and Nancy Greene married.

1964
Richard graduated from Columbia Law School.

1965
Traveled to Europe with Hartley.

1967
Granddaughter Olivia born to Nancy and Richard.

1969
Received an Arts and Letters award from the American Academy and Institute of Arts and Letters, New York. Hartley graduated with an M.D. from Tufts Uni-

versity. Summer, traveled to Mexico with Richard and Nancy. Traveled to Russia with John Rothschild.

1970
Hartley Neel and Virginia Taylor married.

1971
Awarded an Honorary Doctorate of Fine Arts from her alma mater Moore College of Art (formerly the Philadelphia School of Design for Women). Nancy and Richard's twins, Alexandra and Antonia, born.

1972
Included in the Whitney Museum of American Art Annual. Traveled to Greece and Africa with Hartley.

1974
Major retrospective of Neel's portraits held at the Whitney Museum of American Art. Victoria, Nancy and Richard's fourth daughter, born.

1975
Major retrospective of Neel's work held at the Georgia Museum of Art. Ginny and Hartley's daughter, Elizabeth, born. John Rothschild died.

1976
Elected to the American Academy and Institute of Arts and Letters.

1978
Ginny and Hartley's son, Andrew, born.

1979
Received a National Women's Caucus for Art award for outstanding achievement in art, presented by President Jimmy Carter. Major retrospective exhibition held in Connecticut at the University of Bridgeport and the Silvermine Guild of Artists.

1981
Major solo exhibition held at the Artists' Union, Moscow.

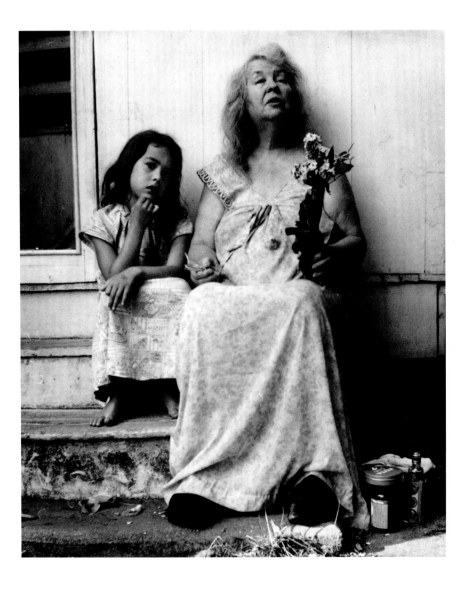

Alice Neel with her grandchild Olivia in Spring Lake, 1974.

List of Exhibitions

Solo Exhibitions

1926
Havana, Cuba

1938
Contemporary Arts Gallery, New York City

1944
Pinacotheca Gallery, New York City

1950
ACA Gallery, New York City

1951
New Playwrights Theater, New York City

1954
ACA Gallery, New York City

1960
Old Mill Gallery, Tinton Falls, New Jersey

1962
Reed College, Portland, Oregon

1963
Graham Gallery, New York City

1965
Dartmouth College, Hanover, New Hampshire; Fordham University, The Bronx

1966
Graham Gallery, New York City

1967
Maxwell Gallery, San Francisco

1968
Graham Gallery, New York City

1969
Nightingale Galleries, Toronto

1970
Graham Gallery, New York City

1971
Moore College of Art, Philadelphia

1972
Bowling Green University, Bowling Green, Ohio; Bloomsburg State College, Bloomsburg, Pennsylvania

1973
Graham Gallery, New York City; Langman Gallery, Jenkintown, Pennsylvania

1974
Whitney Museum of American Art, New York City; Old Mill Gallery, Tinton Falls, New Jersey; Summit Art Center, New Jersey

1975
Portland Center for Visual Arts, Portland, Oregon; Georgia Museum of Art, Athens; Hobart and William Smith Colleges, Geneva, New York; American Can Collective, San Francisco; Smith College, Northampton, Massachusetts; University Center Gallery, University of the Pacific, Stockton, California

1976
Graham Gallery, New York City; Choate School, Wallingford, Connecticut

1977
Graham Gallery, New York City; Washington County Museum, Hagerstown, Maryland; University of Wisconsin, Oshkosh; Lehigh University, Bethlehem, Pennsylvania; Fort Lauderdale Museum, Florida; Queens College Library, New York; Wichita Museum, Kansas

1978
Graham Gallery, New York City; Artemisia Gallery, Chicago; Alverno College, Milwaukee; Skidmore College, Saratoga Springs, New York; State University of New York, Plattsburg, New York

1979
Middendorf Lane Gallery, Washington, D.C.; Akron Art Institute, Ohio; Williams College, Williamstown, Massachusetts; Guild of Artists, Silvermine, Connecticut; University of Bridgeport, Connecticut

1980
Lancaster Community Gallery, Pennsylvania; Sarah Institute, New York City; Boston University Art Gallery, Massachusetts; Drury College, Springfield, Missouri; Graham Gallery, New York City

1981
Artists' Union, Moscow, U.S.S.R.; Bennington College, Bennington, Vermont; The National Academy of Sciences, Washington, D.C.

1982
Robert Miller Gallery, New York City

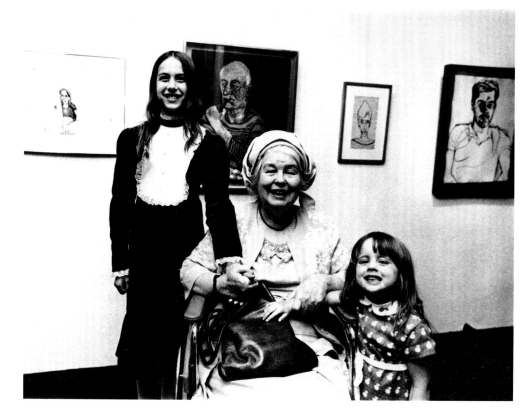

Alice Neel with her grandchildren Olivia Neel and Elizabeth Neel at her drawing show in Miami, 1978

Group Exhibitions

1933
Boyer Gallery, Philadelphia

1938
ACA Gallery, New York City

1942
WPA Exhibition, Macy's Department Store, New York City

1960
ACA Gallery, New York City

1962
Kornblee Gallery, New York City; Zabriskie Gallery, New York City

1963
Byron Gallery, New York City

1964
Nebraska Art Association; Wadsworth Atheneum, Hartford; The Riverside Museum, New York City; The American Federation of Arts, New York City (Traveling Exhibition); The American Academy of Arts and Letters, New York City; The Silvermine Guild, New Canaan, Connecticut

1968
The Museum of Modern Art, New York City (Traveling Exhibition)

1969
Graham Gallery, New York City; The Museum of Modern Art, New York City (Traveling Exhibition); The National Institute of Arts and Letters, New York City; Studio Museum in Harlem, New York City

1971
National Academy of Design, New York City; Whitney Museum of American Art, New York City

1972
Whitney Museum of American Art, New York City; Colorado State University, Fort Collins; The American Academy of Arts and Letters, New York City

1973
The New York Cultural Center, New York City; Women's Interart Center, New York City; School of Visual Arts Gallery, New York City; Emily Lowe Gallery, Hofstra University, Hempstead, New York; The American Academy of Arts and Letters, New York City

1974
Women's Interart Center, New York City; Samuel S. Fleisher Art Memorial, Philadelphia; Langman Gallery, Jenkintown, Pennsylvania; Philadelphia Civic Center; The Queens Museum, Flushing, New York

1975
Randolph-Macon Woman's College, Lynchburg, Virginia; National Academy of Design, New York City;

The Queens Museum, Flushing, New York; The New York Cultural Center, New York City; The Minneapolis Institute of Arts; University of Houston Fine Art Center; International Biennale, Tokyo

1976
Everson Museum of Art, Syracuse; Fendrick Gallery, Washington, D.C.; Pennsylvania State University, University Park, Pennsylvania; Wildenstein Gallery, New York City; Philadelphia Museum of Art; Los Angeles County Museum of Art

1977
Downtown Whitney, New York City; Whitney Museum of American Art, New York City; Princeton University, New Jersey

1978
WPA Exhibition, Grey Art Gallery, New York City; WPA Exhibition, Parsons School of Design, New York City; Squib Exhibition, Princeton, New Jersey; P.S. #1, Queens, New York; State University of New York, Stony Brook, Long Island

1980
Whitney Museum of American Art, New York City; University of Hartford, Connecticut; Harold Reed Gallery, New York City

1981
Forum Gallery, New York City; The Butler Institute of American Art, Youngstown, Ohio; San Antonio Museum of Art; Indianapolis Museum of Art; Tucson Museum of Art; Carnegie Institute, Pittsburgh

1982
Terry Dintenfass Gallery, New York City; Newport Harbor Art Museum, Newport Beach, California; Portland Art Museum, Oregon; Joslyn Art Museum, Omaha; Hirshhorn Museum and Sculpture Garden, Washington, D.C.; Whitney Museum of American Art, New York City; Sierra Nevada Museum of Art, Reno, Nevada; Whitney Museum of American Art, Stamford Branch, Connecticut; Contemporary Art Center, Dayton Art Institute, Ohio; The Aldrich Museum of Contemporary Art, Ridgefield, Connecticut; Lever House, New York City

Selected Bibliography

Albright-Knox Art Gallery. *American Painting of the 1970s.* Buffalo: Albright-Knox Art Gallery, 1978. Essay by Linda L. Cathcart.

The Aldrich Museum of Contemporary Art. *Homo Sapiens: The Many Images.* Ridgefield, Connecticut: The Aldrich Museum of Contemporary Art, 1982.

Alloway, Lawrence. "Art," *The Nation* (May 5, 1979): 514–16.

Artists' Union, U.S.S.R. *Alice Neel: Catalogue of the Works in the Exhibition.* Moscow: Soviet Artists, 1981. In Russian.

Bailey, Patricia. "Alice Neel Portraits," *Art/World* (November 20/December 20, 1980): 1, 6.

Berrigan, Ted. "The Portrait and Its Double," *Art News* 64 (January, 1966): 30–33, 63–64.

Boston University Art Gallery. *Alice Neel: Paintings of Two Decades.* Boston: Boston University Art Gallery, 1980. Essay by Patricia Hills.

Bourdan, David. "Women Paint Portraits on Canvas and Off," *The Village Voice* (February 20, 1976): 54.

C[ambell], L[awrence]. "Reviews and Previews," *Art News* 69 (November, 1970): 24.

Cochrane, Diane. "Alice Neel: Collector of Souls," *American Artist* 37 (September, 1973): 32–37, 62–64.

Columbia University, Department of Art History and Archaeology. *Modern Portraits: The Self & Others.* New York: Columbia University, 1976. Essays by Kirk T. Varnedoe and others.

Crehan, Hubert. "Introducing the Portraits of Alice Neel," *Art News* 61 (October, 1962): 44–47, 68.

Everson Museum of Art. *Paintings by Three American Realists: Alice Neel, Sylvia Sleigh, May Stevens.* Syracuse, New York: Everson Museum of Art, 1976. Essay by Phyllis Derfner.

Evett, Kenneth. "From Top to Bottom at the Whitney," *The New Republic* (May 4, 1974): 27–28.

ffrench-frazier, Nina. "New York Reviews," *Art News* 76 (December, 1977): 141–42.

Fort, Ilene Susan. "Reviews," *Arts Magazine* 55 (January, 1981): 26–27.

Fort Lauderdale Museum of Art. *Alice Neel.* Fort Lauderdale, Florida: 1978. Essay by Henry R. Hope.

Frank, Peter. "New York Reviews," *Art News* 75 (April, 1976): 122.

Friedman, Jon R. "Alice Neel," *Arts Magazine* 57 (September, 1982): 23.

Gaugh, Harry F. "Alice Neel," *Arts Magazine* 53 (March, 1979): 9.

Georgia Museum of Art. *Alice Neel: The Woman and Her Work.* Athens, Georgia: Georgia Museum of Art, 1975. Preface by William D. Paul, Jr.; essay by Cindy Nemser; statements by Dorothy Pearlstein, Raphael Soyer, and Alice Neel; and poem by John I. H. Baur.

Goldstin, Patti. "Soul on Canvas," *New York* (July 9–16, 1979): 76–80.

Goodyear, Frank H., Jr. *Contemporary American Realism since 1960.* Boston: New York Graphic Society, 1981.

Graham Gallery. *Alice Neel: A Retrospective Exhibition of Watercolors and Drawings.* New York: Graham Gallery, 1978. Essay by Ann Sutherland Harris.

Halasz, Piri. "Alice Neel: 'I have this obsession with life,'" *Art News* 73 (January, 1974): 47–49.

Hall, Lee. "The Sullen Art and Craft of Portraiture," *Craft Horizons* 34 (December, 1974): 40.

Harris, Ann Sutherland. "'The Human Creature,'" *Portfolio* 1 (December/January, 1979–80): 70–75.

Harris, Ann Sutherland, and Nochlin, Linda. *Women Artists: 1550–1950.* New York: Alfred A. Knopf and the Los Angeles County Museum of Art, 1976.

Heinemann, Susan. "Reviews," *Artforum* 12 (May, 1974): 74–75.

Henry, Gerrit. "The Artist and the Face: A Modern American Sampling," *Art in America* 63 (January-February, 1975): 34–35.

Henry, Gerrit. "New York Letter," *Art International* 14 (December, 1970): 77.

Hess, Thomas B. "Art: Behind the Taboo Curtain," *New York* 7 (March 4, 1974): 68.

Hess, Thomas B. "Sitting Prettier," *New York* (February 23, 1976): 62–63.

Hills, Patricia, and Roberta K. Tarbell. *The Figurative Tradition and the Whitney Museum of American Art: Paintings and Sculpture from the Permanent*

Collection. New York: Whitney Museum of American Art in association with the University of Delaware Press, 1980.

Hills, Patricia. *Social Concern and Urban Realism: American Painting of the 1930s*. Boston: Boston University in association with District 1199's Bread and Roses Project and The American Federation of Arts, 1983.

Hope, Henry R. "Neel: Portraits of an Era," *Art Journal* 38 (Summer, 1979): 273–81.

Johnson, Ellen H. "Alice Neel's Fifty Years of Portrait Painting," *Studio International* 193 (March, 1977): 174–79.

Kramer, Hilton. "Alice Neel Retrospective," *The New York Times* (February 9, 1974): 25.

[Kroll, Jack.] "Art: Curator of Souls," *Newsweek* (January 31, 1966): 82.

L[evin], K[im]. "Reviews and Previews," *Art News* 62 (October, 1963): 11.

Loercher, Diana. "Alice Neel," *The Christian Science Monitor* (March 4, 1974): F6.

Mainardi, Pat. "Alice Neel at the Whitney Museum," *Art in America* 62 (May-June, 1974): 107–108.

Mellow, James R. "When Does a Portrait Become a Memento Mori?" *The New York Times* (February 24, 1974): Section D, p. 19.

Mercedes, Rita. "The Connoisseur Interview: Alice Neel Talks with Rita Mercedes," *The Connoisseur* 208 (September, 1981): 2–3.

Munro, Eleanor. *Originals: American Women Artists*. New York: Simon and Schuster, 1979.

Neel, Alice. "A Statement," *The Hasty Papers: A One Shot Review*, ed. Alfred Leslie. New York: Alfred Leslie, 1960.

————. "Moore College of Art Doctoral Address, 1971," later published in Georgia Museum of Art, *Alice Neel: The Woman and Her Work*. Athens, Georgia: Georgia Museum of Art, 1975.

————. Review of *The Dream and the Deal* by Jerre Mangione. *Daily World* (November 11, 1972): 8.

————. "New York—14 Years Later," Whitney Museum of American Art, Alice Neel. New York: Whitney Museum of American Art, 1974.

———— in "Ten Portraitists: Interview Statements," *Art in America* 63 (January-February, 1975): 40.

————. "I Paint Tragedy and Joy," *The New York Times* (October 31, 1976): Section D, p. 29.

———— in Gerrit Henry, "Is New York Still the Artistic Place to Be?" *Art News* 75 (November, 1976): 44–45.

————. The poem "Oh, the men, the men," was published in *Night* 2, No. 3 (April 1979).

Nemser, Cindy. "Art: Alice Neel—Portraits of Four Decades," *Ms.* 2 (October, 1973): 48–53.

Nemser, Cindy. *Art Talk: Conversations with 12 Women Artists*. New York: Charles Scribner's Sons, 1975.

N[emser], C[indy]. "In the Galleries . . . Alice Neel." *Arts Magazine* 42 (February, 1968): 60.

Nemser, Cindy. "Representational Painting in 1971: A New Synthesis," *Arts Magazine* 46 (December, 1971): 41–46.

Nochlin, Linda. "Some Women Realists: Painters of the Figure," *Arts Magazine* 48 (May, 1974): 29–33.

Ortega, Susan. "Art for Detente," *Daily World* (September 3, 1981): 17.

Perreault, John. "Catching Souls and Quilting," *The Village Voice* (February 21, 1974): 26.

Perreault, John. "Go Ask Alice," *The Soho Weekly News* (December 3, 1980): 25.

Perreault, John. "Reading Between the Face's Lines," *The Village Voice* (September 27, 1973).

P[erreault], J[ohn]. "Reviews and Previews," *Art News* 66 (January, 1968): 16.

Perreault, John. "Talking Heads: Portraiture Revived," *The Soho Weekly News* (February 19, 1976): 20.

Peterson, Valerie. "U.S. Figure Painting: Continuity and Cliché," *Art News* 61 (Summer, 1962): 36–38, 51.

R[aynor], V[ivian]. "New York Exhibitions: In the Galleries," *Arts Magazine* 38 (October, 1963): 58–59.

Rubinstein, Charlotte Streifer. *American Women Artists: From Early Indian Times to the Present*. Boston: G. K. Hall & Co., 1982.

Schmitt, Marilyn. "Alice Neel," *Arts Magazine* 52 (May, 1978): 9.

The Silvermine Guild of Artists with the University of Bridgeport. *Alice Neel: A Retrospective Showing*. New Canaan, Ct.: The Silvermine Guild of Artists, 1979. Essay by Martha B. Scott.

Slesin, Suzanne. "New York Artists in Residence," *Art News* 77 (November, 1978): 71. Photographs by Michael Halsband.

Stevens, May. "The Non-Portraits of Alice Neel," *Women's Studies* 6 (1978): 61–73.

Turner, Norman. "Alice Neel," *Arts Magazine* 52 (December, 1977): 14.

Wallach, Amei. "Late in Life, the Moment of Triumph," *Newsday* (February 24, 1974): Part II, pp. 20–21.

Whitney Museum of American Art. *Alice Neel*. New York: Whitney Museum of American Art, 1974. Essay by Elke Morger Solomon.

Whitney Museum of American Art. *Focus on the Figure: Twenty Years*. New York: Whitney Museum of American Art, 1982. Essay by Barbara Haskell.

Index

Photo Credits